PENGUIN BOOKS

MY INNER SKY

Mari Andrew is a writer, artist, and speaker based in New York City.

●　●　●

PRAISE FOR *MY INNER SKY*

"There's something about Mari Andrew's words and illustrations that make you feel at home. *My Inner Sky* reminds readers of the shared grief, joy, and sorrow that we experience throughout life—and how to cope with it."

—*Marie Claire*

"To say this year has been challenging is an understatement and it's easy to despair at the scale of the loss we are collectively experiencing across the globe. This book is a reminder that healing is humbling, that resilience is beautiful, that there is joy in choosing yourself, and that life is made of little moments worth paying attention to and celebrating. Mari makes no grand pronouncements and doesn't offer any easy advice. Instead she shares with us one word and one illustration at a time why being alive is so damn worth it."

—Aminatou Sow, author of *Big Friendship*

"Mari Andrew's words and artwork in *My Inner Sky* are exactly what the world needs now: hopeful, uplifting, and healing. This book is for anyone who needs an infusion of light in their life."

—Ally Love, founder and CEO of Love Squad, Peloton instructor, and host of *Basics of Bossing Up*

"Mari Andrew is so relatably thrilled, frustrated, and fascinated by life—so recognizably human—that it's impossible not to root for her, and in doing so, root for all of us. *My Inner Sky* is the deep, peaceful exhale everyone needs right now and always."

—Mary Laura Philpott, author of *I Miss You When I Blink*

"Mari Andrew has a jeweler's eye. She teaches us to look at the world, and then to look again—to make a scared ritual of the ordinary, to search for magic in the mundane, and to excavate beauty from pain. Her collection of essays, *My Inner Sky*, is an enchanting, big-hearted study of how to navigate the in-betweenness of grief, illness, love, and, ultimately, of healing. Through Andrew's stories, we travel through her innermost thoughts, the turbulent passages of her past, and all around the world—Spain, Greece, Australia, France, and the streets of New York City. At each turn, she uncovers hard-earned coins of wisdom in the most unlikely places. This book is a wonder, and a must-read for the heartsick, the suffering, the lonely, the seeking, which is to say: All of us."

—Suleika Jaouad, author of *Between Two Kingdoms*

"A timely and modern prompt to allow, even celebrate, the full spectrum of emotion and experience into our lives, the pain, the splendor, and the many, many nuances in between."

—Zoë Foster Blake, author of *Break-Up Boss*

MY
INNER SKY

On Embracing Day, Night,
and All the Times in Between

MARI ANDREW

PENGUIN BOOKS

PENGUIN BOOKS
An imprint of Penguin Random House LLC
penguinrandomhouse.com

LIBRARY OF CONGRESS CATALOGING-IN-PUBLICATION DATA
Names: Andrew, Mari, author.
Title: My inner sky : on embracing day, night, and all the times
in between / Mari Andrew.
Description: New York : Penguin Books, [2021] |
Identifiers: LCCN 2020041571 (print) | LCCN 2020041572 (ebook) |
ISBN 9780143135241 (hardcover) | ISBN 9780525506928 (ebook)
Subjects: LCSH: Life cycle, Human–Social aspects. | Life cycle,
Human–Psychological aspects. | Maturation (Psychology) |
Emotions. | Conduct of life.
Classification: LCC HQ799.95 .A565 2020 (print) | LCC HQ799.95 (ebook) |
DDC 155.2/5–dc23
LC record available at https://lccn.loc.gov/2020041571
LC ebook record available at https://lccn.loc.gov/2020041572

Printed in the United States of America
1 3 5 7 9 10 8 6 4 2

BOOK DESIGN BY LUCIA BERNARD

Some names and identifying characteristics have been changed
to protect the privacy of the individuals involved.

For the Wong Family

CONTENTS

INTRODUCTION

Humans have rituals for beginnings and endings. We get all dolled up for New Year's Eve, throw retirement parties, buy gifts for both engagements and weddings, and send graduation announcements. We ritualize the beginning of a day with a morning routine that we probably copied from someone else, and mark the end of the week with a Friday margarita. We're good at starting and we're good at finishing.

But we don't know what to do with ourselves in the in-between—with the melancholy as we wait to fall in love, with the frustration of infertility, with the hope of a job interview, with the worrisome boredom six months in once we get the job. Our culture just isn't set up to support it.

In other words, we are just really bad at waiting.

One creature that's very good at waiting? The lobster. About twice a year, lobsters begin outgrowing their shells. The signal that they're growing: they get really uncomfortable. But they know what to do when their shells begin feeling tight and their limbs get awkwardly long.

They go into hiding.

I imagine a lobster saying to its friends, "Hey guys, I'm going to be out of the office for a couple weeks. Busy growing a new shell, nothing personal." And then it goes into a burrow, puts up a Do Not Disturb sign, and, I don't know, catches up on all five seasons of *The Wire* or something. The lobster knows it's going to be vulnerable during this time, unprotected and getting used to a new shape. The time hiding by itself is not only a poetic period of self-reflection, but necessary for its survival.

I think humans might be so uncomfortable with transition periods because we don't give ourselves the *right* to be lonely and uncomfortable like lobsters do. We're so often told, "Focus on the positive. Choose happiness. Good vibes only" that we feel like something must be wrong with us when we're not a living, breathing inspirational cross-stitch pillow.

I'm not irritated by cheeriness (in fact, my worldview skews canary-yellow-level optimistic) but I don't like emotional binaries: the idea that you're either happy or sad, positive or negative. "Think positive" gives us only one option, out of a vast and fluid range of perspectives, for experiencing whatever we're going through. It implies that anything less than the nebulous "positive" is undesirable, and that it should be fought against. If we're not happy, we must not be making the correct emotional choice.

Two years ago, I received a book deal, which made my life seem a million times brighter and more glowy than ever. Making a book is the only dream I've ever had for myself, and it came true. So I decided to make that dream-come-true even dreamier and write my book in a foreign country—why not? I googled "most bohemian cities in the world" to help me decide on a place to be a real writer for a few months. After getting a few cosmic, or totally coincidental, signs pointing in the direction of Spain, I decided on Granada. It sounded pretty nice: *Gra-nah-dahh*.

And, indeed, it was pretty nice. I'm an avid solo traveler, so for me it was heaven getting to explore the streets and art and architecture by myself. My days went like this: In the morning, I'd write from an outdoor cafe with a cappuccino. In the afternoon, I'd go to my daily flamenco lesson, which took place in an old cave. In the evening, I'd go out to wine bars and seafood restaurants and meet people— many of whom were also artists and writers. Turns out, Granada actually is a very bohemian city!

It was bliss, until one afternoon when my legs began feeling really weak after dance class. I dismissed it—chalking it up to too much dancing, too much wine, and probably not enough water—until my hands and arms started weakening too. I was diagnosed with Guillain-Barré Syndrome, an autoimmune disease that went on a rampage through my body, trying to destroy my nerves so they couldn't work for me anymore. Rude, right?

The next couple of weeks were marked with excruciating pain and discomfort from lying on a hard mattress in a hot hospital room. I was discouraged, in pain, and feeling very sorry for myself.

But I wasn't alone. Friends texted me nonstop, asking me how I was, telling me they were praying for me. Flowers arrived for me daily. My mom was there, and nurses checked on me once an hour. I was miserable, but surrounded by people.

The transition time that followed was actually much lonelier. When I got out of the hospital, I could walk, but it was unpleasant—I felt like I had a rubber band tied around my legs so each step was a chore. I could use my arms, but my hands were so weak I needed help with daily tasks like opening a can to make lunch. And I could socialize, but I found it really hard to stay present when my friends would tell me about their relationship woes or work struggles. People kept asking me when I'd get better, but I had no idea what that would look like, or even if it was possible for me.

It was a period of waiting. During that time, I wasn't focusing on the positive or choosing happiness; in fact, I was distinctly unhappy, so I felt like I wasn't making the right emotional choice.

Over the course of a couple months, it got too strenuous to keep pretending I was "getting back to normal." It became clear that there wouldn't be one specific day when I'd wake up and feel like my old self, and it also became clear that my old self no longer existed.

Trying to keep up with my self-induced pressure to be positive was exhausting, so I made some decisions to be true to my own experience. I stopped using the phrase "I feel like I should" and instead tried to show up for the emotions I was feeling in that moment. I also went into my own burrow (i.e., my bedroom) for a while and began creating art and writing about what was really going on with me: my fears that I'd never get better, my frustrations with my new physical changes, and the way that depression felt like a flame in my heart that I couldn't put out.

My honesty was met with community: people told me that they felt the same way, and that I wasn't alone.

After a couple of months, I began feeling different. I started getting accustomed to my new way of moving, and even took a dance class again that accommodated my inability to point my toes. I found that I could bring some new empathy to my conversations with friends that I didn't have before. My art and writing style evolved, and reflected what I was truly going through. My shape was changing. My shell was hardening. And it felt like a new morning.

◐ ◐ ◐

I love positive affirmations and intentional candles as much as the next millennial, but after a couple of years coming up heartbroken or just bored after striving for unsustainable happiness, I looked inside and thought, "Isn't this all beautiful too?" When I finally gave up positive thinking for present thinking, that's when I really began not only to get comfortable with this transitional period, but to see the beauty in it.

Giving my transitions as much attention and curiosity as my brightest afternoons has helped me appreciate the inner sky I'm continually trying to make more colorful. Who wants a sky that is blue all the time?

Give me some clouds, some rain, the occasional crazy lightning storm that makes your cat sit on your socks in the closet.

Give me a night so dark it looks like a wall finished with black lacquer—the perfect backdrop for stars, an outdoor dance party, or an existential cry.

Give me early mornings where I'm rushing to the airport, to work, or to get

coffee before the Sunday morning crowds, where I'm taken aback that the light is still pink and I think of the day as a newborn.

Give me breezes, still air, rainbows, and those giant cumulonimbus clouds that look like friendly ancient grandfathers.

I want the full menu, everything available to me in this life: dark, bright, that purply-pink weird twilight color, and golden.

GOLDEN HOUR

IMAGINE A JUNE
EVENING AT 7 PM WHEN
THE CITY IS WASHED IN A
GLOW THAT MAKES EVERYTHING
AND EVERYONE SEEM MAGICAL.
THIS IS A TIME FOR NOTICING,
APPRECIATING, FOR EASILY
BELIEVING, AND EXCLAIMING,
"I WOULDN'T WANT TO BE ANYWHERE ELSE!"

THIS TEMPORARY HIT OF GRATITUDE
AND GRACE CAN GET US THROUGH
THE COLDER DAYS.

MAGical THiNGS I'vE SEEN iN New YoRK

It all started with a grumpy September afternoon. Two weeks after moving to New York, I was walking down Second Avenue in my least favorite kind of weather—overcast but humid, the worst of both worlds. I was carrying a grocery bag that was going to fall apart at any minute and wearing the wrong shoes, and I was sweaty in the long sleeves I'd ambitiously worn that day in hopes that early fall would deliver a nice chill. Silly me.

Mindlessly devouring Twitter for news as I waited to cross the street, I was startled by the sound of two pigeons arguing about something in the road. They were pecking, squawking, generally making a very unnecessary ruckus. When the traffic began moving, a young, hip guy on a bike braked with a screech and pulled over toward the sidewalk. Getting off his bike, he quickly looked both ways and

walked right into the street to lightly stomp near the birds. "Hey, guys, knock it off!" he yelled, and the pigeons broke off their fight. It was so absurd it made me laugh, but he earnestly got back on his bike and kept going. Sort of a magical New York moment. I made note of it in my journal.

Since then, I've kept a running list of "Magical Things I've Seen in New York." The criteria: they have to take me out of what I'm doing and immerse me in the city's human landscape. The experience may only last a few seconds, but the effect lingers for hours. Instead of whisking myself away from the city, as I sometimes dream of doing when I'm carrying a heavy grocery bag in grey humidity, these observations wedge me in deeper. After scrolling through a depressing comments section and concluding that "humans are awful," joining people on the sidewalks of this city changes my stance to "humans are complex" and even "humans are wonderful."

When I decided to move to New York, I could barely finish my sentence "I'm moving to Ne—" without someone piping up "I like New York but I could never live there." Outrageous living expenses aside, I wonder why people feel that way, and so strongly. As a highly sensitive introvert who can barely listen to chewing noises, much less a cacophony of sirens and honking, I of all people should be going around announcing the same stance. Instead, I think sensitivity is a strange asset in a big city; you're more naturally attuned to secret moments and nuances that make it feel cozy and kind.

It's not easy to be attentive, just as it's not easy to be optimistic when the world is feeling overheated and overwhelming. While attentiveness might come a bit more easily for the super-sensitive, it still takes a lot of effort for anyone to stop and really look around. But to love New York, you have to train yourself to

be attentive and to be on the lookout for the moments that make it feel homey; otherwise, you'll probably feel like you're being swallowed up most of the time. It takes energy to observe, not simply just to see.

Of course, it's way easier to be attentive when you're new to a city or when you're on vacation there. That's the allure of travel for me: it's amazing what I notice when I have an excuse to be wholly present. Everything is new and darling, even when it's inconvenient and confusing.

To become as present in your own city as you would be while traveling, you have to make the city feel new: take a different commute home, listen to different music, go into restaurants where you haven't looked at the menu beforehand and may not be sure what to order. You have to get a little disoriented, even annoyed. That's what it's like to be around humans, who are unpredictable and often annoying. Trust me, treasures await among the noise and energy: a sign on a bakery door will melt your heart or you'll overhear an interaction so sweet that your massive city feels like a fictional town from a Christmas movie.

When I encounter tangible kindness in front of me in my own city—not just cute viral videos but kindness I can see in my own bustling neighborhood—it makes me want to be better. It makes me feel like the momentum of our humanity is not plunging into mayhem but gliding into slow and gentle progress. The sirens become tolerable to me when I imagine them as wild opera singers who have gone rogue. If someone is walking very slowly in front of me, I imagine the possibilities that could be contributing to their leisurely pace; perhaps they are recovering from an incident that could have taken their life but that was gracious enough to take their fast gait instead, or perhaps they are too early for a first date, or perhaps they are trying to align their steps with the rhythm of their heartbeat. I de-

cide to take a detour past the dog park and watch a golden retriever take a bath. The street appears as more of an invitation than an obstacle.

I miss New York when I'm in New York. I either feel this way because I love it so much that being here is not quite enough to satiate my longing, or because I miss the way New York felt when I visited for the first time. Before I had a quotidian experience of the city, I had a wide-eyed tourist's experience. Every fire-escape staircase, every subway ride, and every front door was magnificent. Once a place becomes home, it rarely remains magnificent. It's comfortable, and even Manhattan can feel a little boring on a humid Tuesday.

That's why it's a discipline and a practice for me to keep it magical. Especially when I feel like the internet is yelling at me, or when I'm so irritated with my commute that I begin cursing the crowd like it's a singular unit rather than a mass of individuals like me. In those moments, I take a pause and try to pretend I just got here.

I listen, and I watch, and I make lists of magical things. I record the split seconds of magic, humor, kindness, and grace that give me the sense that I have escaped into the kind of world I dream of inhabiting. I'm not away from the chaos—rather, I'm right in the middle of it—but I am away from the despair, the disorientation, and the easy irritation that I'm so desperate to flee when the weather is bad and the news is worse.

Here's my list so far:

1. A sign on the window of a pet food store said that two senior cats that had lived there for months had been adopted. On the sign, people left Post-it Notes reading "We love you guys!" and "Enjoy your new home!"

2. A seventy-six-year-old woman at a nightclub on a Tuesday

3. I witnessed a secret code between a bartender and a regular who brings her dates to that bar. One ice cube = staff likes him. Two ice cubes = they don't.

4. A couple danced the tango five stories above the sidewalk

5. I had an ear infection that prevented me from using earbuds for a few days, during which I learned that the man who stretches by the fountain every morning does so while jamming to opera on an emergency radio

6. A bench at the park dedicated to "Writer, gastronome, polymath, bon vivant"—the kind of legacy that provokes you to consider your own

7. A subway door opened and two friends were perfectly lined up facing each other. They squealed!

8. A taxi driver dropped me off and said, "Whoa! I lived here forty years ago! We had a baby and a piano! The neighbors hated us! But they couldn't hate away our love!"

9. Two doormen did a secret handshake of delight when a resident took a date home

10. I sat next to a group of teenage boys at *Hadestown*. At first I was skeptical about their desire to be there, but they were so excited and enthusiastic and engaged, it made the experience 10,000x more joyful.

11. A couple holding hands through an entire play squeezed each other so hard at the emotional peaks that it shook the row

12. A secret garden

13. Window cleaners gracefully glided in sync to the Brahms sonata playing via my headphones

14. A museum security guard practiced bachata moves in an empty room

15. A kid made his mom laugh with his observations about his classmates, and she said, "I needed that today."

16. A gruff-looking, no-nonsense businessman gave fifty dollars to a street musician playing "Maria" from *West Side Story*

17. An elegant dame dining solo asked the waiter to take her photo so she could "remember this pleasure"

18. I shared a communal coffee-shop table with a father and his two-year-old son. The dad told his kid, "Be very careful when drinking water around the lady's laptop—water and computers are not friends." The child looked up at him and said, "Maybe they should try just talking to each other."

19. An Arabic speaker and a Korean speaker were trying to remember the English word for something, which turned out to be "muffin"

20. Three people rushed to help a man on crutches who tripped on a can

21. An old lady ran to ask a couple taking a selfie in Central Park, "Don't you boys need a proper portrait?"

22. A tourist used Google Translate to tell me "I like your purse" on the street

23. An elderly dame pulled over on the sidewalk to let me by and said, "I'm sorry I'm so slow, I just take these walks to feel a little more human. And seeing you in that tiny dress reminds me of my tiny dress days, so now I feel extra human."

24. A woman who didn't read English panicked on the subway about where to get off: her friend on speakerphone asked if anyone could help. A little boy drew her a map in a Spider-Man notebook.

25. At a church service in celebration of Pride, a very, very old man wept and clapped the whole time and told strangers afterward, "I just didn't think I'd feel so loved at a church."

26. A man at a coffee shop told me I had "calm, grounding energy" and gave me his number on a napkin. Later that day, a man asked me to dance on the sidewalk. Nineties romance lives!

27. A guy asked me to guard his book when he went up to order coffee. Delighted by the concept of a book thief

28. A fire department went apple picking together and left a barrel of free apples outside their station.

29. A man looked at a painting for ninety minutes (I kept checking back) with tears in his eyes

30. A taxi driver and I got to talking. I asked if he had kids, and he told me he had only one beloved child, seven years old and spoiled rotten. He

looked a bit old to have a seven-year-old, but no matter. He pulled out a cracked phone and said, "Here, I'll show you a photo." It was a big floppy-eared bunny named Brownie he described as "the light of his life."

31. Taxi drivers managed to hold a conversation from their cars for five blocks down Malcolm X Boulevard

32. A nervous couple kissed for the first time on a busy sidewalk and everyone walked reverently around them

33. A somber subway platform exploded into applause after a soulful rendition of "Guantanamera."

PET STORE

CLUB

DOG PARK

OMG!

OFFeRiNGS oF LiGHT

If you live in a city where it rains a lot, you probably also have a dependent relationship with street lamps. Not only do they illuminate the streets at night, but when it's dark outside, they also show if and how hard it's raining. When I was a teenager, it occurred to me that I'd never actually seen the street lamps turn on. When did it happen? All at once? At a certain time? Up until then, I had never stopped to think that there was a time they were off and then on. They were just always there when I needed them.

My last summer in Seattle, before I moved to college, I decided to solve the street-lamp illumination mystery for good. I began watching them every evening, sometimes even staring out the window for ten minutes. But I kept missing the

changeover. There was always a time when they weren't on, then a time when they were. No revelation of the big moment they switched.

The night before my move, after everything was packed and ready to go, I took a drive. In seventeen-year-old carefree wonder, blasting whatever indie rock CD I'd just triumphantly purchased, I drove to a neighborhood I rarely frequented and decided to climb a big hill that overlooked Lake Washington. The sky had just begun to glow bright gold as the sun made its grand finale performance for the day—an appropriate phenomenon to witness on my final evening.

Right then, I could practically feel my future older self looking back at me: seventeen, with short, shaggy hair, wearing dirty sneakers, shuffling up to the top of the hill with my headphones on. How poetic, I thought, to be on the cusp of this hill, looking out at my childhood city, dreaming of somewhere new. I wrapped my knees in my arms and rested the side of my face on my elbow. I felt so young, too young to have lived a full childhood already. I twisted my hair in an attempt to hang on to some comforting childhood habit, and switched the song to something folksy and comforting, and—

Illumination.

In one instant, the whole city before me lit up like it was covered in a million little fireflies. They wrapped around the lake and stretched up the hills and covered certain neighborhoods with a duvet of orange light. I turned around and saw a street lamp behind me, then looked down and saw several more leading down to the car. I smiled, which turned into a laugh, which turned into a cry, which turned back into a smile as I wiped tears with the sleeve of my hoodie.

There are two ways to tell the story of this moment:

One is that it was a matter of odds. I'd gotten in the habit of watching the city

every evening at the time when the sun goes down, and witnessing the automatic flip of the great street-lamp light switch was bound to happen sooner or later.

The other is that it was serendipity, combined with a periwinkle sky, that I would solve this childhood mystery on the symbolic last day of childhood, that Seattle would be gracious enough to reveal something about itself as I left. A magical souvenir and blessing.

● ● ●

The English word "desire" is derived from the French word "desir." The "sir" part comes from the Latin *sidus*, which means "star." The verb *desiderade*, translated as "to want," literally means "to gaze at the star."

I was in high school the first time I heard that the stars we see now are probably dead already. Our brain is not built to fully understand the speed and vastness of astronomy. We can't begin to fathom the infinity of the sky, that we can't see the stars' progress in real time. Nothing about humans is designed for stargazing and star-comprehending.

And yet, and yet, even though we know by now that the stars are dead, we still wish on them, navigate by them, name them. The activity makes it into hit poems, songs, books, and films. When we look at the stars, we must suspend a bit of belief, and we must acknowledge the embarrassing limitations of our comprehension. All most of us can really do with a star is to wonder at it. That makes for great lyrics and love letters.

The very word "desire" has embedded in it this fully conscious, intellectually sound suspension of belief. Nobody ever says they *desire* another slice of

cheese while at a party, or the passenger seat of the car on a drive. The word seems to be reserved for those wants and wishes that stretch just a tad beyond reason.

<p style="text-align:center">◦ ◦ ◦</p>

"What I really desire for myself, for my future," I wrote in my journal at the beginning of this year, "is a family."

Even as I wrote it, I could feel myself slipping into the patriarchy-influenced cliché: newly thirty-two, newly heartbroken, *of course* I, with all the countries I wanted to visit, all the speeches I wanted to give, all the homes I wanted to furnish, would still put children at the top of my desires for the future.

Lately, I had taken it upon myself to educate every man in my life that they had been undeservedly blessed with the luxury to "not know yet" whether or not they wanted kids—waiting until they were senior citizens, or so it seemed. I dated a forty-two-year-old man who, when pressed on the subject, answered, "I haven't really thought about it. I guess, with the right person."

And yet my girlfriends were spending thousands of dollars to freeze their eggs, and—more unbelievable to me—putting successful careers on indefinite hold to have children while their partners, or semi-supportive male friends, complained about the difficulty of choosing between a lager and an IPA.

I felt chaotically ambivalent. I confessed to friends that I'd never felt very maternal, nor did I feel a biological urge of any sort, but I also *knew* I'd be a mother somehow, someday, and every rejection on every date made me panic that this desire was as delusional as wishing on dead stars.

The more panicked I got, the less control I felt over the situation. So I start-

ed doing months of late-night research on countries that supported single-parent international adoption. I began following foster parents on Instagram who made the prospect seem manageable. I also read about the expenses involved with both, and how adoption can take years of waiting and disappointments. I listened to friends who easily got pregnant in their forties, but also heard from my close friend who really struggled with infertility. "I just wish I'd started earlier," she told me over and over.

The more I researched, the more resentful I became toward my male friends and exes. From my perspective, clouded by the feeling of scarcity, it seemed like they could freely date without a care in the world. When a dinner with a new love interest didn't go well for them, it just meant a Thursday night ruined—not energy wasted on an unsuitable co-parent.

I began feeling rushed, and I hate being rushed. I began feeling pressure, under which I do not work well. And then, a decision.

Like most of the big decisions I've ever made, this one came in an undeniable, irresistible flash: I should freeze my eggs. Just in case.

I knew women who agonized over freezing their eggs because it seemed like a symbol of surrender. But to me it felt like freedom, the way I'd heard birth control described for my parents' generation. It gave me the ability to date or not date, and to do either one with curiosity and ease.

I chose the month rather arbitrarily; I had already missed the window for December because my period came early, and I was traveling in February, so January would have to do. As I waited, I began to think about how I'd have a completely different set of potential children if I waited one more month, much less one more year. It seemed like I held power I wasn't supposed to, like I was somehow intervening in the realm of signs and wonders and sparkles and moonbeams—

catching them in a petri dish. I even wondered if these eggs-on-ice would some-day result in my "real" baby.

Soon after her divorce, one of my friends brought a print with these words: *Magic is something you make.* She used it as a dating mantra, but also as a newly-single-woman mantra. She'd been falling back on the apparent magic of chance-meeting her now-ex-husband for years to get through the misery of being attached to the wrong person. Now it was time for her to concoct the magic herself.

As I opened the terrifying box of tubes and needles and the crinkled instruc-tion manual that unfolded to take up half my kitchen, I remembered that print. Everything about this was artificial. I was finally making magic for myself, I guessed.

As I did, I imagined myself somewhere in my hazy future holding the newest human in the world, teeny-tiny and squinting at me.

I could tell the story of her birth two ways.

One: Her birth was the result of taking out my retirement savings, giving myself shots in the stomach for two weeks, and having invasive surgery.

Or: "What a miracle."

◑ ◑ ◑

This past February, I spent time in the south of France. When I was there, I went on a date, the first since I began the egg-freezing process. I met Cédric when I was writing in my journal at a cafe and he sent a glass of wine to my table. After, we talked throughout the alleys of Bordeaux until 3 a.m., when the stars were outshining the street lamps. I was delighted to realize that dating really did feel different now. This gorgeous, French-speaking man could just be that to me—nothing else. I was only disgusted by his smoking because it made his kisses

smell bad, not because I was subconsciously wondering how it would impact our future teenagers.

In the five days I was there, Cédric took me to seven-course Beauty-and-the-Beast-esque feasts, on long walks along the river on mild evenings, and to the border of Spain to see his childhood home, where I heard the Basque language for the first time. "This has been a really magical week," he told me over our final glass of merlot under a heat lamp in the town square. "But it's hard to tell if it's actually magical, or if it's just magical because you have to leave, so there's this sense of tragedy. And with very limited time, we can imagine whatever we want about each other."

I had to laugh at his honesty.

One way to tell this story: I met a hot French guy and our connection was intensified by the fact that I was leaving soon, and if we had met in New York, we probably wouldn't even go on a second date.

Another way to tell this story: I fell fast and hard for a hot French guy I serendipitously met at a cafe and we had a strong, playful connection and I'll always wonder if we were meant to be together.

◐ ◐ ◐

Something I find a bit comforting is that I'll never know which version of the story is the true one. We'll never know which stars are still alive, where exactly the miraculous ends and technology begins, which romances are contingent on fleeting time. It reminds me of the observation by video artist Bill Viola: *In the Middle Ages they painted the sky gold in the paintings. Today our photographs show a blue sky. We think the gold is an abstraction. To the medieval eye, the blue sky was the ab-*

straction. It was realism they were after—the reality of the divine effused through everything in the physical world.

I think medievals would assume that the most realistic explanation for the great street lamp illumination is that it was the obvious result of timing, emotional will, and dusk conspiring together to give me an astounding parting gift. My friend the atheist physicist would certainly argue otherwise.

What I do know, however, is that a great tragedy of the human experience is when we don't allow for the miraculous. We know that the act of desiring depends on forces beyond logic, and we know those forces are capricious and randomly kind and cruel. We go into this knowing all that, and yet, and yet, the forces still devastate us when they fail.

When I was nine, my dad took me to see the movie *A Little Princess*. It came out at the ideal age for me to see it: in the throes of my fascination with frills and boarding schools, and when I still idolized and adored my father. The movie follows a young girl named Sara who is sent to boarding school when her father leaves to fight in World War I. Not long afterward, Sara's father is presumed dead in battle. Seeing someone my age lose her dad on screen was almost too much for me. It was the first time I'd seen childhood grief explored. The images and dialogue stuck with me so vividly, I can still envision Sara drawing a chalk circle around herself as a symbol of protection and safety, and then falling asleep in the middle of it, crying out "Papa!"

There's a moment when Sara's best friend, Becky, asks why she doesn't tell stories anymore, in the aftermath of her father's death. "They don't mean anything," Sara answers. Becky tries to convince her. "But they've always meant something to me. There were days I thought I would die until I heard you talk about the magic."

Sara responds with maybe the saddest line in cinematic history: "There is no magic, Becky."

The magic has failed Sara. It was the shimmering lens through which she saw the world and it allowed her to invent wild tales of mermaids, and to assume that her father was on a mystical journey and not in the middle of war. When her father died, the curtain lifted, and the world presented itself in front of her: painfully real, full of poverty and despair.

When logic fails us, it's an inconvenience. When magic fails us, it feels like an essential part of our humanity is brutally taken away: our ability to imagine beyond our circumstances, our potential to make meaning from the ordinary.

○　○　○

Four years into the loss of my father, I set up a phone call with Victoria, a psychic who charged the equivalent of a week of my rent money for a forty-five-minute talk. She came highly recommended from a friend who lives in a world of magic and breathtaking serendipity. The psychic told this friend a variety of flattering things about herself—that her soul mate was a millionaire, and that her greatest career success was imminent.

I knew exactly what I was doing when I booked a session with Victoria: I was wishing on stars that were probably dead. I didn't care. I just wanted to feel hopeful about my future, and to have that confirmed by someone who'd never met me.

Victoria's reading style was interesting. She talked so fast that sometimes her words didn't make grammatical sense and she'd have to backtrack to form complete sentences. She said that she received her messages so quickly that her mind

was not always aware of what she was saying. She talked about images that came up, and laughed at herself when they seemed out of the blue—a box of Swedish Fish, a violinist in Central Park.

Victoria talked about a certain man on my father's side of the family who died of lung cancer. My dad had died of a heart attack, but the other details all pointed to him: he died four years ago, in San Francisco, and had an unmarked grave. Check check check. She talked of his being estranged from me before he died. Check.

She spoke of the healing journey I'd been on during the past several months. Check. She said I had been healing him while I did work on myself. She assured me that I was the light of his life, and his soul would find me again in another form. She said I could believe with my whole heart that he loved me, and loves me, and is so proud of me from the other side. It seemed so easy to believe, coming from her with her no-nonsense, fast-paced voice.

Then she said I'd be going to Greece soon. And I'd find a coin that my dad left for me in Greece, at a point when I felt particularly vulnerable and needed a reminder that he was there for me. In a way, the coin would lead me back home.

After months of trying to talk to my dad every morning, asking him to visit me in dreams, and shelling out all my spending money on therapy, it was encouraging to hear from a stranger that it had been paying off. And the reward would be a coin! In Greece!

It all felt like magic: I was already scheduled to give a talk in Athens and, after a nudge from friends, decided to stay a bit longer. After all, Greece? In early May? My favorite cuisine? Probably some very nice-looking men? Come on.

I didn't just think Victoria was right; I knew she was. I couldn't wait to have tangible proof—at last—that my father really did love me.

You can't go wrong with any Greek island, but I'm pretty sure I chose the perfect one. With its twisting stairways, ancient chapels, and nectarine-scented plazas, Hydra is not an island for mere mortals.

Hydra adores every sense: it gives kyanite-colored water to the eyes, donkey hooves clacking on cobblestone to the ears, squeezes of lemon and frosted glasses of beer to the tongue, dirt roads through olive and pistachio orchards to the touch, and fresh orange cake to the nose. Hydra awakened, massaged, gifted my mind. How I wished to be treated by a man as well as that island treated me.

There's not much to do on Hydra, so it didn't take long to feel like a local. After a week, I began revisiting the same osteria—the one in a couple's home, where when you ask for the fish of the day, they bring you through their daughter's bedroom to the kitchen where they have the morning's catches laid out on display in the fridge. I'd walk through town and hear, "Hey, New York Girl!" coming from the old man who took me out on his boat on Tuesday. I knew all the names of the donkeys who lined up at the harbor every morning to take produce to the restaurants.

During my time in Hydra, my knee had been bothering me a bit—I could vaguely remember straining it in yoga before I left—so instead of taking a hike up to the monastery on the top of the island, I spent a lot of time swimming in the Aegean Sea. It was like swimming through silk. I pushed myself a bit farther out each day, and had to chuckle at the absurdity of the beauty when I'd look to the beach and see a herd of goats walking by. When I was tired, I'd go back to shore, order a cappuccino and sparkling water with half a lemon, then go back out and sit in the

water for a while. I barely moved my arms, and the sea offered to keep me lifted and immobile for minutes at a time. Having a bum knee was not the worst thing that could happen in Hydra.

However, I soon found myself itching to explore more of the island, which looked fantastically wild from a swimmer's view, so one day, I sprayed my knee with some numbing potion the pharmacist gave me and set out toward the other side.

After passing several small villages, each with their own favorite taverna and little beach, I stopped to swim at a beach that could fit, at most, three towels. I was the only person there. While bobbing up and down, I noticed, within swimming distance, a tiny island that appeared to be home to one tiny chapel. The mystery was too thrilling to resist; I decided to make my way over.

When I arrived, I realized the church was bigger than I'd thought—at least big enough for someone to walk inside—but, to the detriment of my curiosity, the door was locked. I peered inside, of course, rubbing the glass with my fist until it was clear enough for me to see a couple of icons, a single chair, and a burning candle at the front. A burning candle! Someone had been there recently. What a comfort that somebody—anybody—had been there, and would keep a candle going for someone—anyone—and that the light would be shared perhaps only between us that day. Well, us and God.

I had practiced and practiced the Greek word for "thank you," which I found inordinately difficult to say: *efcharistó*. I read that our word "eucharist," a term which implies grace and spiritual gratitude, comes directly from this modern Greek word. In its etymology, *efcharistó* implies that we did nothing to deserve the offering, nor did we hold the power to make it happen. It was simply an act of grace, for which we give thanks. I offered this candle a whispered *efcharistó* and

crossed myself, because it seemed like the thing to do. Never mind that I was in a bikini and dripping water on the door.

After I swam back, I continued my journey, walking through the rocky landscape, passing the very occasional house, none of which appeared to be inhabited. The telephone wires above seemed out of harmony with the sprawling olive trees before me. The road was littered with remains of old fishing boats, but otherwise didn't betray any evidence of human activity.

For a while, the beauty distracted me. But as the day went on, I became more and more aware of my knee. I have a high pain tolerance. I've walked with pain before. But this pain was markedly different. It was uncomfortable, sure, but the discomfort seemed to signal the probability of something much worse. There were certain steps I'd take, at a certain angle, when pain would shoot up from my ankle to my hip so suddenly and ferociously I thought for sure I'd buckle over. The likelihood of doing so seemed to increase with every step, and I had so many steps to go. Eventually, I reluctantly and responsibly turned back around toward town.

It was still at least an hour's walk until I would potentially see another person, when I began to imagine seeing a man ahead, walking aggressively toward me without any of the warmth I'd come to expect from the residents here. When I thought about this imaginary man, I'd suddenly feel vulnerable—like I was naively swimming in waters not meant for me. What if he came out of that house, or out behind that boat turned sideways?

I also thought about the coin. Per Victoria, when I felt in danger, it would appear. It would lead me to security, my own chalk-drawn circle, to my dad. Strangely enough, every time I felt a little scared about the man, I felt a little

excited too. The fear meant the coin would appear—my reunion with my dad was imminent.

So I kept walking and looking for the coin. I walked past bougainvillea-covered gates that protected nothing but a field, and past For Sale signs that appeared to advertise a patch of dirt. I walked past boat graveyards with dinghies that still attempted to wave a tattered Greek flag. I walked past rows and rows of olive trees, plumping in the sun. There were long stretches where I limped. I realized it wasn't so bad when I walked on softer dirt, so I tried sticking to the side of the road where the path met the grass.

I was slowly walking by the edge of the sea, admiring the deep blue gradient that marked the varying depths of the water, when I stepped just a little sideways on a rock and my knee seemed to completely lose any sense of what it was for. I fell onto the ground. The gravel jammed into my hand, and my knee began to throb.

I pushed myself up, cutting both my hands with the sharp pebbles, and put a bit of weight on my knee. It buckled again. I realized that my knee was useless at this point. It had just given up.

"Okay," I said to myself, frantically looking across the whole path for the coin. This was its time to shine, literally: the moment I was vulnerable, in danger, in need of my father. Where was he?

Where. Was. The goddamn coin.

No luck.

I felt angry and disoriented and realized neither feeling was going to get me home, so I began to hop while my other foot dangled behind. At first I did short little hops, then came up with a system to propel myself a bit farther with more productive, longer jumps forward. It felt so ridiculous. And with each passing min-

ute, I grew more and more resentful toward my dad for not somehow helping me home. I refused to entertain the tears that welled up; I didn't have energy to cry.

I looked for the coin again when I rested by the side of the road, sitting in the hot dirt, holding my knee up to my chin, rocking it slightly. No coin. I considered kissing my knee, then felt self-conscious doing so, even though I was completely alone. I wondered about doctors on the island and about getting my suitcase back on the ferry to Athens. I wondered about Greek hospitals. I wondered if my dad would have cared, were he alive.

After who knows how many minutes of hopping forward, I reached the first of a few villages, a comforting sight. I also saw my first human since I'd set out on this adventure—a fisherman, who rushed down the steps to the village and offered his arm. "*Efcharistó*," I said, hopping up with his weathered arm supporting my ascent.

Getting closer to the hotel meant safety and security; it also meant that Victoria's prophecy was losing meaning. I was supposed to find the coin when I felt vulnerable and needed help.

It never appeared.

◑ ◑ ◑

Becky is an interesting character in *A Little Princess* because she's never experienced Sara's privilege. A Black scullery maid at a boarding school in the 1900s, Becky, presumably an orphan, is banished to live in the school's attic. Her love of Sara's fairy tales apparently has nothing to do with her lot in life, but perhaps more with the encouragement to see beyond the attic—to envision another life altogether. At a young age, Becky knows she probably won't ever get to experience the petits fours and porcelain dolls of her peers, but hearing about them fuels her

imagination. She's able to think about a different world—perhaps not possible for her, but adjacent to her.

Becky has wisdom that newly orphaned Sara has yet to integrate: that belief in the divine, the extraordinary, the miraculous doesn't have a direct impact on what happens to you, and it doesn't matter. The belief is transformative in and of itself. The people who gaze and wish upon most-likely-dead stars probably don't *really*, *truly* believe that the stars hear them. But the very act of desiring, of *desiderade*, changes something within them.

"What would have changed if you'd found the coin?" my therapist asked a week after I returned from Hydra. I sat back. "Good question." I actually couldn't really think of an answer.

Had I found the coin, I could tell the story in two ways:

One, my father gave me a sign of his love at a time when I needed it—both physically and spiritually. I will always cherish this ancient treasure that shows how much my father cared for me all along, and how proud he is of the healing I've been doing since his death.

Two: I found this old Greek coin near an olive orchard. Cool, huh?

"What if the magic isn't real?" I asked my therapist, already anticipating her cynical response.

"Well, it's probably not," she answered. "Yes, this psychic seemed to know a lot, but I don't know if I believe that your dead dad traveled from his grave in California to Greece and left that symbol for you. I mean, what if you hadn't gone to the psychic beforehand and you just found this coin? His efforts would be for nothing because you wouldn't even associate it with him."

She was right, which made me frown.

"But you're real. And he's such a huge part of you; you say it all the time, you're

just like him. You don't need a coin to tell you that he really did love you, and in a lot of ways, still does. So yeah, no coin, but you still have you."

◑ ◑ ◑

After my disastrous walk that day, I returned to the hotel and sprayed my knee with more of the pharmacist's potion. I looked at the ingredients: eucalyptus, menthol, lemon. Even Hydra's medicine was something akin to divine elixir. I spread out on the cool tile floor and let my body and mind rest for a while, permitting my thoughts to wander to the orchards and back again, to the disappointment over the coin, to counting my blessings.

A scorching afternoon mellowed into a balmy and beautiful twilight, and I walked with my numbed knee through the narrow street that twisted behind my hotel. I found a taverna right away—under a giant lemon tree, no less—and happily gobbled up a whole snapper with fluffy bread and Greek salad drizzled with olive oil, washed down with crisp white wine. I was grateful and content, in a way that felt very specific to almost being stranded earlier that day.

I walked the short distance back to the hotel and decided to stay outside just a bit longer. My knee was in no shape to take a post-dinner walk but I still wanted to feel the air on my skin before heading inside. So I sat down on a bench and swung my legs under me, pleased that my knee had retained some of its playful energy. A promising sign. I leaned back and lay comfortably across the bench. My view was the whole night sky, plus a couple of branches from a nearby tree that poked their way in front of the constellations.

I can't usually see stars in New York, so the sight was utterly magical to me. A bit wine-buzzed, I snuggled into the cradle of the bench and studied each con-

stellation carefully, creating my own visuals to accompany their patterns. As I was reimagining the Big Dipper as a cat with a swishing tail, a vibrating brightness darted across my view, sprinkling light from its tail. It startled me so much I shot up on the bench, looking around as if to summon witnesses. That couldn't have been a shooting star, I thought to myself. But I decided to trust in the strange beauty I had so clearly just seen. I swore I could still see its remnants, like dust speckles on the otherwise pristine layout of the perfect sky.

Were any of those stars dead? Did it matter *at all*? What's incredible about Becky is that the magic is real to her no matter what. She has the wisdom of a spiritual authority who says of their holy book of choice, "All of this is true, and maybe some of it actually happened."

While not finding a coin was disappointing, I had felt closer to my dad while sitting on that dirt road than I had in the past ten years, since our estrangement. I was talking to him, pleading with him, as though he were as visible as the cuts on my hand. Me begging "Why aren't you here?" is the most we had spoken since the day of my college graduation, the last time I ever saw him.

I gathered my bag and headed inside the hotel, where the owner's cat was sitting on an armchair, pushing her paws into the soft padding beneath her. "Hey, cat," I said, and thought about how everything in my life had culminated in this one moment: talking to a Greek cat, at midnight, chilly from sea breeze and warm from wine, having just seen my first shooting star instantly cross the island that I had walked earlier that day.

Do you make magic happen, or does it happen to you?

I can answer that two ways.

One: I got myself to a wild, enchanting island, and opened myself to the possi-

bility of deeper beauty even at the risk of physical discomfort, so I was bound to experience at least a bit of the extraordinary.

The other: I was minding my own business after a disorienting day, when light suddenly danced in the sky as though only for me—a performance of spontaneous grace: *efcharistó*.

I READ THAT CATS Like To Be PET BECAUSE iT MiMiCS THE FEELING oF TheiR MoMS LiCKiNG THEM aS BABieS; iT GiVeS THEM The SAMe FeeLiNG oF CoMFoRT aND SAFeTy. I, aN AdulT HuMaN, SeeK ThiS FeeLiNG Too, WHeN My MoM'S ARMS WeRe a WoRLD aND MY HoMe WAS a uNiVeRSe AND I FelT PRoTeCTeD aND STABLE. CHiLDReN'S EMoTioNS ARe MoRe CoMPlex THAN We ThiNK, aND AduLTS' EMoTioNS ARE MoRe SiMPLe: WE WANT To FeeL SAFe aND LoVED AND WE LASH ouT WHEN We DoN'T.

I CAN No LoNGeR GiVe MySeLF The CoMFoRTS oF My CHiLDHooD UNiVeRSe.

The MuFFLeD SouND oF A GARAGE DooR CLoSiNG, THE OVEN LiGHT SWiTcHeD oN, The GLoW oF NiGHTLY NEWS oN TV, The FAMiLiAR ANSWeRiNG MACHiNE RoBoT VoiCe FRoM ouR KiTcHeN PHoNe, oR THE PRoMiSe oF "ITS oKAY, BABY, MAMA'S HoMe."

BUT NOW I CAN
GIVE MYSELF THE SOUND OF
MY NEIGHBOR PLAYING PIANO
OR THE SOFT FOOTSTEPS ABOVE.
I CAN SWITCH ON THE LAMP THAT
GIVES MY APARTMENT A ROSY GLOW.
I CAN MAKE MYSELF LEMON
RISOTTO AS A FAMILIAR PODCAST
BEGINS WITH ITS RELIABLE INTRO
AND I PROMISE MYSELF,
"IT'S OKAY, BABY, YOU'RE HOME NOW."

HARVEST

When I worked full time in non-creative jobs and only communed with Creativity after-hours, at bars and in the comfort of my dimly lit desk, I didn't realize how erratically behaved she was. After I finished my second year as a full-time artist, however, I was familiar with this side of her, could easily chart our ebbs, flows, delays, and dry spells. By the time I began my third year as a full-time artist, I had a hefty collection of Creativity-dependent unknowns: where jobs would come from, how I'd make money, and how and when she'd choose to show up.

Creativity was like a flaky friend who never remembers to RSVP but then appears at the party in a Gatsby-level gown and with a gift of expensive champagne. She didn't seem to have a favorite day of the week or type of weather she thrived

in. I imagined her swirling a dry martini and laughing at my naive hubris when I thought I could control her.

My work now depended on this invisible force who kept strange hours and threw tantrums without warning. I'd endure weeks at a time where she'd fail to visit me and I'd start doubting my judgment, and then she'd throw open the doors and come through with a dramatic "Miss me?"

She was intoxicating to be around, perhaps because of the very real possibility that she might leave for good at any moment. I worried Creativity would become easily bored with me and go on to the next thing, with no concern for my paychecks and my dreams.

◦ ◦ ◦

That winter, to escape February in New York—a pretty bleak month where we're getting sick of the snow but know there will be at least a few weeks more of it—I booked an astoundingly cheap flight to what turned out to be the astoundingly empty south of France. I guess people who want to get away from a cold climate are more inclined to devote their resources to a significantly less cold climate rather than to a very slightly less cold one.

I used to get my best ideas in the midst of new scenery—Creativity seemed to enjoy accompanying me on vacation—but, for the first time in three years, I wanted to relieve myself of that pressure on this trip. It felt risky to do so, like if I didn't keep writing and making art, I'd forget how. But if this was going to be my career, I needed to learn how to take a few days off from worrying about Creativity, and instead learn to trust that, even in her capricious moodiness, she would come back to me again.

When I arrived, Bordeaux smelled like sweet rain. It didn't rain the entire time I was there, but somehow it was always wet. The sidewalk tile was slippery under my feet, and I had to walk cautiously, like one of the plump ducks that waddled along the river. Of course, the Bordelais people, in characteristic French effortlessness, could gracefully clip along the slick stone streets in heels.

Because I love to dress up for travel, I brought with me the frilly long dresses and ruffly tops and satin hair ribbons I couldn't quite find the occasion for in New York. I told my friends I felt like Belle in her Christmas cloak. My clothes matched the scenery perfectly: lots of ivy curling up the sides of produce shops and spectacular plazas that could make anyone feel like they were about to attend the opera.

A river splits the ancient city in half. During the days, I wandered back and forth between the two halves, fueling myself with inelegant seafood lunches at loud, communal, family-run bistros with checked tablecloths. These uncouth, laughter-filled bistros were a very different picture than the typical prim Parisian cafe, but they were more my speed. I sat in damp, sumptuous bars, drinking red wine at 4 p.m., when the sky began to crinkle inward and the limestone buildings began to glow violet, with not much to do except look around—and it was a very nice city to look at.

One afternoon, it was actually warmish enough to sit outside. It seemed I had the same idea as most people in the city. (I spent a lot of time wondering if people in France had jobs.) I took over a bench and decided to face the people rather than the water. With my mittens on, I sipped a coffee from a nearby kiosk, watching the world around me.

I watched the sun struggle to peek out beneath a dominating cloud. I studied a boat that seemed to be making its way across the river unusually slowly, when its captain emerged from behind the helm, smoking a cigarette.

I observed a man feed his poodle scraps of his pastry, but only if the dog first stood on his hind legs and clapped his paws together. The man smiled up at me. "Like the circus," he said, except he pronounced circus like *seer-coos*. I chose not to be offended that he just assumed I spoke English.

At home, I would have been frantically looking around for Creativity, tugging on the hem of her gown if I saw her pass by: *Notice me, visit me!* It would be tempting to do the same here; after all, it's alluring to align your self-worth with productivity, and Creativity is a cousin of productivity. But that day, I released myself from the pressure of finding inspiration. I wasn't seeking material for my next drawing or trying to sneak this man into my next essay. It was the first time I didn't automatically assume that a change of scenery meant a boost in creating work.

And I delighted in that freedom. It felt like the day belonged only to me, so every walk was only for the pleasure of walking and a tree was just a tree; neither had any pressure to inspire me. That afternoon, my only obligation was to finish a coffee and find out which kid would win the game of tag going on before me.

◊　◊　◊

Despite my overwhelming appreciation for the elegance of Bordeaux, there wasn't a whole lot to do there, especially when it was too cold to spend much time outside. In most touristy areas there were posters and brochures for vineyard tours, but I assumed this was more of a summer/fall activity, not one for the dead of winter. Even so, strangers insisted I should go; I might get a private tour on the off-season.

Sure enough, that's exactly what happened.

A taxi took me an hour outside of the city to the closest winery. I can't tell

you what made this one distinct to others but apparently it was very old and very good. That's about as much as I could really glean from my French conversation with my driver, who had arranged the tour on my behalf.

I spent the next couple of hours with the vintner's daughter, Genevieve, who looked a little irked that she had to spend her day out in the freezing vines with a clueless tourist.

Irked or not, she took me to places around the property where she wouldn't normally bring groups, like the stables where they kept the Clydesdale horses who pulled the ploughs so the winemakers could avoid motorized engines and chemical weed killers. The horses looked like they came from a scene in a fantasy movie; they were so enormous, with big brown, knowing eyes and silver manes that swooshed back like they had superpowers. I came eye to eye with Charles, the patriarch, whose pink muzzle warmed my hand. He scratched his cheek on the wooden fence and it shook the ground.

We took a long meander through the vines themselves, which looked like skeletons of mythical creatures with multiple arms and heads. I thought of the scary Greek serpentine water monster, the Lernaean Hydra, whose remains would perfectly resemble these spiky branches. I could hardly imagine what this land would look like in just a couple of months, but my heart lightened at the thought of it: edgeless waves of light green leaves spangled with juicy little grapes.

"What do you do during the winter?" I asked the increasingly amiable Genevieve, who had at some point resigned herself to the fact that she was stuck with me whether she liked it or not. "I mean with the vines?"

She looked at me with a furrowed brow like I had just asked her if I could take Charles out for a spin and answered, "Nothing." I fully expected her to add a "duh" at the end.

I waited, and she continued. "Well, the workers prune the vines to keep them healthy." Again, I imagined she added an "obviously" to that sentence. "But we're in the cellar most of the time during the winter, bottling and working on sales." She looked sternly at me as if to imply, *Except when a tourist decides to come here in the middle of February.*

Inside the cellar, she showed me a painting belonging to her grandparents, featuring the very vines I'd just walked through. It depicted a beautiful woman in a robe and crown pointing to the vineyard—the agriculture goddess Demeter, perhaps. She looked proud of the abundance that sprawled out across the canvas. However, the important part of this painting, Genevieve shared, was not the woman, but the tiny snail near the goddess's foot—a reminder to the vintners that this could all go away in a relative instant if it fell into the hands of a particularly aggressive pest.

It all seemed so magically and terrifyingly precarious. An early frost or one little bug could destroy a year's harvest. A few generations had devoted their lives to this particular vineyard, and a premature chilly day could throw it all out of whack. Genevieve told a clearly painful story about a year when the harvest was ruined, which resulted in far fewer bottles than surrounding years—making those bottles attractive to collectors now.

In Manhattan, while we grumble about having to pull out the parkas when we haven't fully enjoyed wearing our trench coats, an entire team of workers in Bordeaux might be out of a job for a few months. We complain about winter nudging its way into fall a bit too enthusiastically, but for this family outside of Bordeaux, it's close to life-and-death.

"This painting is very wise," I told Genevieve when I studied the woman stand-

ing in front of the vines, as though she needed me to give an assessment. She nodded and we moved on.

The winemakers, devoted to their art, are constantly aware that conditions could destroy their tireless work, make the grapes scarce, or just skip over a harvest willy-nilly. But rather than obsessing over losing their crop, it seems to me that this awareness gives them more attentiveness and reverence for what they've already accomplished. Hence the proud woman in the foreground looking over her crop with awe.

<div align="center">◦ ◦ ◦</div>

Several months later, I took a yoga class in the fullness of New York summer. Summer in New York City is dense with the smells of steamed garbage and sudsy ammonia from laundromats. Walk by a fish shop and you feel like your senses are assaulted. My yoga studio wasn't quite cool enough—nothing ever felt cool enough—and the stickiness of sweat under my sports bra put me in a decidedly non-yoga state of mind.

Moreover, I was dealing with a familiar hot-weather affliction: lack of ideas. My friend Creativity had seemingly taken the summer off, and my mind was mushy in the humidity. I was trying to summon Creativity back from her extended vacation by getting into a routine. For me, that usually involves physical activity. Thus, I committed to daily yoga, even if the short walk to my studio was excruciating in August's heat.

When the teacher told us to close our eyes and imagine a happy place, I shifted around to different moments, mostly involving drinking foreign beverages. A cap-

puccino in Berlin? A sparkling water on a Greek island? With these memories at my fingertips, the sweaty sports bra complaint seemed a little bit ridiculous. It didn't make it any less irritating, though. Good thing the mind and heart are expansive enough to be irritated and grateful at the same time.

After a couple moments of more mental fumbling, I eventually landed on the afternoon I sat outside drinking coffee and watching the world go by during my trip to Bordeaux. The yoga teacher asked us to think about how we felt in that moment, what made it feel so good right then. What came to mind was how much I appreciated my surroundings. In normal ho-hum life, you're not usually thinking, "Wow, this coffee is so delicious and dainty, this man and his poodle are so charming, these children in peacoats playing tag are our future and I'm so endeared toward them." You're thinking, "Did I remember to buy cat food?"

I rolled the scene around in my mind. What made me appreciate those mundane little details with so much enthusiasm? Maybe I was on hyper appreciation mode because the sun was giving us only a sliver after many months of grey, and the trip wouldn't last forever. Maybe I was on awareness overdrive because I knew the moment was fleeting. Who knew if I'd ever be in Bordeaux again? Maybe letting go of waiting for Creativity to visit gave me the permission I needed to treasure my surroundings. Every wisp of the scene felt precious: the children, the river, the mittens. Even winter had begun its lingering exit (not without saying good-bye to every single party guest and woefully outstaying its welcome).

My mental screen displayed the vineyard image next, and I thought about how the vines must be covered in soft green grapes this time of year. At least, I assumed so. I remembered how appreciative Genevieve was of her own work; she seemed to relinquish control to the vineyard rather than feign control over it. She wasn't aggressive toward her vineyards; instead, she devoted her energy to

sweetly caring for them and respecting the elements far beyond her control that have guided and turned their back on winemakers for millennia.

I thought about Creativity. I already knew she had a mind of her own, but what if I were more reverent toward her whims, like Genevieve was with her orchards? What if I treated Creativity not like a fickle friend, but like a vineyard, with the ancient steady presence of roots deeply grown?

<p style="text-align:center">◐ ◐ ◐</p>

You have to be reverent to go into the winemaking business. Grape growing is unpredictable and affected by many factors completely out of human control. For the winemakers, every year is a gamble. But every fall is also a victory: the farmers did all they could and the grapes provided—sometimes abundantly, sometimes less so. Either way, winemakers get back to work. They trust in the centuries-old soil, knowing that a break or a bad year won't curse the vineyards into permanent deficiency.

The winemakers stand in awe of their vineyards, amazed by all they can withstand and all the delights they provide. This amazement is in no small part due to the fact that the harvest is unpredictable, but not unreliable.

Writers and artists and ceramicists and anyone else with an artistic bone in their body are told so often that they can create on demand, they often begin to believe it. I certainly did, in my less enlightened moments. But I'm learning that ideas are as wild and susceptible to weather as sweet, sensitive grapes; unpredictable, but not unreliable.

And each are deserving of reverence.

Reverence is the practice of remembering your place in the world: small, and

with very little control. It sounds defeatist, but I think it's actually the key to living with a sense of wonder and appreciation. Nothing was ever promised to us, including the miracle of life itself. To go through the world feeling entitled to such precious gifts like inspiration and creativity is just setting yourself up for a life of annoyance and rage. Treating Creativity like an unreliable friend—assuming she was out to deceive or abandon me—was not a reverent way to treat something so precious.

Revering Creativity would mean humbling myself in front of her power. She's much older and wiser than any of us—even older than wise old trees and vineyards—and she will come visit when she wants. That means we have to pay attention, discipline ourselves to do good things with her, devote our time to her. Just as the winemakers showed up to tend to their grapes no matter what, creative people have to keep showing up and be patient when Creativity doesn't meet them exactly when and where they want.

I could only hope for my own abundant harvest of ideas come September. Nonetheless, I vowed to appreciate the return of the seasons with all their different energies, new smells, and promise of an inevitable harvest—even if it didn't yield much this year.

SPRING:

IDeAS ARe FRESH
AS GReen PEA SHooTS
AND NeW AS CHeRRY
BLoSSom BUDS on BARe TRees.
They inViTe You inTo
CHILDLiKe WONDeR.

SUMMeR:

ABunDANCe of NoiSe
AND HeAT MAKeS iT HARD
To QuieT DOWN AND LiSTeN To
CReATiViTY. YeT SHe STiLL SHoWS uP in
WARM NiGHTS and SunFLoWeR FieLDS.

FALL:

You RETURN TO iDEAS
You MIGHT HAVE HAD LONG AGO
THAT NOW SEEM iNTERESTING AGAIN.
JUST aS SCHOOL SUPPLIES SEEM
EXCITING AGAIN iN
 SEPTEMBER.

WINTER:

PREPARATION TIME: CREATIVITY
MAY NOT SEEM ACTIVE BECAUSE
THERE'S NOTHING TO SEE ON THE
SURFACE, BUT SOMETHING iS SURELY
STIRRING BENEATH SNOW-COVERED GROUND.

THIS TIME OF DAY BRINGS UP a LOT OF UNCOMFORTABLE FEELINGS: REGRET, DREAD, LONGING. IT'S NOT DAY, NOT EVENING, NOT THE MYSTERIOUSLY COMFORTING NIGHT. IT'S A LIGHT PURPLE TRANSITION THAT WE DON'T QUITE KNOW WHAT TO DO WITH.

THERE ARE SO MANY TIMES OF LIFE THAT FEEL LIKE a TWILIGHT— WHILE MOVING, WHILE RECOVERING, WHILE UNHAPPILY SINGLE OR AMBIVALENTLY PARTNERED. THIS IS THE UNCOMFORTABLE TIME WHEN YOU'RE VERY MUCH ANTICIPATING THE NEXT CHAPTER, AND NOT EXACTLY SURE WHEN IT WILL BE.

The Soft City

I n every stage of life, there's usually one question you get all the time:

"Have you picked your college yet?"

"Dating anyone?"

"Are you guys thinking about kids?"

While recovering from a serious illness that left me partially paralyzed for some time, I kept getting one that was a surprise to me: "What percentage are you right now?" They meant back to normal. "80 percent? 90?" It struck me as such a bizarre thing to wonder, and an impossible question to answer. Of course, it made sense; our brains crave completion and tidy conclusions. But life and brains don't see eye to eye on this because life is far messier than a brain ever wants to admit. And so the brain tries to grasp very nuanced situations in terms

of numbers and facts: a college major, the name of the guy in the picture who is on his way to his full potential as a boyfriend, clear and unwavering feelings about having children.

Recovery in terms of a percentage made me laugh, it was such an absurd concept. The healing process is unquantifiable—a scribble, not a line. Sometimes I'd think my hands were back to their full strength, and then I'd spontaneously drop a ceramic mug of hot coffee all over the floor. To pacify people around me—I did a lot of that during those months—I would say, "Oh, probably 75 percent." But privately, I would write in my journal that I had no memory of what it was like to feel "normal," so really I had no idea. Sickness was a dramatic dip in the XY graph of my life, and I was now trying to push the parabola back up to the "normal" line, not knowing where that line was anymore.

I couldn't remember what it felt like to walk down a street without resistance, as though I had a rubber band tied around my feet. I didn't know if I was ever good at opening water bottles; I couldn't remember if there was ever a time I didn't need a stranger to do it for me. I didn't know how it would feel to sleep comfortably; what was my previous definition of comfort? Did I used to live in this paradise where everything was easy—brushing my teeth, climbing stairs, sticking my foot out of the blankets at night to feel a breeze on my calf? It would seem that I did, but that holy land couldn't have felt further away after getting home from the hospital. During my recovery, I often wished that my past healthy self would have taken better notes about what it felt like to be totally normal.

There was also the far more ambiguous "normalcy" to which I aspired even more greatly: mental wellness. In the throes of post-traumatic stress, I felt crushed by an overwhelming apathy. My sharp emotions, which had long since guided me through my decision-making and my art, had dulled. I could no longer identify

what I was feeling. I didn't *feel* like anything—certainly not like myself, though I had also forgotten what it meant to feel like me. I remembered the activities I used to enjoy; now they just sounded difficult and annoying to do. It was too hard to do anything physical, including drawing and writing. Plus, my brain was just tired, and it was so tedious to try to reach into the crannies for ideas. I didn't feel like talking to my beloved friends because no one could understand me and it was easier to be alone. I dreaded going on walks, grew frustrated trying to draw, and looked forward to sleep.

When you're physically sick, you recognize that something isn't right and needs to be cured. When you're mentally sick, it just seems like reality. Depression doesn't feel like something you have. I truly believed that my heart and my soul and spirit no longer wanted or enjoyed anything. I thought that's just how my life would be from now on. It didn't even make me sad to think about. I didn't long for my past self, who wanted to go to every country and learn every dance. I didn't long for anything.

Perhaps this shutting down of longing was a defense mechanism against the distrust I had developed toward my body. Like many women, I struggled with body image for years and it took piles of journals and dozens of Cheryl Strayed essays to come to peace with my earthly vessel. Before my illness, I had finally gotten there, to a place of motherly and unconditional love for my body, which allowed me to dance, walk, and create—the foundations of the identity I'd cultivated over my twenties. I was told my whole youth to *follow my passions* and to identify with them; I'd done the work to find them.

Now they were unavailable to me. I lost trust in my body, which could no longer deliver. In my darkest moments, it felt useless to me.

So . . . 75 percent recovered?

During my 75 percent stage, my friend painted *El tiempo lo cura todo* on a locket for me—time cures all. I'm not sure if time cures, but time certainly allows for space to explore every angle of a challenge. During those long days, when sleep seemed so achingly far away and I had a full twelve hours to fill with zoning out on TV in between struggling to feed myself, I put mild effort into learning new things. I watched wine-tasting videos online (probably not the best hobby for someone struggling with mental wellness, come to think of it), and I caught up on some ancient history reading I'd been meaning to get around to since high school. I tried to focus on what this period of inactivity allowed me to do: spend more time with my mom, truly rest after a couple of years of nonstop motion.

As my hands regained enough strength to pepper my conversations with gestures and my toes began to curl again when I pointed them, my mental health began to sprout. It was a slow and nonlinear process to grow the flowers of pleasure, anticipation, and longing in my mind, but I felt them sprouting and I celebrated and spurred on their growth. After a few months of forgetting what it was like to aspire toward anything, I began to *want*.

88 percent?

Yet while I regained my ability to desire, my distrust still lingered. My body had betrayed me in a profound way: it had stopped moving. Perhaps even more egregious, it had abandoned me while I was traveling alone.

My love for solo travel began when I was nineteen years old, and I'd spent years justifying and defending myself. Nothing had ever happened. I had the hubris of youth and a long list of privileges on my side that made me feel as safe abroad as I was at home. I interpreted this to mean "I can take care of myself,"

when it hadn't yet occurred to me that there were a lot of invisible powers at work to protect me.

I'd navigated small Guatemalan villages and abandoned Patagonian islands and romantic Parisian restaurants built specifically for couples—all by myself. I'd never gotten so much as pickpocketed. I wasn't afraid of bad things happening, which I thought gave me some sort of divine immunity. I've heard that cats are drawn to the one person in the room who hates cats, and I figured that misfortune while traveling would steer clear of me because it was never a worry.

See? Everything's fine.

And then, while traveling alone, everything was suddenly and totally not fine. My disease was not genetic; if I hadn't been exploring the caves of Southern Spain, I wouldn't have gotten it.

Now I was cursed with worry. I was just like the people I used to smirk at when they asked if I was afraid to go abroad solo. I was angry with my body for doing this to me. Would I ever want to go anywhere now? The world suddenly felt so large and scary, whereas before it had felt so warm and easy.

And these feelings were only amplified by the chaotic political situation at the time. After Brexit and the 2016 US election, I didn't feel like I could quite trust the world in the same way. On the surface level, many Americans enjoyed the illusion of eight years of relatively low drama, settled into our comfortable perspectives and assumptions about the people around us. Then, boom. Overnight, our assumptions toppled. Social media was a volatile nightmare and the news unwatchable if you wanted to retain any sense of optimism and softness. I, for one, just wanted to escape to a cabin with a fireplace and a pile of books, never to look outside my window again for fear of what lurked beyond my safe space.

Safety: it eluded me. I didn't feel completely safe in my thoughts, dominated by

my bodily distrust. I didn't trust other people to be gentle with my fragile physical or mental state. And, sorrowfully, I didn't trust new experiences. I didn't feel like I could take a risk again. I was torn between a true and identifying love of mine—adventure—and the longing for safety that a no-risk lifestyle would provide.

"I'm not sure I want to travel again. I just want to stay in a little mouse cabin," I half-joked to my friend Rodrigo. He responded in full earnestness, "Since when are you interested in a small life?"

That sobered me up.

I had to take a risk or I might never again. It would be so easy just to escape life and forget to try anything new for fear of sickness and political unrest. Instead, I needed to dip my toe into adventure again, now that my toe could move.

I imagined the coziest country I could think of—one where I'd feel comfortable spending a month in the hospital if need be. Ireland? That seemed really nice. I imagined plaid blankets and cheerful old men and accents that sounded like whispering. I could handle Ireland—and the breezy six-hour flight over.

◑ ◑ ◑

Post-traumatic stress is an ongoing journey and you never know when it will flare up. I spent the entire six hours over the Atlantic in tears, fighting back against memories of collapsing and screaming in pain, waking up to my IV being yanked out of my arm by a sudden movement, and a piercing alarm going off in my room. I grasped the armrests and tried to sink into what trust I still had—in this plane, in my seat, in this movie I'd seen at least twenty times before. Deep breaths and a mini bottle of chardonnay helped me resist my heart's instinct telling me, "The last time you did this, it was not good! Do not do this!"

It's the same feeling I get when I'm going on a date after heartbreak. Our organs will do everything they can to protect us, even if it means lumping together a group of experiences that are unrelated. I knew that going to Ireland was a completely separate experience from going to Spain, but I couldn't tell my heart that. The poor thing beat ferociously as the plane descended into that thick, green fog, begging me, "Please, I don't want to do this again." I had to retreat inward and speak to it: "We do not want a small life. This is our first step out of smallness."

Dublin is a small city. I stayed in a small apartment, in a small bed, with a small flowerpot next to it. I drank small cappuccinos during the day and listened to folk music in small bars in the evening. I walked down small alleys and ducked into small doors that opened into small vegetarian restaurants that served small portions of roasted sweet potatoes and beet soup.

My first winter living in Chicago, I injured my shoulders by hunching them up too much during all of January and February. The body wants to protect itself from the cold, so it tightens up for battle mode during those excruciating arctic blasts. However, this isn't actually a good move on our body's part. Keeping ourselves flexible and mobile will keep our blood flowing, and keep us warmer.

I didn't realize how much my heart had been hunching up in self-defense until I exhaled all of my emotional tension in Dublin.

<p style="text-align:center">◐　◐　◐</p>

A series of exhales is how I began to regain my trust with the world, and all of them followed a gentle interaction with another human being.

"Just relax," a woman told me when I didn't have quite enough euros for a hot apple cider at a kiosk in Dublin Park. She shook her head and handed me a cup.

"Just enjoy your apple juice," she said with a smile. I exhaled. There was no reason to fear this place or any place; places were just filled with people, and being afraid of people is the best way to live a very small life.

I met up with a beautiful black-haired Irishman named Iarflaith at a touristy whiskey bar where we talked of poetry and the passage of time. When a homeless man approached us to ask for money and excused himself for "being a bother," Iarflaith replied instinctively, "You're not a bother." Exhale.

I went out for a breakfast of plump brown bread and coffee in the morning, delivered to me by a cheerful waitress who didn't flinch when I spilled it all over the table, the fault of my still-shaking and half-numb hands. "Oops!" She said it as though she was delighted it happened, and insisted she clean it up herself with a pink floral washcloth. Exhale.

Cab drivers, baristas, and bus drivers alike talked to me and others, leaping past small talk and into "Here's an anecdote about my beloved grandfather who just died" and "What is the most difficult part of being a writer?" Exhale.

95 percent?

◐ ◐ ◐

During a cursory skim of Facebook from my Irish bed, I read that there was a mass shooting in Las Vegas, the deadliest mass shooting in US history. I wanted so badly to shut my laptop and the horrors of the world along with it, to close my eyes and pretend it away. I imagined the frantic energy back at home, the increasing distrust of every person in a public space. Who would want to go outside after that? Whose heart is so resilient that it wouldn't beg to stay inside instead, secluded away from all the harm that is just waiting for us outside?

I looked to the world outside my window: a backyard garden with a humming-bird feeder and some lopsided plants whose leaves craved the light of the sun. Where on earth were we safe? Our poor hearts, craving stability and coziness like those lopsided plants yearning for the sun. They were all growing in different directions, chasing a new definition of safety every day.

That afternoon, I took a long, wonderful walk to St. Patrick's Cathedral. The cathedral stands out in Dublin's unassuming landscape like an orchid in a wheat field. I'd seen a couple of other churches on my taxi ride into the city, assuming that they must be this famed church, but there was no mistaking the majesty of the thirteenth-century building when I actually saw it for the first time. When a snippet of sun rested on the windows, they twinkled. From afar, it resembled a jewel box.

As someone fortunate enough to have studied art history in Europe, I've been to so many damn cathedrals in my life. At a certain point—I'm sorry to be the one to say it—they all look pretty much the same: another elaborate altar and a zillion candlesticks.

This one had all the usual details—the stoic statues of saints, the dusty Bibles—but the space felt sacred to me in a way that no other church ever had.

At the front of the cathedral there was a striking steel sculpture of a barren tree. From afar, it was a gorgeous piece of art; its branches were covered in leaf-shaped papers, many of which had fallen to the ground and formed a white pile around it, like the magical fake snow in *The Nutcracker*. Up close, I saw that the tree's bark looked intentionally distressed, and it was surrounded by barbed wire. I picked up one of the leaf shapes that was printed with "Remember a loved one who has been affected by conflict."

I scooped up a small pile of leaves from the ground and began reading them

one by one: "My sweet Marie," one read in French, "I am in Dublin walking the streets and thinking of you."

"To all affected by the wars fought by USA, we are so sorry."

"For our beloved Jonathan, who died of PTSD following his return from Afghanistan."

"To my mom, who lost my brother, her son. I love you."

"For the love of my life, Marco."

And, on a table next to the tree, a couple of candles next to a binder with a handwritten cover: "Book of condolences for victims of the Las Vegas shooting." I skimmed the pages full of hearts, scribbles, prayers, and hopes:

"Canadians send love to our American friends. Stay strong and united together."

"We are praying for Las Vegas, from Bristol UK."

"Mexico loves USA."

These weren't the types of prayers I'd seen in other old cathedrals. This space was alive with humanity, in all its brokenness and grace.

I looked up from reading through the binder to see a man standing next to me, looking through the leaf-shaped papers in the tree's branches. He had a gruff face covered with an unkempt blond beard, was wearing a football jersey from a Southern university team and cargo khakis that I'm pretty sure he purchased before the turn of the millennium. Definitely American.

I quickly assumed he'd been dragged here by his family and would rather be down the street at a pub than looking through messages written on paper leaves.

I looked back down at the binder, tears building behind my eyes with every one of these generous offerings that a stranger had let me in on. Even only a few hours after getting news of the massacre, there weren't enough pages left, so people

had begun writing in the margins—"We love America, from Germany" and "We pray for the end of gun violence in America, love from Sweden."

After a few minutes, I heard muffled sniffling.

It was from the American man standing near me.

This man and I, we were in this together. Not the centuries-old cathedral, but *this*—this life, this world, this fear, this beauty together.

I thought about how many people throughout history had come to the cathedral, praying for healing. The place carried the weight of undiagnosed depression, rare illnesses, and record-breaking massacres. Whether its visitors believed in any greater power or not, they had come to this spectacular building in the middle of a city to ask for help, for themselves and for their world. They came here to remedy their distrust in themselves and in others.

◐　　◐　　◐

There was a time in my life when I thought that spirituality and good art were mutually exclusive because the "spiritual art" I was exposed to was terrible.

You know what I'm talking about: pleasant images of sailboats or snow-covered cottages, maybe with Bible verses at the bottom about how God has a plan for our lives. They show only atmospheric comfort—not any joy or grief, change or decay, relationships or loneliness, struggles or tragedies. They make for lovely dentist office lobby decor, but never acknowledge the brokenness of the heart, the grit of the city, the inconvenience of other people. This innocuous brand of "spiritual art" refuses to acknowledge our wounds while evangelizing comfort for them.

The sculpture of a distressed barren tree decorated and littered with hopes

and pleas was the most moving piece of spiritual art I've ever seen. The steel structure guided us—me and the football enthusiast—deep into that place in our brains we don't purposefully visit. We were raw together, held by those thirteenth-century walls, where hundreds of thousands of people had been raw together before. Together, we were compelled to cry for strangers and send love across oceans, to give all our thanks for all we have.

If you don't engage in the world, it's pretty easy to be afraid of it. It's easy to generalize about groups of people, to close yourself off to risk-taking, and to assume that people are out to get you. The world can be a very scary place, especially for those of us who are particularly sensitive, and for those of us who carry trauma. It is so scary that it can feel easier to just stay at home, loudly announcing on the internet that we don't like people or we hate an entire country just because we had a bad food experience there.

But the small life isn't the good life. The good life is a hot mess, but along with rejection and people yelling at you in line because you can't make up your damn mind already, it comes with intimacy and delightful interactions with strangers you'd otherwise never meet.

St. Patrick's Cathedral felt good, but not because it was safe. I walked a few feet away from my new American acquaintance, through the large cathedral, admiring all the medieval artifacts along the way. The crest of a lion reminded me of a C. S. Lewis quote from *The Lion, the Witch, and the Wardrobe*:

"Is he—quite safe? I shall feel rather nervous about meeting a lion."

"Safe?" said Mr. Beaver . . . "Who said anything about safe? 'Course he isn't safe. But he's good."

Even in Dublin, I knew I wasn't immune from disease or even violence. I had no idea what lay ahead in the next several days of this trip, or the next several years of my life. Perhaps I'd always walk with a slight limp and spontaneously drop water glasses on the floor. But here I was, adventuring again, taking a chance on travel and a chance on human connection, and both brought me deeper into the world— which is exactly where I wanted to be.

Reading the news about Las Vegas alone on my laptop was so scary and isolating I never wanted to leave my bed again, but going out into the world actually made it better. There were *people* in the world, people who were praying for the victims in Las Vegas and those suffering from post-traumatic stress. People with whom I have very little in common, except my entire humanity.

I was inspired to open up to others, stubborn in my gentleness and my softheartedness. Exhale. 99 percent.

◑ ◐ ◑

After a few months of going back and forth about my next life step, I decided to permanently move to New York City. During my illness and the time of recovery, it seemed so scary. Too big, too loud, too much for someone who needed so much gentleness following trauma and loss. But after traveling to Dublin, I knew that going into the world—being around other people and sharing humanity with them— was the final step in my recovery. And it felt like gentleness to me.

New York has a bad reputation for turning peoples' hearts to stone, rewarding the powerful and manipulative over, say, the humble farm girl. But I beg to differ. I beg! I never feel more open, surprised, and attentive than when I'm here, bumping into men wearing zebra-stripe stilettos and old elegant women walking their

Persian cats around the reservoir. New York is a breathtaking blend of softness and steel.

You know the New York smell. It's filthy, a suffocating blend of worn concrete, garbage, exhaust, armpits, the backwash of Brooklyn Lager, and a million red leather Louboutin soles stomping around the subway stairs that are slathered in shoe residue and spilled takeout.

But to me, it smells like life. It's the scent of a city that belongs to bartenders, billionaires, teachers, teenagers who wear short denim shorts over ripped leggings, women whose platforms elevate them to the height of tax accountants who read self-help books on the subway, and old men who play chess with the seriousness of expressionless Eastern European civic building guards.

It's the smell of people who are disappointed, drunk, ecstatic, awake, longing, experiencing, riding subways, drinking Negronis, praying to gods whose temples compete with the mastery of skyscrapers, meeting strangers who will become lifelong lovers, raising children who will someday be called good friends and experts in their fields.

And one of the most holy places in this city is the subway. In other cities where I've lived, most middle- to upper-class people own cars; public transportation is reserved for the lower classes and environmentalists. But in New York, everyone from private school kindergarteners to octogenarian fortune tellers is jammed in there together and forced to interact on some level, so you're obligated to see a bit of someone's humanity, not so different from yours.

There's a silent agreement that none of us are here to make new friends, but we do smile. We help. We see people with canes and give up our seats. For a few minutes to an hour, we are a very small community sharing space in a moving room, twisting underneath the city.

It's not a safe, convenient place to be. But, in my final stages of recovery, riding the subway in my new home city allowed me to trust the world again once and for all. It was my daily spiritual practice, bringing me deeper into humanity after a long period of separation. Every morning and evening, I'd participate in the ritual. I'd give up my seat for the woman who was having trouble balancing as the train barreled below Brooklyn, knowing exactly how she felt. I'd marvel at the art student drawing in her sketchbook, and make faces at the child dressed like a tree. I pulled out novels and journals, hit play on podcasts, savoring this time to sit with others in silence as we hope and worry together—an activity that felt a lot like being in a thirteenth-century cathedral. For someone whose definition of God is the whole of humanity—all the tiny flames that live within us creating an enormous bowl of fire—the subway was my slivered glimpse of God.

Exhale.

100 percent.

I am WASHING MY FACE
BEFORE BED WHILE THE WORLD
APPEARS TO BE CRUMBLING:
WILDFIRES, A SHOOTING, AN EPIDEMIC.

IT FEELS RIDICULOUS TO WASH
MY FACE. IT FEELS RIDICULOUS
NOT TO. IT HAS NEVER BEEN
THIS WAY. AND IT HAS ALWAYS BEEN THIS WAY.
SOMEONE HAS ALWAYS CLINKED A COCKTAIL
GLASS IN ONE HEMISPHERE WHILE SOMEONE
LOSES A HOME IN ANOTHER WHILE
SOMEONE FALLS IN LOVE IN THE SAME
APARTMENT BUILDING WHERE SOMEONE
GRIEVES. THE FACT THAT SUFFERING, BEAUTY,
AND MUNDANITY COINCIDE IS UNBEARABLE
AND REMARKABLE.
How IS A PERSON SUPPOSED TO DO
ORDINARY THINGS LIKE FACE-WASH OR BIG
THINGS LIKE FALL IN LOVE WHEN A QUICK
PHONE SCROLL IS BOTH ADVERTISING DESIGNER
SOCKS AND INFORMING ME OF WILDFIRES?
I DESPAIR, WITH AN EXHALE. THEN I
REFUSE TO DESPAIR, WITH AN INHALE. I SCROLL
SOME MORE: A NEW BABY, A FLOWER, FIREFIGHTERS.
A THREATENED WORLD HOLDS SO MUCH.

"I MUST CHOOSE BETWEEN DESPAIR
AND ENERGY: I CHOOSE THE LATTER."
 —KEATS

WHAT DOES IT LOOK LIKE TO STATE IN THE
MIDST OF DESPAIR, "I CHOOSE ENERGY?"
FOR STARTERS, I CHOOSE TO FINISH
WASHING MY FACE. THEN I CHOOSE TO LOOK:
NOT AWAY FROM, BUT TOWARD.
I CHOOSE TO TRUST: FIRST IN GOODNESS,
THEN IN PEOPLE I KNOW, THEN IN PEOPLE
I'LL NEVER KNOW, ALWAYS IN MYSELF.
I CHOOSE TO ENJOY.
 I CHOOSE A NEW RECORD. I CHOOSE
TO CHANGE MY HABITS. I CHOOSE TO
SEND A SUPPORTIVE TEXT. I CHOOSE TO
SHOW UP AT A BIRTHDAY PARTY BECAUSE
GRIEF AND CELEBRATION OFTEN HAPPEN
 IN THE SAME NIGHT.

PAPER BOXES

Men haven't disappointed me in the typical ways: forgetting a milestone birthday, buying me the wrong size as a valiant attempt at clothing-as-gift, or failing to understand basic principles of feminism.

Rather, they've disappointed me by responding to the most heart-scorchingly beautiful saxophone solo at the park with a look of apathy and a "Want to get going?"

They don't say anything about the dim orange shine of the bar and how it makes everyone look more beautiful.

Instead, they complain about having to walk on cobblestones, even though I

planned it this way for ambiance. *Can we go down the other street? It's hard to walk on this.*

They accompany me to the perfect bustling Italian restaurant, the one with jasmine vines crowding around the doorway and the endearingly stern waitress who instructs, firmly, with love, "You need some cheese with this wine." We're seated at the perfect table, and a cellist across the street plays "Moon River," and the special today is my favorite. I'm presenting them with an enchanted dinner, and they look completely unaware of the magic and say a few times, "I'm full."

I think we're going to stop to watch the salsa dancers in the window and we don't.

I think they're going to say something about how this weather couldn't be more perfect and they don't.

I squeeze their knees in the middle of the play because I'm so overcome with resonance, and they say they have to pee.

Their failures to engage in the world as sensuously as I hope leaves me feeling lonely while we're holding hands.

I joke with performative self-awareness, "Well I don't want to date *myself*," but in secret I think it would be so much easier just to be with someone exactly like me. I've been told that I should look for someone who challenges me, who I can grow with. But at age thirty-one I've grown in enormous ways already and don't feel like I need to learn, perhaps, a totally different sense of humor. I'm great with mine. I think my political views are perfect and my taste is impeccable. I don't want to have to convince someone why we should paint the bathroom marigold or explain my stance on a social issue that I've invested years developing. I don't want to be tied to someone who doesn't share my observations, someone who

never says things like, "Isn't it marvelous how the cobblestones seem to glitter after the rain?"

I'd love to find the male version of me plus a few skills I don't have, like mental math.

<p align="center">◐ ◐ ◐</p>

People talk a lot about "the right person." I hate this concept. I especially hate it because it's used as a weapon in disguise, like an innocent sheet of stationery that can slice your finger if you handle it the wrong way. It sounds like a pleasant enough idea, but I most often hear it in the context of dismissing all my fears and ambivalence about being in a long-term relationship.

What if the person I'm with doesn't like the names I'm 100 percent sure about for my children? What if I get married and two years later my husband is on a work trip and I meet another writer at a party and he begins articulating something about the light hitting the buildings in Lower Manhattan and I gasp because what if that's the person I should have been with? What if I suffocate to death from having to sit by the same person on every plane for the rest of my life? What if he doesn't like to dance, or he voted differently, or he listens to the incorrect music in the morning, or he thinks New York is too dirty? What if he yawns loudly? What if I miss having Christmas just with my mom?

What if, ten years from now, when I'm celebrating our anniversary in Italy (let's assume he's rich), I see a woman eating bucatini alone, reading in between big bites that she has all to herself, occasionally gazing up to flirt with the waiter whom she'll meet up with after his shift? And she doesn't have to ask anybody if they

should get more wine or if he's tired or not? And I want so badly to be her that it physically aches?

"Oh, none of that will matter when you're with the right person."

That response is a paper cut across the part of my heart that has been bravely putting itself out there for ten years—sending love letters across the country, participating in sad good-byes, going through breakups I still regret, staying awake at 2 a.m. when we are most definitely, without a doubt, the only people awake in London. If my personality and my values and my insecurities were going to suddenly evaporate upon meeting this mythical Right Person creature, wouldn't they have done so by now? Was all of that letter writing just a waste?

That's what it sounds like when people tell me that. I always shake my head. "I've met the right person. Lots of right people. I still don't like sharing a bathroom."

◐ ◐ ◐

An interesting thing happens when you've dated quite a lot of people: they form a kaleidoscope-like Venn diagram of personality traits and interests, with each person reminding me a bit of the last, or a lot like the third-to-last. They overlap and run together, and yet, I still take mild offense when my best friend can't remember the difference between Jeremy 1 and Jeremy 2, or the two software engineers, or the three who grew up in Michigan.

Now, in my early thirties, My Dream Man has become a Frankenstein's monster of my favorite things from all of the men I spent time with in my twenties—limbs, emotions, skills, and proclivities that could never exist in the same being.

I've also begun looking at each man I date as sort of building up to the next—a

progressive series of small improvements, closely inching toward this Right Person I've heard so much about. "You're getting closer," my single friends and I tell each other when a relationship among us ends. This myth seems to be supported by plenty of poems and song lyrics that insinuate that the many mistakes and breaks somehow carve a path toward finding The One. The only one who matters. The one who has mystical abilities to evaporate the need for alone time and memories of backseat make-outs with any others.

The more I buy into this mind-set, the more personally offensive it is when the men let me down—whether they shake my hand at the end of a first date or refuse to properly acknowledge the wonder of that heart-scorchingly beautiful saxophone solo in the park.

"I put in all this work," I frantically text my best friend Susan. "I love myself. Isn't he supposed to show up when I finally love myself? Or is it when I stop looking? But how do you stop looking?"

My phone lights up: "Don't worry, my love. He's on his way. He's so close. I can feel it." And I soften.

Activate, delete, reactivate, repeat: Such is the cycle of dating apps. Unlike some of my more energetic friends, I can only maintain one app at a time. Every time I hear an urban legend of some woman finding true love on her phone, I delete my current account and switch over to the app she used. I cultivate a new identity for myself: selecting a different set of photos from the last, ones that reflect the energy I am going to put out *this time*. I need to be with someone spiritual. No, funny. No, French. A nice person. A traveler.

I scroll through my photos in search of an adventurous-looking portrait of me, pairing it with an earnest bio this time. I'm not messing around anymore.

The next month, I throw out the earnestness and I'm back to a witty one-liner.

What a mistake to date someone so serious for two weeks, even if he was well-traveled. I need to be with someone funny. It is a constant guessing game, predicting the accurate combo of app and profile and intention in order to unlock the Right Person.

<p style="text-align:center">◐ ◐ ◐</p>

"Stand right here." Dave shifted my shoulders into position, slightly to the left. "Now look down this street."

It was 6:50 a.m. and I was walking him to the Astor Place station; he had to run home to Queens and change before going back to work in Midtown. "Look," he repeated. My eyes were open but I pretend to reopen them with a dramatic blink. The sunrise had rushed down this avenue so the entire street was bright and red. It's so overwhelmed with color, it almost seemed like there must be some barricade that wasn't able to hold in all this light. I saw buildings I swore weren't there last week, and they were shimmering.

"Wow," I said, not sure what I'm referencing with the word: The color? The buildings? New York? The fact that this man introduced me to morning light I'd never noticed?

"I love when it looks like that. This is one of my favorite streets in New York," he said.

"Wow," I repeated softly. "What are . . . others?"

Dave artlessly brought out his outdated phone and pulled up Notes on the cracked screen. "Streets I Like," the list began, and I laughed because I couldn't express my delight in words. Not words I really wanted to say after our third date, anyway.

Even though there were very few cars, we waited until the light turned green to cross his beloved street. The morning felt too sacred to rush through.

On his lunch break, he texted, "I pass Astor Place on my commute home every day. I'm so happy I'll now associate it with this morning every day, and I look forward to filling it with many more memories."

<center>◐ ◑ ◐</center>

We met a week ago at a cocktail-dessert bar. I complained at his suggestion; it seemed like an awkward combination, and at 7 p.m. to make matters worse.

"So what does he expect you to do?" Susan asked. "Eat dinner at home? And then have dessert at 7? With drinks? On a Tuesday?"

"I know," I texted. "Rookie move."

His profile said that he was a transplant to New York from Durham, North Carolina. I assumed, and was endeared to the fact, that he was maybe trying to suggest a cool place without understanding exactly where it fit into the time and space of New York City.

And I suspected that maybe he embodied some part of the winning combo I had been missing so far: open-mindedness. The unexpected. Willingness to overlook some typical deal breakers. I'm a "hair person" and he was bald. I combed through the questions he answered and had to read "Yes" twice in his response to "Have you ever been married?" just to make sure.

"I guess we're at the age now where we're dating divorced guys?" Susan offered. That seemed likely. It also seemed likely that he'd potentially be more evolved than the usual twenty-nine-year-old man who had never held down a real relationship. Maybe this guy owned picture frames. Maybe he knew how to talk to

someone else's mother. Maybe he knew something about commitment, and for-
giveness, and courage. Maybe that would make up for his clumsy date suggestion.
We were going with best-case scenario here.

<p style="text-align:center">◐ ◐ ◐</p>

"I met someone."

I'd never said that phrase in my life. I'd heard it, many times, usually in roman-
tic comedies, as it seemed to carry lots of implications, like: someone with whom
I've not only imagined marriage, but also parenthood, the complications of midlife
careers, and side-by-side cemetery plots.

I had called my friend Kiki and tried to chat about other things first: the day, the
work, the weather. And then, after a highly anticipated space in conversation, "I
met someone." It was a release to let those words spill out, words that hadn't just
been pent up during our call but, it seemed, my whole life.

Dave had texted me earlier that day to say that he'd just spent the weekend
with his good friends—a married couple—on Long Island, and he had "gushed"
about me, and they were "so happy" for him. This was the type of text that the
eyes take in first and the body then takes in. As I fully processed it, I could even
feel my fingertips relax.

I didn't recognize that I'd been carrying this tension since the time I asked my
first boyfriend of two years what his parents thought about me and he said, "I'm
not sure if they know about you."

It's the kind of text that makes you tip the barista extra, the kind that needs to
be physically released by a fast walk down the block blasting the most celebratory
Carly Rae Jepsen song as loud as your earbuds will allow.

I told Kiki the on-paper details about Dave, but none of it felt particularly true to who he was because he wasn't a man I met; he was a whole universe.

"Well he's an urban planner," I said, leaving out, "The world must have let out a sigh of relief when we finally met."

"He's from Durham," not, "I'm looking for new ways to express how excited I am to know him."

"We've had a few good dates," not, "We both agreed that the morning we walked to Astor Place was the best morning we've had in years."

"He's smart, he's nice, he's funny," not, "His texts are so quick and make me laugh so hard I'm convinced they're written by a comedy writing team."

"Oh and he's divorced—isn't that interesting?"

It was perfect, actually. I could swoop in and rescue him from any brokenness he felt; I could be the redemption, the reward. I fantasized about him thinking about all the ways I was better than his ex-wife but also the narrative that he had to go through all that to get to this, and he'd appreciate me so much. Everyone would agree that our wedding was so much better. They'd praise me for bringing so much light to his life.

❦ ❦ ❦

"You brought me light in a dark time," he would say to me a few weeks later, but instead of feeling like redemption, it went down like lava.

"Shut. Up!" Followed by a sob that physically hurt. I'd never heard my voice make this type of sound.

"Why do I have to bring light to every sad, broken, fucked-up man who can't

find himself on his own? Go travel or join a meditation club, don't use women! Write in your journal!"

I could see him in pain and wanted to hurt him more. "Where's *my* light? When is someone going to be a light to me?"

He just kept attempting "I'm sorry" over and over.

<p style="text-align:center">◑　◐　◐</p>

Two weeks ago, he said he was sorry for getting out late—something about his boss stopping him in the lobby to chat about the new Bronx project. He was frazzled and a little sweaty when he pushed through the revolving doors of his Very Midtown Building to meet me on the sidewalk. I was leaning against a marble column, trying to look casual and coy, my idea of a 1950s film bombshell meeting her man after work.

"Sorry, sorry, sorry," he repeated in my ear after kissing my cheek, and then took a step back. "Oh my," he said sweetly and looked me up and down. "I like . . . I like what this outfit is doing."

I liked what his was doing too. It's thrilling to see someone you like in a different context than usual because it makes them seem like an infinitely mysterious being. In this case, a man in a suit who goes to meetings and, I don't know, plans cities, I guess. It was my first time seeing him in a tie and looking frazzled, and I instantly pictured a lifetime of 6 p.m.s and loosened ties.

He took my hand assertively and said, "This way."

We walked past the row of outdated chain cafes with French names in curly font—"I'm saving one of these for our sixth date," he said, smiling.

"Do you go to any of these places?" I asked.

"I do get coffee from that bodega," he said. "I have this little routine going where I get off the subway, look at my favorite building, pick up a newspaper from the guy George on the corner, and then get coffee there. It's pretty bad but, I don't know, I love the ritual."

I imagined any of my friends overhearing this and giggling at how similar we talked. *Oh he looooves the ritual, huh?* And I'd smile because what's better than being teased about how in love you are?

Along the walk to this unfamiliar station, he pointed out his favorite building. He positioned my shoulders: "Here's where I like to stop." I turned my chin up, and the art deco building dominated the whole sky. "This one always gives me hope," he added, like he's a character I wrote.

We continued our adventure with a subway ride in which the air-conditioning was broken and we were smooshed up against people who were not newly in love—and therefore miserable. But, to fulfill a cliché, I barely noticed. *It won't matter when you're with the right person.* The whole ride, Dave's hand was on my hip as the other held on to the overhead pole. When we passed Astor Place, he squeezed my waist.

It was my first time seeing his neighborhood, and it felt like being let in on a secret. I wanted to know everything: where he did laundry, what he looked like when he waited in line for a subway card, what his voice sounded like when he was interacting with a cashier. Did it go up a little the way mine does? Did he say, "Have a good one" or "Have a nice day"?

He apologized that we had to pick up cat litter on the way home, but I was excited to see him in a grocery store setting, to observe him in such an ordinary

place. At the beginning of a relationship, all the boring and humdrum experiences that weigh down a long-term relationship seem as thrilling as a jaunt to Positano, but maybe even more so because they foreshadow longevity.

When we got to the cashier, she looked up at us both for a moment and asked Dave, "Is this your girlfriend?" He looked at me and laughed, then replied with a confident and appropriate, "Sure." The cashier smiled and said to him, "Well, she's beautiful. If she's not your girlfriend, you should be trying very hard."

This type of interaction had happened every time we'd gone out so far. A bartender or an old man on the subway would notice us and say something, usually along the lines of "You guys are so cute together." I'd never gotten this kind of attention from strangers before and of course I took it to mean that our chemistry was the most powerful force in the bar or the grocery store, so strong it compelled people to take notice, to say something. It was both comforting and exhilarating to have this feeling confirmed by the public. New York was suddenly pulling for me.

◐ ◐ ◐

"How can this hurt so much when I didn't even know he existed in April?" I blinked to control tears.

Alex reverently inhaled. "Well, for one thing, you can feel however you want. But I think it's . . . you know, not a *wide* wound. But a *deep* one.

"And, I'd add, Dave tapped into a feeling you didn't think you were capable of. So no matter how long it lasted, that feeling was uncovered. Some people don't have that feeling, ever, in their whole lives. I'm not going to tell you you're lucky for having felt that, but it's rare. So, yeah, the length of time doesn't really matter."

I nodded and a tear fell, another quick to follow. "I can't believe how quickly

we built this whole house. It was a real relationship with four walls and a roof. But, I don't know, I guess it was just built out of words. A paper-box house. The second it began raining, it couldn't hold up."

○ ○ ○

We dropped off the litter and I met Dave's cat, Jane. She warmed up to me immediately, and seemed like the kind of cat who would, but Dave insisted, "She likes you. She's not like that with everybody."

"Could I take a look around?" I asked.

I walked into his room, a new set of evidence pointing to who he really was. There were framed concert posters from alt-country bands, a few plants, sweaters neatly organized on shelves, and books everywhere on every surface. I tried so hard to mentally commit them to memory as quickly as I could that my brain mixed them up over coming days, but I was dazzled by the range—architecture, philosophy, short stories, everything James Baldwin. I knew it already, but the books confirmed that his mind was a lush place to be. I felt honored to be somewhere in it.

He asked if I wanted to see his workshop. "Uh, duh," I said as he led me through a room off to the side. It was a total mess, but contained. Paper scraps and rulers and glue everywhere. But, on the walls, four meticulous and orderly pieces— works—of art: big maps created from thousands of tiny paper boxes. He had made the Manhattan map into a lamp so all the streets lit up when he turned it on. The Cuyahoga National Park map looked like paper waves coming out of the wall, every hill created to scale.

As I looked at the maps, Dave looked a little nervous and drummed his finger

on the desk. I was so grateful—grateful that he would make and then share all this with me. I thought, I've found the most special person alive, who loves James Baldwin and these weird bands and makes 3-D maps out of tiny boxes with his hands. I thought, stay, stay, stay. Let me learn every sweater on that shelf and let me read all these books and let's eat every taco in New York and let me love you as much as I want to.

"I'm so grateful we found each other when we did," Dave whispered. There was nobody around he was going to disturb, so the whispering was out of reverence, for what I'm not exactly sure.

◐　◐　◐

Susan and I call it "The Shift." It's a dreaded downturn on the graph of an early relationship's progress, marked by a noticeable change in energy from the first few dates. The first time you split the bill, the first time he waits a few hours before texting back, the first time he says he's busy at work. Nobody is busy at work before The Shift. Work is not something that matters pre-Shift. Pre-Shift, if you're out with people and can't text back, you go to the bathroom to tell the person you're thinking about them. The Shift is the exact moment he says, "Sorry, I was at my friend's party last night. How are you?" at 2 p.m. the next day.

I could feel The Shift before it even happened, or maybe there were signals that I ignored except in the most intuitive part of my gut—which is also pretty quiet pre-Shift. We had kissed that morning as I was leaving his apartment and I said something about our connection that, the day before, he would have reciprocated with just as much cheesiness. As soon as I said it, I felt exposed, like someone had just read a text meant for somebody else. Perhaps I had stepped just a little

too far. A little too soon. But it was also weird, because hyperbolic statements had been our language since after our first date. He was the one who said he was searching for an adjective powerful enough to describe how pretty I looked that night. Was I out of bounds to suddenly and openly discuss our chemistry?

"Yeah, we have a nice connection," he replied.

The line on the graph began turning downward.

Later in the day, I presented our usual "When can I see you again?" And in reply received a very unusual "Let me check my schedule."

Not him, not him, not him. Please, please, not him. I really wanted this one. I really wanted this to work out this time. Please let this work out. Please give me this. I know I'm fine on my own, okay, okay, I know. I just really, really wanted this one, this once. Please.

<p style="text-align:center">❦ ❦ ❦</p>

Single people have their own little imaginary monuments all over the city dedicated to sites of bad and promising dates. I have invisible plaques on coffee shops, cocktail bars, seafood restaurants reading "Mari's Second Date with the Start-Up Guy" or "Where Mari Broke It Off with the Lawyer." First kiss on this bench, last kiss on that stoop. After a while, the city begins to feel heavy with auspice and disappointment. I've seen artists draw subway maps marked with all their exes' homes and places of work. I still think about a guy I dated three years ago when I walk by his dentist's office.

At most, these monuments provoke a little pang of wistfulness when I pass them. Sometimes they make me laugh—I still can't get over the finance guy who brought me to that juice bar with no seating on a stormy day so we just stood

there drinking our cucumber-pear tonics next to the register. I think about being in the most romantic, postage-stamp-size, dimly lit wine bar in Brooklyn with a guy whose conversation skills reminded me of a beginner's foreign language textbook conversation: *I like television. And you, do you like television?* I think about the many dive bars with the many guys who thought they'd discovered Radiohead.

These sites of long-extinguished love don't haunt me because I always had the most control over the atmosphere. I was always the nicest one to the waitress. I always ordered the more interesting drink. I would point out things he didn't see—the painting on the wall, the weird mirror in the bathroom. I noticed magic, so magic was more likely to happen. I began to realize it was my power.

Discovering your power is thrilling, perhaps even a little dangerous. When a superhero discovers he can fly, it's probably euphoric but also really freaky. *I can do this? And not everyone can?* He has more control now than he ever thought, and it quickly becomes exciting. What can he do with it? Whom can he share it with? A power isn't really a power unless it changes things and helps people.

I could see my dates falling for the way I could—from their perspective—summon the extraordinary just by pointing it out. But I could also see them confused, and when they were disinterested, it really hurt.

After a while, our flying superhero may feel lonely. He doesn't care to impress people, but is bothered when he doesn't impress them. It might be nice just to find a companion who can also fly.

As we walked the length of the Brooklyn Promenade on the first balmy evening of the year, Dave pointed out a house in the foreground of the river and told me about its inhabitant, the writer Joe Mitchell. I leaned in close to him on the railing and our shoulders touched as he told me a story, building that paper house that

I'd already furnished and filled with memories that hadn't happened yet. I could already hear the shuffle of slippers on Thanksgiving morning, I could see myself rolling over to wake him when I couldn't sleep, I could smell the coffee he'd meticulously measure into a French press on a rainy Sunday and the sweater I gave him two birthdays ago.

I don't go to the Brooklyn Promenade anymore. But I could almost swear there's a plaque there that says "The Beginning of the Future That Never Was. It Was Such a Beautiful One, Though."

<p style="text-align:center">◑ ◑ ◑</p>

Moments after he left my apartment, I sat down, in every way exhausted, and looked at the water glass I'd poured for him, from which he took several sips as I screamed at him. My last offering to him. It looked so pathetic. I was still trying to provide for him until the final moment, still grasping at ways to make him want to stay. I took a slow sip from the glass as if to touch him one last time. It still smelled like him—thank God.

I sat back on my couch and tried to remember everything he just told me so that it would make sense, but his words just scattered themselves around my mind as though someone blew them around with a wind machine. Something about how this wasn't the right time. Something about how he's been down lately and couldn't be consistent. Something about how he'd give me money back for an upcoming trip, and how he had a good time, and wished me well. I couldn't put the phrases back together in logical order; I just knew that he didn't want me.

I wanted to text him so badly. It physically hurt to not grab my phone and beg

him, for anything. I tell friends when they want to text their ex, text me instead. Pretend I'm him. But I couldn't gather any magical thinking to allow for placebo satisfaction right now. There was nothing more to lose—my dignity had left as soon as he came in the door and I began sobbing. So I picked up my phone and violently tapped out my final benediction to him, the plaque I hoped he'd magically see every time he passed by the Astor Place station.

"I thought you were my reward for everything I'd been through. But you were just more to go through."

 ◗ ◖ ◗

In the days that followed, my friends told me they'd never seen me in such bad shape. Dave had cracked open a part of my heart and flooded it with morning light, and now that empty space was wide open and unprotected. I condemned more parts of the city as unsafe for my heart: the 6 train, the oyster place I used to love. How dare he contaminate it.

People told me I'd be fine, there are other fish in the sea, I'd meet someone else. The notion made me wince. Someone Else would never be the person who told me we'd make peach crisp together in July, or the person I wanted to take upstate in October to take that cheesy leaf photo together. I don't want a new photo album in my phone labeled "Someone Else." Someone Else's chin doesn't fit right above my head. I couldn't possibly comfort myself with the foggy idea of an abstract stranger stepping into Real-Person-Dave's spot. It made me want to shout at a hypothetical someone I'd never even met: "Hey, don't sit there—that's Dave's place!"

Months later, sitting in Gramercy Park, I hear a song I had associated with Dave, and actually don't think about him. Instead, I think about how I am loving the park more than usual. The trees are plump with blossoms and look so tender and friendly, like a good-natured woman you might find running an inn in Ireland or some such thing. I catch a glimpse of the light on the fountain water, bouncing around like it's boogie boarding from one end to the other. The song in my earbuds accompanies this setting nicely.

For a second, I enjoy the view, then I wish so badly I could share it with someone. I'd once shared my ability to notice magic with a person, and it was wonderful—so much more wonderful than keeping it to myself.

But Dave is not the only person I will ever share this with. Maybe, maybe, someday, I will see something beautiful or funny and want to share it with Someone Else. And Someone Else will have his own name, his own bookshelf, his own rituals he will share with me.

WITH EVERY HOPE, I'M PAINTING a THOUGHT THAT LOOKS LIKE a FUTURE, AND THAT PAINTING IS OF a FIELD — NOT OF A PARKING LOT.

WHEN I HOPE, I TELL MYSELF: "I WON'T ABANDON YOU. I WANT WHAT'S BEST FOR YOU. AND HE WASN'T IT."

HOPE HAS NEVER OUTRIGHT
ABANDONED ME. I MIGHT
NOT HAVE GOTTEN WHAT I
WANTED, BUT IT WASN'T WRONG
TO HOPE. THE OPPOSITE OF
HOPE IS NOT DISAPPOINTMENT,
BUT APATHY. WHEN I KEEP
HOPING, I TELL MYSELF:
I CARE, I WANT, I WONDER,
I WISH.

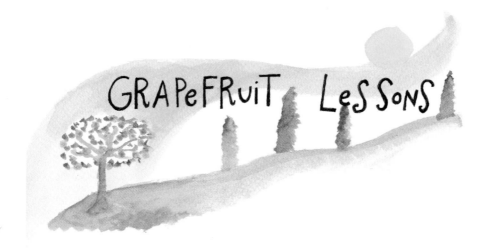

GRAPeFRuiT LeSSonS

A s a college student, I devoured travel memoirs. I was enchanted by these glamorous authors who *found themselves* while in a different country. They would eat a lot of meals whose vowel-heavy menus take up multiple paragraphs, they'd make tons of attractive foreign friends with cool names, they would learn the language and love the way the words sounded, they would usually fall in love, and, then poof! Self: found.

All of this led me to a belief in young adulthood that my dull Chicago life sucked, and everything would come together if I could just spend a few months eating, praying, and loving under the Tuscan sun. If I lived abroad, I would actually change into a much more attractive, fabulous, confident person who accidentally finds herself on the back of a Vespa zooming down the Amalfi coast.

Because I wanted to change into this person as soon as possible, I signed up to study abroad as soon as I could, during the first semester of my sophomore year. Since the semester in Florence cost the same as studying in boring old Chicago, there was no reason for me not to be prancing around citrus trees becoming the enlightened dilettante I'd been promised by movies that follow a woman from humdrum grey skies to a land where it's apparently always sunset.

Turns out, living in Italy was one of the most depressing times of my life. For one thing, I was nineteen years old, an age when many people feel so uncomfortable in their own skin that they would do anything to be in any body other than their own. And after my first day in Florence, it quickly became clear I wouldn't immediately become the happy, carefree, suit-wearing, Italian-speaking, international woman of mystery I had envisioned, the one who never checked her watch and ended all her interactions with "Ciao!" Florence did not inspire a revolution of character or change my inner world into continuous blasts of golden hues and angels on the piano. It was just a change of address.

Instead of saving me from my insecurities, living abroad actually exacerbated my anxiety. I felt perpetually uncomfortable, as though I were wearing too-small shoes and a too-large sweater. Instead of clinking glasses at fabulous dinners, I'd eat in my room by myself and then feel guilty for not taking advantage of such a marvelous opportunity. My self-consciousness built a thin wall between me and the beauty of the city.

The pressure to have a great time didn't help matters either. I would confess to my friends at home over instant messaging that I found myself in a funk, and they'd reply, "But you're in Italy." I knew I should be grateful, and should probably have a boyfriend named Giuseppe by now, but my dark feelings made me feel even more lonely.

Through twenty-page journal entries and desperate prayers and navel-gazing monologues delivered to anyone who would listen, I tried to find the meaning of my pain. Was it the weather? Bad grades in my art classes? Homesickness? Pasta-induced bloat? I would settle on one source of sadness for a couple of days with a triumphant "ah-ha, that's it!" and work to resolve it, only to end up still very sad.

During free afternoons, I'd linger in cafes and attempt to find myself. That's what I was in Italy to do! Like the heroines of travel memoirs, I'd look to the combination of a cappuccino and a novel to thrust me into nirvana. Instead, I'd end up sitting there like half of a self, wondering where the rest of me went and if she was ever coming back. I'd inconspicuously add more sugar to my cappuccino, wishing it was hot chocolate in the first place. Questioning why I hadn't yet found a taste for espresso led me to other dilemmas: Why was I not in love with Italy? Why was I not in love with anybody? Why didn't this floral sundress make me look effortlessly devastating like that beautiful French girl in my art class, and why the hell wasn't my name Philomene?

◑ ◑ ◑

My host family called me Maria; my teachers overcompensated for their Italian accents by insisting on pronouncing my name "Mary" and exaggerating it: *MAIR-EEEE*. If finding myself meant assuming a new identity, then having a new name was at least a good place to start. I had never liked mine very much; I loved romantic and feminine names that went on for miles. Mine was short, always mispronounced, and carried a dreadful meaning: bitter.

In one of my rambling emails to my dad about my loneliness and foreignness fatigue, I asked him why he had burdened me with such a name. He was a linguist

and knew the etymology of any word I could think of. Surely he had thought about this. I waited for his reply.

In the meantime, like the best of the travel memoirists, I kept trying to find myself.

As Maria or Mair-eee I experimented with my style; I got an "artsy Italian girl" haircut and, like a cliché of an American abroad, began wearing scarves (albeit awkwardly, with hooded sweatshirts). I tried getting into poetry and changed my way of writing to reflect the sophisticated woman of mystery I longed to be. I bought new elaborate stationery from a centuries-old paper mill. I spent the last of my savings to fly to London for a night to go to a concert just so I could tell my friends at home that I did so, even if it meant spending a night in Heathrow Airport because I couldn't afford a hostel.

Finding myself was a lot of work—and money.

And nothing was working. I wasn't becoming anything resembling what I'd gone to Italy to become. And what exactly was that? Philomene. Or my statuesque host sister Martina. Or the barista Piero's Greek girlfriend, Anastasia, who would float into the cafe like a Mediterranean breeze. All these elegant women with their elegant names were taunting me: Why couldn't I just be more effortless? What was wrong with me?

I took my friend Megan to Piero's café. I'd seen Megan around our small college campus but we bonded quickly within our study abroad group when we were both late to class the first day. She was a couple of years older and carried the confidence of a fabulous twenty-two-year-old who knew how to drink wine and took her espresso without four packets of sugar.

I cried to her about the sticky place where I'd found myself. "I don't want to be

here anymore," I whispered, and I felt a sharp surge of shame as soon I released those words.

But Megan didn't scold me; she only listened and sympathized. "Living abroad isn't always beautiful, huh?" She told me of her own struggles, feeling financially scarce and disappointed by her own experience with loneliness. What were we missing that was so easy for the travel memoirists?

As she was leaving, a woman in the cafe stopped by our table. Her smile warmed up the entire room—not an easy feat since ancient Tuscan rooms in November don't get comfortable with a single space heater alone. She wore a cashmere blanket over her shoulders and clutched a collection of books and postcards tied with a pink ribbon. She looked at home in the cafe, but even more so at home with herself.

"I'm so sorry to eavesdrop," she said in a delicate British accent, "but I heard you girls talking about the struggles of being foreign and just wanted you to know that you're not alone. My husband and I have lived here for a couple of years now and it's wonderful but also so challenging, and you're both so young. It's so hard to be young!

"I'm Barbara," she continued. "I live on the next block and I'd love to have you both over for tea sometime if you have any questions about Florence, or just want to talk to someone who isn't from school. I'm here."

We were immediately enamored with her. She looked to be in her forties, beautiful and elegant but in a completely different way from Philomene, Martina, and Anastasia.

Being in her presence felt like a relief.

"We'd love that," Megan said, and we made plans for the following afternoon.

Barbara lived in an adorable house converted from a fourteenth-century horse stable. It looked like one of those illustrations of a cottage where a mouse in a bonnet lives at the base of a tree. There were homey trinkets everywhere—matryoshka dolls and bright green pots with baby rosebuds sprouting out of the dirt. Her dishes were a mismatched collection of antique plates and teacups, and she used wine bottles as candle holders. We sat in big armchairs that partially swallowed us when we sat down. She pulled up a space heater to our feet and gave us a handmade quilt to lay over our legs.

It was so easy to fall into conversation with her; we shared all of our angst and longings from the past two months. She laughed as we pouted over not being as pretty as Italian girls, offered us empathetic sighs as we shared our frustrations with the bus system. Surely she knew that our irritation was not rooted in confusing buses, but in discomfort with ourselves. She had been in college before.

Barbara also offered us the comfort of silence, where we could just sit together without saying anything. My mind had been so frantic lately, jumbled with new words and a panicked inner monologue, I didn't realize how much I needed that silence until I felt my brain and heart relax into the chair along with me, releasing their tensions into the ambiance of this little urban cottage.

"Do you mind if I . . . pray for you?" asked Barbara. "I don't want to force anything but . . ."

"Um, yes, please," I interrupted. Despite visiting cathedrals left and right with my school group, I had not been nourishing my spirituality at all in Italy. It was just another way I was feeling entirely untethered and unlike myself.

As I took a stealthy bite of cookie, she bowed her head and murmured a quick, ecumenical prayer beseeching God to bless our friendship and the rest of our stay in Italy. "Amen," we said together, and I freely began crunching.

"I love these," I gushed about the occhi di bue cookies filled with Nutella.

Barbara looked back up and hesitated, "Um."

I stopped chewing.

"Sometimes I get visions of people when I pray for them. Would you want me to share the ones I saw for you?"

"Of course," Megan said. Who wouldn't want a free vision?

"Okay," Barbara continued, smiling. "Megan, I saw you dancing with joy in your future. For now, I know it's hard to come into your full joy because you haven't grown up yet; you're still learning that you really are truly lovable, but you'll get there. The dancing isn't literal, I don't think, but I see your life will be full of music and color and community. It's really beautiful!"

Megan glowed. "I love that," she said. She gestured toward me. "What do you see for Mari?"

"Um," repeated Barbara, "I don't want to embarrass you, Mari." I tensed up. "But I just saw . . . a grapefruit."

"Like . . ."

"The citrus, yes. Just a grapefruit on a tree."

I said nothing, so she continued. "It is in the sunshine, on a beautiful sunny day . . . so maybe that's something similar to Megan, about your life being light?"

"Thanks," I said, but I was so jealous of Megan's vision. Did this mean I should be a food writer? I don't even like grapefruit. It's too bitter.

On the walk home, our steps created rhythms on the damp stones. I loved the sound; it was as satisfying as a golf clap, and amplified by the tall houses that lined the streets.

"Grapefruit is such a distinct flavor," Megan finally said. "It actually kind of makes sense. You're such a unique person and grapefruit is a unique fruit. Does that make sense?"

"I'm just already feeling so bad about myself, I didn't really need that," I sighed.

"But that's the thing. Think about a grapefruit who is trying to be more like an orange, or one that isn't fully itself. It will taste weird. Then think about a Florida grapefruit in the sunshine and how it probably tastes so good you wouldn't want anything else. Maybe Barbara's vision is about you just being more like yourself."

"But I don't even like grapefruit," I reminded her.

"Not everybody likes every fruit. That's not the point."

I squinted at her, irritated with my own fate, and kept walking.

But in the following days, as I continued failing at becoming the Italian goddess I longed to be, I started to own the self-conscious American student I was. All the late-night journaling about my ambivalence toward the city had led me toward hidden coffee shops that even Italians didn't know about. I came up with a gelato combination that my host family hadn't thought of before, and I developed a limited, but very nice, conversational relationship with the stationery store owner. Florence was unexpectedly becoming mine, in a very unexpected way. There was absolutely

no frolicking in fields, but there was cobblestone strolling at my own pace. I didn't find a new self, but I was beginning to uncover the self I brought with me.

I began to see what Megan and Barbara were alluding to. You can't be what you're not. You can only be the fullest version of yourself. You can't please everyone. The only thing that can please everyone is water, and it has no flavor. A watery grapefruit would taste disgusting, and why would it want to be bland like water anyway? Why would a grapefruit spend any energy on making itself less flavorful rather than just embracing its full, flavorful, bittersweet self?

A week later, I finally got an email back from my dad, with the story of my name.

Once upon a time, ancient Hebrews camping out in the desert, approximately 1,920 years before the invention of the personal refrigerator, used to preserve their meat with herbs. These herbs had protective qualities that would guard their valuable meat from decay. The Hebrews favored a certain ambrosial herb that was bitter at first taste; its distinct flavor was bold, piquant, strong, at times overpowering, but delectable. It was so beloved and even revered that it was worth more than its weight in gold. It was delicate, precious, sacred.

The qualities of this herb echoed their culture's favorite feminine qualities: fragrant, spicy, tangy, sharp, strong—but at the same time nurturing, protective, valuable, mysterious, and precious. This herb is called maror—the origin of Mari.

"Bitter isn't a bad thing," my dad concluded. "Cranberries, dark chocolate, and grapefruit are bitter too."

◦ ◦ ◦

Megan and I would have tea with Barbara many more times before we left Italy. I was beginning to release the idea that I needed to transform into Philomene, and

I began feeling shame that I'd spent so much energy on vanity when I could have used it to help others. "Why am I not more like Elizabeth? Why am I not better?" I asked, referencing Barbara's sweet assistant who spent her evenings volunteering at the food pantry while I was out taste-testing every occhi di bue cookie in Tuscany.

Barbara shook her head. "Mari, nobody is ever going to ask you, 'Why are you not more like Elizabeth?' If anything, they're going to thank you for being you. The question isn't, 'How do you become more like Elizabeth?' but 'How do you become more like Mari?'"

 ◦ ◦ ◦

I had my first truly delicious grapefruit experience in a small town in Tuscany on my twentieth birthday. Champelmo was the name of my drink: sparkling wine with fresh citrus juice. The waiter suggested it and explained, "The grapefruit is in season right now and so good. The bitterness with the sweet wine . . ." He kissed his fingers and closed his eyes. "Nothing better."

The flavor was complex and interesting, unexpected and a little weird. I felt so grown up, learning to appreciate this very sophisticated flavor and even learning to crave it. It wasn't a simple, easy pleasure like those cookies with Nutella; this one took more time to evolve and was only very good at its absolute prime, in season, full of flavor, sometimes overpowering.

Nothing better.

CITRUS ALWAYS SEEMED SO
SUMMERY TO ME; IT'S HARD
TO BELIEVE THEY REALLY
THRIVE IN FROST AND CHILL.

IT DOESN'T MAKE ANY SENSE,
AND YET IT MAKES SO MUCH SENSE.

How kind of the world to provide abundant citrus during winter, when we are most in need of vitamin C.

It makes me believe that nature is on my side, the universe is on my side, my soul is on my side if orange trees are on my side.

NiGHT

SOMETIMES THE ABSENCE OF
LIGHT HELPS YOU SEE MORE CLEARLY.

IT TAKES AWAY MANY OF OUR
COMFORTS TO REVEAL THE ESSENTIALS:
WHATEVER YOU MIGHT CHOOSE
TO ILLUMINATE WITH A LANTERN
ON A DARK PATH. NIGHT IS
A SACRED QUIET, INWARD-TURNING
TIME. IT'S A TIME WHEN WE'RE
RESTORING AND PREPARING FOR
MORNING BUT DAYLIGHT CAN
FEEL YEARS AWAY.
 THE DARKNESS CAN SCARE,
 COMFORT, AND REVEAL.

The Loneliest Goddess

I pretend to hate the end of daylight savings time in the fall, to go along with the ethos of the city, which values long, luxurious days that end with rosé on boisterous patios at sunset.

But I secretly love it.

The sudden abundant darkness feels like a blanket around my heart and mind, keeping them close and snug so they make decisions together as a loving team.

I love how much I notice in the dark. When light has washed the city, some really marvelous sights have a harder time standing out—like the flickering neon Neil's Coffee sign on the Upper West Side, which was not made for summer.

I also was not made for summer. Even as a child growing up in the perpetually

damp Pacific Northwest, I'd silently celebrate the last drips of light in September and relish the moody purple that was about to dominate the sky for the next six months. I'm content for the air to be a bit cold, the sky a bit dark, my mind-set a bit melancholy. Perhaps because I've always felt somewhat lonely, it feels comforting when the weather and the days cooperate and affirm that feeling instead of ushering me outside to that boisterous patio.

◐　◐　◐

In Greek mythology, it's the journey of the goddess Persephone from earth to the underworld that marks the beginning of winter. Persephone was a carefree teenager, effortlessly adored and blissfully ignorant to pain; her home was the wildflower fields of Mount Olympus and her mother, Demeter, goddess of the harvest, provided her with more than she ever needed. You probably knew a girl like this in college—she was the sweet, naive volleyball player with the photos of her family's beagle and cheerful quotes on her mini fridge.

But Persephone's sunny and stable world was shaken when, unbeknownst to her, her father had arranged for Hades, the God of the Dead, to take her to the underworld to be his wife. Persephone was out picking daisies on a bright summer morning when Hades violently ripped her from the field, kidnapped her, and carried her down into a pitch-dark abyss she didn't know existed. He held her hostage, told her she would never see her mother again. A traumatized Persephone was forced to scrape the bottom of her shallow barrel of resourcefulness in order to survive, to keep going.

Hades only released Persephone when the grief-stricken Demeter threatened to bring famine to earth. But before Persephone left, he fed her pomegranate

seeds—binding her to the underworld forever. The seeds sentence her to spend half the year with Hades underground, causing the colder months on earth as Demeter mourns.

◊ ◊ ◊

The first time I ate a fresh pomegranate was in Granada, Spain. I had just left the frigid east coast January for a drizzly Mediterranean winter, and I was enamored with this jewel of a city that looked even more otherworldly in the thin fog.

I had gotten off the plane hours earlier, and was now trying to conquer jet lag by orienting myself in the mazelike city. Many of the main streets were actually cramped alleys, illuminated only by barely functioning lanterns. Even the least woo-woo of my friends who had visited admitted that Granada seemed like a city dominated by ghosts. The January drizzle made the city feel even heavier with ancient stories.

I stopped and bought one of the inhospitable-looking fruits from a vendor at the weekend bazaar, his wooden crate of fruit hidden behind a pile of Moroccan rugs and a display of copper teakettles on the ground. It seemed like the perfect time to try the fruit for which Granada was named, and I had nothing to do that first day but wander around my new home for the next three months.

The vendor sliced the fruit in half for me, and some of the seeds spilled out onto the street below. I could easily see why pomegranates symbolize abundance in so many cultures; it was like a treasure box had just opened to release a thousand ruby beads. "Gracias," I said while licking the juice that was running down my arm.

I was in heaven.

Two months later, that heaven felt like a lifetime ago as I lay on a stiff twin-size hospital bed. The scratchiness of my gown, the sweltering temperature of my room, and the intensity of my pain all competed for top contributor to my misery. I thought about the tangy-sweetness of the pomegranate as I ran my tongue around my mouth. At that point, I was mostly paralyzed below my neck so I moved wherever I was able.

My gums tasted bloody after not being brushed for a few days. The nurse had left my toothbrush in a ziplock bag in the emergency room, and when I asked if he would go get it for me, he laughed at me. "Oh poor girl without your toothbrush," he fake-cried. I guess it seemed absurd to him that a person who couldn't move her hands would also want clean teeth. "Sorry," he smirked, "the janitor already threw it away."

There is no comfortable position to be in when you're paralyzed. I never realized how many small bodily adjustments I made while I sat or slept until I had to have someone do it for me. Even if I had a nurse assigned to this one task, they wouldn't have been able to keep up; it was a full-time job that exhausted even my mom when she came to visit.

Without the usual comforts of internet, TV, or socializing, the hospital-bed-bound days seemed endless, but at least the relentless pain that felt like an iron rod hitting my back at all times made the hours somewhat interesting. It sounds absurd, but I was grateful for the stimulation of excruciating nerve damage; otherwise I would have just been lying there thinking about my situation, which was the last thing I wanted to do. Pain was something to focus on, to work through. It felt productive, which made me feel alive. Saying "I'm in a lot of pain" was a more

satisfying answer than, "I've been staring at the grey ceiling for five hours dreading the rest of this day and the rest of my life," which would have been the truth after the afternoon dose of industrial-strength painkillers.

Night fell without much pain, but instead brought the hellish task of using all my paltry strength to scoot myself into some kind of lying-down position, which would inevitably tangle my one sheet and slump my body weight onto one arm, which would then tingle all night. I'd find myself jealous of those who were completely paralyzed and numb; at least they didn't have to feel the physical effects of their affliction. Then I'd hate myself for my envy and cry myself to sleep. After successfully escaping into slumber, a nurse would wake me up in the night for a test and I'd begin crying again, frustrated that I wasn't allowed this one respite, frustrated that this interruption involved me having to speak a foreign language.

But the mornings were the hardest. I'd wake up hoping to feel some miraculous change that occurred overnight, but instead I'd face another *Groundhog Day* cycle of peeing in bedpans, begging for an adjustment, screaming for painkillers, crying for my mom, reliving happy memories, and fearing I'd never have that kind of joy again. How was I supposed to have any joy after knowing this level of loneliness, this dramatic separation from the world? I felt like I was as close to death as you could get without dying.

◊　◊　◊

Some ancient Greeks considered Persephone to be the bringer of death. When she descends into the underworld every year, she takes with her the abundant life of spring and summer. Her descent initiates the harvest season, the in-between. While she walks the long, twisting staircase to the underground, the

earth's bounty begins to die. Her journey between worlds is concurrent with the season of smoke, shivering, and the demise of evening light. It mimics a poetic interpretation of suffering: the place between life and death.

What must be going through her head as she takes this journey? She relives trauma, she misses her family, and yet she returns to something she knows well: darkness. Perhaps her mother and her friends insist that she is strong, but she has no choice but to be brave.

In my heavenly healthy January days in Granada, before I became ill, I'd sit in elegant Art Deco cafes on rainy nights, sipping the famed Spanish thick hot chocolate that needs to be scooped with a spoon or the end of an oil-crisped churro. I hadn't bought data for my phone—something I'd regret later while sitting mostly paralyzed in a foreign emergency room for twelve hours—so I'd be able to fully immerse myself in the books that took up half my suitcase.

One was a travel memoir from the 1950s about a journey through Andalusia, with a loving chapter about the wonders of Granada. Back then the Arab and Roma influences were even stronger, and they brushed the Spanish city with Islamic architecture, street flamenco, and saffron-infused dishes.

The memoirist wrote tenderly about attending bullfights and his ambivalence toward the beloved local custom. I found it so sorrowfully amusing when he noted that, quite often, a bull would enter the ring as though it were a new pasture and attempt to nap or to graze. In all their physical power, bulls aren't particularly violent, and have to be prodded into the fiery passion that we see displayed on old posters and in cartoons. Like most of us, they don't want to fight. They would much prefer to sit down and enjoy a nice snack of grass.

"You're so strong" is something one hears a lot during times of suffering. It's

definitely my instinctual response when a friend reveals a bout of terribly bad luck. It seems like the encouraging thing to say, a recognition that the person is capable of handling misfortune with aplomb—perhaps because they've had to many times before. But it can fall on the ears of the sufferer the same way a bull might hear "You're so strong." Even if you know you're powerful, sometimes you don't want to be strong. Sometimes you'd much prefer to just sit down.

<p style="text-align:center">◑　◐　◑</p>

I wasn't strong. Every morning I would wake up and cry, and cry until I could sleep. I would throw tantrums to the doctors and anyone who would listen, begging them to help me get out of this darkness.

My body desperately ached for a massage, my only goal at the moment and often the only desire keeping me going. The nurse would tell me every day for two weeks that the therapist was coming, just a bit backed up on clients. I'd wait for hours, my muscles stiff from stress and sore from immobility.

One day, in one particularly bold moment, I finally asked my doctor, "Is the massage therapist ever going to come?" She shook her head no, the therapist wasn't licensed to work on non-European citizens.

I seethed. "Every day I wait here, all day long, all day waiting for the therapist." I was limited by vocabulary so made up for it in volume and tears. "It's the only thing I want, the only thing, the only reason I feel like I can live right now. And you say 'Tomorrow, tomorrow, tomorrow.' But now you tell me she's never coming. Why can't you give me this one thing? Just make it happen? This one little thing? Do you see what I'm going through? Why, why, why?"

I had no Spanish words left so my plea devolved into sobs. My useless hands couldn't wipe my eyes so my eyelids collected minutes of tears, and after the doctor nonchalantly stepped out of the room, I thought I might have blinded myself.

I yelled out for my mom, who had gone to have lunch, and yelled for the next half hour until she came in. I switched between gentle whimpering and gasping so hard it hurt my lungs.

"How dare you leave me?!" I screamed. "I can't even get my water, I can't get my ChapStick, I can't do anything by myself! I can't go to the bathroom, I can't get comfortable, I can't reach my nurse phone, I can't move! Why would you leave me? Don't you care?" I'd never raised my voice like that at her, and she looked devastated.

"Why is this happening to me?" I howled. Again I shouted, "Why is this happening to me?" I shook the bed and hoped the whole floor heard. I hoped the world, the sky, whoever was out there, could hear the roar of my suffering. My mom began to cry.

◦ ◦ ◦

When Persephone goes back to the underworld, all Demeter can do is watch her daughter and wait for her return. Even as a deity, she is powerless.

I wondered many times during those days how anyone who has suffered can believe in God. If we are supposed to believe that the creator of the universe loves us, why would he allow this kind of pain? No religion made sense of it, nor did any secular belief system. Pain seemed like such a cruel and purposeless part of life, it made me even question the purpose of joy. How can we be happy in a world that also holds all this? Even as a goddess, perhaps Persephone wondered the same.

One evening as I was drifting in and out of sleep while waiting for dinner, a chaplain came into my room. He might as well have been the Grim Reaper. Nothing is quite as unsettling when you're in the hospital as an old man with a collar and an opulent rosary coming to visit your bedside.

"Hello, Mari?" He read the sign on my nightstand scribbled with my diagnosis and prescriptions, then looked up. His sweet smile quickly put me at ease; he reminded me of the kind of man who would host a children's television show. "I'm just here to say hello."

He knelt down beside me and reached out to touch my shoulder. Except for my mom, I hadn't been affectionately touched in so long. The many touches I had all day were all purely functional—lifting me during the daily aggressive sponge bath, stripping me and sponging me, moving my body around to use the bedpan, feeding me as though I were a farm animal.

His hand felt so nice.

"You're not from here, right?" he said slowly so I could understand him.

"No." I shook my head. "I'm from the United States. I was here on vacation . . ."

The chaplain laughed. "Fun vacation!" So I laughed too. It felt wonderful to laugh, like my body was lighting up.

He softly said, "I know, I know what this is like. One time, many years ago—you weren't born yet—I was on a mission to Cuba. Oh, I got the worst stomachache for a whole week! I could hardly stand it, it hurt so bad. And I was all alone, in a foreign country. I couldn't even eat the good food! It was so scary and so lonely . . . but I spoke the language. So I'm sure you're having a very hard time. I'm so sorry."

His anecdote was a life raft. He knew this exact feeling and he had survived it, and now he was happy. How simple, how profound. No medicine could have given me more comfort.

When Persephone ascends to her beloved Mount Olympus, the earth softens into spring. Her friends and mother are thrilled to see her again, but for a few weeks she seems distant, as though she's not fully back above earth again. They get confused when her lighthearted personality turns depressive, and when she excuses herself from gatherings in order to be alone. She is used to the under-world by now, but it's not where she belongs. There she is the Queen of the Dead, when she was born to be a joyful life-loving maiden frolicking among the daisies. But she has trouble frolicking when she's back home in the sun, because she's always in touch with the darkness.

It can feel like a burden, but her gift is her ability to recognize darkness in others—the bits of the underworld that so many people carry with them. Be-cause she lives there, she can speak about it intimately. When she talks to these underworld-carriers, they may not know her full story and are surprised by how well she understands them, how much she can intuit from just a few words and a couple of tears. They are also surprised by her simultaneous levity. As the God-dess of Spring and the Queen of the Dead, the two worlds are integrated in her soul. She can speak about loss, devastation, and trauma as easily as she can dis-cuss daisy picking and cherry blossoms.

That day, the chaplain and I talked for a bit about the best food in Spain and his favorite vacations, and then he prayed over me, asking God to comfort me and heal me. His hands stayed on my head through the "Amen" and I longed for them to stay through the night.

"Thank you," I whispered, and drifted back to sleep.

How lonely it must be for Persephone to explain earth to Hades, and the un-

derworld to earth. She probably feels a Stockholm-syndrome-esque bond with Hades that is hard to convey to her fellow goddesses. She certainly aches for earth while in hell. But I have to think she has developed immense compassion and empathy for mortals who have dipped their toes in hell, and even for Hades who shows brief moments of humanity. I have to think that she falls deeper in love every spring because she really understands winter. I have to think she is continually transformed by the darkness she knows all too well. I have to think this, or all this darkness has no meaning.

I FEEL LiKe I
TiP-ToeD iNTo A RooM
That MoST of uS NeveR
HAve AcceSS To.

IT WAS SO SCARY THAT I'M
SURE IT WASN'T MEANT FOR ME
TO SEE.

NOW I LIVE IN A BEAUTIFUL,
LIGHT-FILLED ROOM, BUT I
CAN'T SHAKE THE MEMORY
OF WHAT I SAW.

HoMeSicK

O n the Lower East Side of Manhattan there's a rest stop for migrating birds. It looks like a sculpture, composed of rectangle wire blocks with thousands of plants that provide food for the travelers: swamp roses, dewberries, and buttonbushes.

The Atlantic Flyway—a kind of highway that takes migrating birds north from their southern winter homes—carries hundreds of thousands directly over the Manhattan skyline. How confusing it must be for these scarlet tanagers and Blackburnian warblers to soar over concrete and poles, not exactly sure how to find food among the rooftop parties and bar patios, fire escape ladders and bodega awnings. The landscape is as foreign to them as a jungle or the tundra would be to me. I can admire it, but how would I survive in it?

I wonder what sorts of conversations the birds have when they arrive in Manhattan.

I imagine them all disoriented and nervous-brave, like people on the reality show *Naked and Afraid* who have to face the Nicaraguan wilderness for a few weeks with only a machete and some matches. They always end up in tears or in a big fight and have to be rescued by a production assistant in a canoe, wearing a fanny pack and a walkie-talkie. The birds go about their fate with a bit more dignity, at least so it seems from afar.

I wonder what they think when they land at the rest stop. Are they fooled, like, "Oh wow, this feels just like the Everglades?" Do they think it's funny to see patches of familiarity in this alien landscape, like seeing a McDonald's in small-town Europe? Do they smirk the way I would if I saw a Sephora in the middle the desert? I have to wonder what goes through a Louisiana waterthrush's brain when he stumbles upon winterberries or beach plums on Houston Street. Is it more relief or bewilderment?

Not to mention, what do they think about the other birds there? Is it like when you think you've discovered some cool underground dive bar, only to return with your friends the following weekend to find all of NYU there? Like, "Guys, I swear it was really cool last Saturday . . ."

Is there instant camaraderie with the other birds or are they skeptical of each other? We lump all the migrating birds together without much acknowledgment for the diversity of their homelands, destinations, and community customs. It reminds me of one of my biggest complaints about being a child: "Just because we're all the same age doesn't mean we get along," I'd rationalize while protesting my banishment to the kids' table.

Occasionally I'll sit on a bench in that little Lower East Side plaza in the morning and just watch the birds peck at the berries or fight over a milkweed blossom. In all their bright colors and patterns, they look incongruous in the foreground of the knish bakery and the nightclub that won't open for twelve more hours. But then again, everyone looks a little incongruous in New York. Even though it's a grand accomplishment of humanity, the city has such a strong spirit of its own that humans look a little pathetic within its towers and shadows. We built this, but it makes us look puny.

The birds don't look puny, but they don't look like they belong. Then again, who looks like they belong in New York? Really, who is your exact vision of a New Yorker? The refined dames of the Upper West Side who waltz through The Park with two basset hounds named Dolce and Gabbana, wearing sunglasses on an overcast day and a leopard-print cloak? Or the construction worker who stands outside your yoga studio, catcalling every woman who walks by in leggings? Or the stylishly disheveled artist whose parents send her rent money every month but pretending she's broke gives her more cachet? Or the manicurist who lives in Jackson Heights? Or a Baltimore oriole who stops here every year on his migration up north? He's spent more time in Central Park than most born-and-bred New Yorkers, that's for sure.

Something I love about New York is that nobody belongs here, so everyone does. In my experience, the only people who don't feel like they belong in New York are people for whom belonging was never an issue. They don't get why it's so important to have this place, because having a place was never difficult for them.

The people who don't belong are people I connect with immediately. I don't

necessarily mean the outcasts; even outcasts tend to find their own community of outcasts. Punks? Anarchists? People who are really into role-playing games in the forest? They have their people. I'm talking about the people who don't know who their people are.

◐ ◐ ◐

I recognized Henry right away because he didn't look like he belonged anywhere.

It's something that I've always seen in others over time, but now I can recognize it rather instantly. It wasn't a matter of strange appearance; Henry is blessed with high cheekbones and a sharp jawline that could easily put him in the movies for life if he were so inclined, plus—quite unfairly—an abundance of black curly hair that leans in the correct direction. He can push it back like a '50s heartthrob while talking and it easily cascades back into place above his eyebrows. His presence is striking, but he offsets his Timothée-Chalamet-esque good looks with playful clothes, like French striped shirts and rolled-up trousers over Chuck Taylors. Scratch that, the clothes make him look even more handsome.

It was a very 2018 friendship: Henry and I met over Instagram and I spent at least an hour going through his witty captions and photos of a seemingly enchanted life: summer trips to small French towns and coupes of champagne with his family at Christmas. They were like people Evelyn Waugh would have written about. Henry himself reminded me of a poet you'd read a biography about a hundred years later and wish you could have met and befriended. But lucky for me, I could meet him, because he lived only a flight to London away.

Henry was going to stop in New York on his way to a California wedding, so we made plans to meet up at a wine bar by way of my apartment. It's always a little

weird meeting Online People in the less curated world, but anything I could have projected onto Henry was surpassed when I met him and his face was hidden by a huge bouquet of pale blue hydrangeas. When he stumbled to awkwardly cradle them and reach out his arm for a hug, I was overwhelmed by the splendor of his hair-face-stripes combo.

So it wasn't the appearance that hinted at his outsider status; he'd be the toast of the town in any town he was in. I still can't put my finger on it, exactly. He just seemed different from other people, and that's how I knew he was my people. Even his accent was untraceable; he has that gorgeous London cadence that makes him sound a bit older than his twenty-five years, peppered with classic British slang that even I could tell was out-of-date. Perhaps his speech was a tad anachronistic, even though he easily broke into spoken internet acronyms and used "like" all over the place—as much as anyone I'd known from California. Yeah, I couldn't place his way of talking or his mannerisms; they were completely his own.

For me, the feeling of falling in love mimics the feeling of creating my own little world, not unlike the ones I made as a kid out of wooden blocks and teddy bears with their own social hierarchy. I am drawn to the weird ones, but not the weird ones who have found their own group, their own weekend takeover at the local convention center. No, I am drawn to the ones who can comfortably navigate any social situation, but, like me, seem just distant enough that I know they are more observers than participants.

When I date a weird one, sparks fly. We form a world to ourselves, one that (exhilaratingly, intoxicatingly) no one else understands. When I think about my exes as a collective, I imagine all the little worlds we created and then left behind, just hoping that someday, someone might be inspired by the ruins.

Meeting Henry, a weird one, felt like falling in love, but without the complications of romance. I caught myself listening to a buoyant pop song one day and instead of my mind throwing a dart of affection at a love interest or lost love, the affection landed on Henry. In a short amount of time, we had created our own world, which we filled with our favorite songs (Taylor Swift, Frank Ocean's cover of "Moon River"), books (Keats, mostly), and flowers (hydrangeas, tulips). We expressed feelings to each other that only we seemed to understand, and developed a series of ongoing conversations and jokes so that our texts quickly became indecipherable to anyone else.

Of Henry, I said what I wanted to say of a romantic partner: I've never met anyone like him before.

<p style="text-align:center">◐　◐　◐</p>

I never quite click with any subgroup, culture, or subculture; I always wind up the odd one out, even in the groups of odd ones out.

In any gathering of people, I'm always a bit removed, as though it's my job to narrate the whole thing like a secret reporter. Sure, I join in conversation and enjoy myself, but another part of me is leaning against the wall watching my own mouth speak and laugh.

When I meet someone else like this, someone with the drifter/wanderer/reporter gene, I don't narrate anything. I just talk. No side monologue, no observations to mentally note.

For someone who has never quite felt at home among people, meeting another weird one feels like setting down my keys, taking off my shoes, and plop-

ping down on a couch as someone asks if I want red or white, then tells me they're in the mood to watch a movie tonight. Let's add a fireplace to this image while we're at it.

The Greek goddess Hestia's relevance has declined over the years, as she is the goddess of the fireplace, the *hearth*—a word that has nostalgic meaning to us, though probably no practical implications, unless of course you're living in one of those wonderful communal living spaces in Finland in which you gather every evening with your kin to the hearth to sing folk songs and whatever else happens in utopia.

Hearth is the name of an Italian restaurant near my apartment in the East Village, and its candlelight and warm exposed brick create an atmosphere that suits its name. When I think of hearth, I think of coziness, familiarity, and, of course, the indefinable feeling of being at home.

The Latin for hearth is *oikos*—the origin of our word "focus," of all things, which proves the significance of the hearth to ancient Romans. The concept that connects a fireplace to focus is centrality. Family and emotional life centered around the hearth, so much so that it was the focal point of the house, the community, the evolving culture. I imagine warriors and wanderers feeling immediately at home when warming themselves at the hearth of an inn or a hospitable stranger's living room. They probably got to know each other over the hearth, and passed down essential stories. A hearth seems like the appropriate setting to reveal secrets, or announce in a whisper "I'm pregnant," or mouth the words "I love you" for the first time. The hearth is a good place for gossip, for grief, and other expressions of shared humanity. A hearth is not a place to look at your phone. A hearth gently commands your full attention.

Attention.

Henry and I finally came up with the definition for love. You grow to love something when you give your attention to it. We talked about how, one week, you don't know a certain person even exists. Two weeks later, all the rapt attention you've given to their texts, their feelings, freckle under their right eyebrow, starts to feel like attachment. Three months after that, walking with this person in a foreign place feels like walking with a home by your side. With enough attention, you can know the rise and fall of someone else's breath like you know the contents of a special shoebox under your bed. This person, nonexistent to you at one point, now smells and feels like home.

Attention: Another word for focus. Focus: an ancient translation of home.

A boyfriend once sent me the F. Scott Fitzgerald quote "With people like us, home is where we are not." We were both drifters who had no attachment to any one place in the world, and we shared this intensely bonding outsider status. Therefore, we needed each other, we depended on our created world.

I believed home was something that happened to you, and it just wasn't in the cards for me. Some people have it, some don't. I don't, my boyfriend didn't— therefore, instant bonding. I thought for this tribe of wanderers and narrators, we'd never really have home and ease except with each other, and there was something untouchably romantic about that concept.

It took me a long time, and many different homes, to realize that a home isn't something you're born with. There's usually a spark of recognition or affinity for certain places like we have with people, but making a home from one of those

places requires as much attention and focus as it does with a romantic partner. It actually takes effort, even discipline.

When people ask me for friendship advice, I tell them that you have to treat it like a job, because it is. You'd think that when you really love someone, caring about them should come easily and naturally. You should naturally remember to ask about their new dog or their upcoming trip to Croatia because that's what happens when you love someone. But showing up is a discipline. Focus, especially for anyone who is easily distracted by birds and mint chocolate chip ice cream and cute guys and the paint color of the wall, is certainly a discipline. Giving your full attention—particularly to one of the more chaotic modern symphonies—is a discipline. So it would stand to reason that creating home is a discipline too. In many ways, it's much easier to keep roaming around than to nest.

◐ ◐ ◐

There's a line in the 1994 movie version of *Little Women* that resonated with me so much when I first saw it in fifth grade that I paused, rewound, and played the scene until I could copy the full dialogue into my journal. "I love our home but I'm just so fitful I can't stand being here. I want to change, but I can't, and I just know I'll never fit in anywhere."

Jo thinks she'll never fit in anywhere because she doesn't feel like she belongs in Concord, Massachusetts, in general. But she finds home in so many other places: among writers, with her sisters, and at her writing desk, the things to which she devotes her attention.

During the spring, I incorporated the migrating-bird rest stop into my morn-

ing routine. I'd walk down to the grocery store, get a small coffee, and sit on the bench and just watch the plants dance a little in the breeze, like they were middle schoolers too afraid to really let loose on the dance floor. I was almost always the only one there as sunlight began to spread across the plaza, and of course I romanticized it as a sacred moment in which I was directly and solely communicating with nature.

Over time, it became pretty clear that the birds were not mistaking this little sculpture for a meadow. It was never an entire flock who descended upon the plants smooshed into wires, but a few at a time who cautiously pecked around it, then flew away over the nearby gym and rows of tenements, which had served as insufficient shelter for many people who surely never felt completely at home here either.

But these birds are migrants; by the design of their species, they will never feel fully at home anywhere. I think about how they might view these rest stops—to me, they seem so artificial and insufficient, but maybe the reasons a lot of us feel at home would seem artificial and insufficient to anyone else.

The reason I feel at home in New York is not because I can easily find my way through all five boroughs and I love every second of being on any subway and I have fallen in love with each building. Obviously, it's a set of specificities that ground me, and make me feel like I belong.

Ask someone what they love about their best friend, and you might get an answer so vague it sounds like they're making things up. "Uh . . . she's . . . a good listener? And fun? And . . . she has curly hair?" The more you love someone, the harder they are to describe in general. When I talk about what I love about New York to someone who's never been, I sound about as informed as someone who's never been either. "I love the energy. The buildings? The people. You

know, things going on all the time. I guess." I begin to think, "Do I actually like it at all?"

But ask me about the specifics to which I give my attention: my morning walk, my favorite martini bar with the live jazz band, the collective flapping of pigeons as they descend on Union Square, and you can't get me to shut up. It's too hard to pay attention to a whole city, so I don't love it all. I love East 9th Street, and I love my neighbor Michael's guitar playing, and I love apartment buildings that are painted black, and I love that there are five options for flamenco lessons within walking distance of my place. Those are the things that yank my attention from anything else.

I thought that home was something that just happened to you because that's how it's talked about. Some people are able to articulate what they love about a whole city! The answers might not make total sense; I've heard "Chicago is a city of neighborhoods" a thousand times and still don't quite understand what distinguishes a city of neighborhoods from a city of . . . not neighborhoods? But people seem satisfied with that, and they're happy to stay there the rest of their lives.

But if you're one of those drifter-wanderer people, the most you might hope to ever feel at home is an artificial and insufficient rest stop that somewhat resembles a place you might have loved in childhood, in the middle of a plaza on the Lower East Side of Manhattan. When you've never felt belonging anywhere, you may find yourself attaching to the most specific places with the other weirdos, like the not-very-chic coffee shop or the floor in between Biographies and Biology in the public library.

To be a wanderer is to always feel a little homesick, with no tools to articulate what exactly you're missing. But we, like the migrant birds, have a secret power: we attach easily as soon as we give our full attention.

To the warblers who fly from the South and rest for a while on the Lower East Side, their entire New York experience is that wire structure filled with berries and bushes; it's their center of the whole city. It's their hearth, their focus, where they come together from the swamps of Louisiana and meadows of Maryland and dewy forests of Panama to gossip, argue, and make this wild city their shared home. No doubt they feel homesick when they gobble up the nectar of Black-eyed Susans, perhaps for a home they've never fully known: a feeling only embedded in their ancestry.

I watch these birds and I think about the eight million people who have found homes in New York: at Tompkins Square Park, at the bodega where they pick up an onion for tonight's dinner, even on the Q train when they see the same mother and daughter every day, and realize in a year that they've seen the daughter grow. All these little homes within a city are every bit as whole and insufficient as the berries woven in wires for birds who have no set habitat.

A few months after Henry and I talked for hours in the open window of a wine bar in the early flush of summer, I went to visit his family right before Christmas. London during Christmastime is, to put it mildly, quite a magical place. We wore our big scarves on walks through the chic streets of Notting Hill and stepped into pastel-colored designer clothing stores with no intentions except to run our fingers along oyster-colored silks and camel cashmeres. We bought a small tree together for the front room, and the family decorated it while I drank sherry from a tiny crystal glass and read the new book I'd bought at a delicious-smelling used bookstore that day. His father added kindling to the fire and the golden retriever used Henry's feet as a pillow.

These glowy, gooey, warm moments did not remind me of a home I recognized

from memory, but from a memory that seemed imprinted somewhere deep in my soul—so they felt more familiar than the home I'd grew up in.

As I watch a bright pink hummingbird, who so clearly does not belong in Manhattan but then again belongs here more than any of us, I hope that it feels that same pang of embedded familiarity I felt in London with Henry, a warmth amidst these soft plants and the ragtag community of other birds seeking solace among the tangled bricks of Manhattan.

"HOW DID I LIVE SO LONG WITHOUT KNOWING YOU?" IS SOMETHING I THINK OFTEN. ALL THE AFTERNOONS I FELT ALONE IN MY THOUGHTS, ALL THE SIGHTS THAT WENT UNNOTICED BY ANYONE ELSE, ALL THE SONGS I THOUGHT BELONGED ONLY TO ME.

I COULD HAVE KNOWN YOU ALL THAT TIME. THEN I REALIZE, MY SOLITUDE WAS FERTILE GROUND FOR MEETING YOU.

THE LONELINESS WAS PREP WORK.
THE SONGS WERE an INVITATION.
THE SIGHTS BECKONED. "THERE MUST
BE SOMEONE ELSE WHO FEELS THIS WAY."
 A TREE MIGHT WAKE UP ONE
SPRING DAY TO FIND FRUIT on ITS
BRANCH AND THINK, "How DID I Live
So LONG WITHOUT KNOWING You?"
AND THE FRUIT MIGHT SAY,
"WELL, WE'VE BEEN PREPARING
FOR EACH OTHER ALL WINTER."

THE SKY'S RITUALS

Celebration and loss are baked into our culture. We have so many rituals for them: champagne toasts, congratulations cards, solemn afternoon funerals, guest books of condolences. But as I've grown up, I've noticed an enormous gap in our span of rituals: marking the sense of gloomy loss that comes along with a happy celebration.

The perfect example is getting married, or even just entering into a relationship. I guess bachelor(ette) parties mark the end of being single, but it's still a pure celebration—there's no space for proper grieving. I don't mean grieving in a sad way. That is, I don't mean sitting around wearing black, crying, and taking one last ceremonial scroll through Tinder, wondering what might have ever been with Dan B. who went to Ohio State and loves tacos.

For example, we rarely honor the solo life as its own, standalone stage—not the *time before meeting The One* but a special, formative, wonderful time every bit as important as time spent in a romantic relationship. If I ever get into a long-term partnership, I never want people to look at this single decade with my own faux-fireplace and my own dinners as the lead-up before my real life begins. This *is* my real life, and I would miss it terribly if I met someone delightful with whom I had to share a fireplace and dinners. I'd want to find a way to mark the end of a season of beautiful solo living before entering into a season of life with a partner.

Another example: Think of the friend who gets pregnant with her first child. While she's probably so happy about this new adventure, this baby also means the end of her current way of life, including her impromptu wild nights out with you. Wouldn't it be nice if, in addition to a fabulous baby shower with no games allowed, we have a special dinner in which we go through all the embarrassing photos we wouldn't dream of posting, and toast with sparkling water to our fun youth, and acknowledge that we'll miss it? Even though she's about to do some-thing important and exciting, can't we also make space for her to miss her old life and for us to grieve as well? I'd really like that.

On the flip side, there are big changes in life that seem like they should be exclusively sad, but sadness doesn't cover the range of emotions either. I'm think-ing of the way that Central America celebrates Día de Muertos, a downright eu-phoric and colorful bash honoring the dead with sweet traditions like leaving out six-packs of a great grandfather's favorite beer. I've never understood why main-stream American death traditions are so . . . drab. And boring. And dark. Aren't we also celebrating a life lived? Dancing in multicolored skirts and bright marigolds and beer all seem like such logical ways to honor the very thin line between death and life, grief and joy.

Or what about life events that have no marker whatsoever? My girlfriends and I often talk about how the big celebrations in a woman's life generally center around her finding a man and procreating, which is why I insisted on throwing a big open-bar party (or "open bar-ty" as it came to be known) when my first book came out. I'd been working on it for years, and therefore it was the longest relationship I'd ever had. Didn't that warrant a new dress and a cheese spread? I felt sheepish inviting people from out of town until I began counting up how much money I'd spent to attend their weddings . . . and I had to stop counting to protect my positive attitude.

What about life events that are much more ambiguous, or even life events that seem too personal to share in a public way, but still warrant some kind of ceremony or ritual or marker? What about the significant life experiences that, for whatever reason, have been skipped over by vocabulary and the greeting-card aisle (though I understand why they're trickier to label)?

For instance, my friend Jumana decided she wanted to have a baby by herself in her late thirties, and dedicated the next four years and countless rounds of IVF and a significant amount of money toward this goal. When it finally had gotten too exhausting and she began questioning her desire for a baby in the first place, she gave herself time and space to sit with the decision and peacefully ended her journey in pursuit of devotion to her community and a different calling. How are we supposed to mark this private journey? What do we call it? It's a tremendous life experience with no name. What a missed opportunity for society.

Couples generally have more societal leeway to be open about their fertility because they're invasively asked about it a lot, though we still don't quite know what to do with it culturally. We don't have any standard ways to honor miscarriage, much less the grief of never getting pregnant at all. A single person has even

fewer ways to publicly mark the disappointments, excitements, beginnings, and endings in this process. There isn't a satisfying range of vocabulary for experiences that are deemed taboo, and there certainly aren't accepted ways to celebrate and mourn the highs and lows.

When Jumana finally completed her journey without anything visible to show for it, she felt like she'd done the emotional equivalent of climbing the seven highest peaks in the world but with no photos, no tangible mementos or souvenirs. If we have the technology to send people on this journey, shouldn't we have the vocabulary to hold them when they return?

<center>◑ ◑ ◑</center>

Every time I take a significant solo trip, I see a flock of birds flying above my head on my last night there. It's become a ritual. I've stopped questioning it because it happens like clockwork: I'm out on the town in Santa Fe or San Pedro de Atacama and I'm feeling wistful about leaving. I'm mythologizing the trip, beginning to mentally weave the funny stories and lessons together with the things I'm currently going through at home, and I decide to look up. And there, right above my head, is a remarkably gigantic flock of birds swooshing across the sky. There are usually so many of them that they look like they're carrying the sky with them, tucking in the clouds for the night with a big blanket of pink. They've ushered in the sunset for me many times.

The reason I decided to go to Spain in the first place was because of the birds. The year before I left, I was walking home from my office job in DC, feeling a familiar pang of longing come up from the bottom of my belly. Something needed to change, but I couldn't put my finger on it. Should I move? That seemed

like the thing to do, but for the first time I really loved my life in this home I'd created, and moving would unravel all my hard work. Or maybe I was thinking about moving in the wrong way. I'd always moved because of dissatisfaction, but now maybe it would serve a different purpose: not the purpose to satisfy, but to expand or deepen. Also, why not? I was single, unattached, and would be quitting my job soon to work on my book. Why not fully lean into this freedom and go away?

I was thinking all this as I passed by the Spanish embassy, a beautiful building, as most embassies are, and one of my favorite landmarks on my commute home. That evening, there appeared to be an art show outside the building, with all sorts of sculptures that paid homage to Spain's homeland hero Picasso. To the side, a long wall had been erected for a whimsical mural. I slowed down and took in all of the art, paying special attention to the mural, which included a bold blue map of Spain. And then I saw a few painted birds over the map. And then I saw that the birds were part of a giant flock. And then I saw that the flock was flying from DC to southern Spain. And I thought, "Okay, I guess I'll go to Spain."

◐ ◐ ◐

One thing that I kept noticing in southern Spain is how few birds there were. There were so many fruit trees and fountains and everything a bird could want, and yet I rarely saw any, especially together.

It made me mad—I felt duped by the mural. I'd flown with those painted birds from DC into a fate of paralysis and agony, and they wouldn't even be there to say good-bye per our ritual.

Birds or not, though, I needed to leave that hospital as soon as I could. I was

sick of being in the stuffy room and uncomfortable bed. In hindsight, I probably should have continued physical therapy for longer. I probably should have moved up the date of my return ticket. I probably should have done a lot of things. But temporary paralysis was uncharted territory for me and all I could do was move toward what seemed appealing at the time: a comfortable bed. Getting back into the world.

Turns out getting back into the world wasn't appealing after all. It didn't mean a sudden appreciation just to be out in the world; it meant tantrums as I clumsily walked up and down slippery hills, going past hospitals and longing to be in one of their stuffy rooms and hard beds. It didn't mean resuming my previous life right where I left off; it meant bizarre weeks outside of the hospital but not yet back at home. Why was I getting dressed up for dinner? Why was I walking down the street? Why was I buying clothes? I asked to continue my recovery in the outside world, and once I was there, I had no idea what to do with myself, so everything felt like the wrong thing, or at least a really weird thing.

◌ ◌ ◌

It was a familiar feeling. When I was grieving the loss of my father, from whom I'd been estranged for six years, nothing seemed like the correct thing to do. Going to his funeral would be every bit as uncomfortable as not going. Missing him felt as inappropriate as not missing him. Crying felt as insincere as not crying. For a few months, I lived in a constant state of "Am I grieving correctly?"

I eventually decided not to go to my dad's funeral. For one thing, he was a niche-famous guitar player whose memorial would be a public event at a theater in San Francisco. A public funeral—ticketed, no less—sounded like a nightmare in

a lot of ways. After all, it would be completely performative, and the last thing I wanted to do was fake-smile or fake-cry my way through a couple hours of strangers playing my dad's music and talking about him in ways that were completely unfamiliar to me. So, yes, I skipped it. It sounds so callous to say now but it was the softest thing I could do at the time. Still, I longed for a ritual to mark my grief, his legacy, this turning point in my life.

Humans need ritual. We came up with it a long time ago. The first evidence of intentional burial goes back 300,000 years. There's never been a culture that didn't develop its own ceremonies. So why don't we have more alternatives for all these different life scenarios? We're just really going to use a one-size-fits-all way of mourning the dead? People are complex and varied, we don't magically turn into saints the moment we die. Amazingly enough, I didn't instantly adore my father the moment after his last breath. I was still mad. Still am.

I needed a way to memorialize my father on my own terms. I thought that would help me to honor all the good things that he gave me, without faking anything.

A few months after his blizzard-weekend death, DC had begun to thaw and there were little pink buds on every city tree. I decided a spring brunch would be a really nice party to have.

I lived in a cramped studio apartment, so my friend with a house offered her living room. I asked my friend Vasu, who sang in a gospel choir, to perform my favorite song about death, "Swing Low, Sweet Chariot," and my friend Amanda sang a Sufjan Stevens song about complicated grief. I supplied mimosas and fancy pastries from the popular new bakery in my neighborhood, and my friends drank and ate as I told a story about how my dad had introduced music to me through "ABC" by the Jackson Five. I asked a couple friends to do readings: one from the movie *Manhattan* and one from *Mad Men*. These all felt very my dad, and

they felt very me. I gave a short spiel about how scent triggers our memories and let everyone make their own scented water to spray on their pillowcases or in the air of their homes. I don't know why, but it seemed like the thing to do.

This was ten billion times more meaningful than attending a public, ticketed funeral for a version of my father I didn't know at all, but people still harshly judge me when I say I didn't go.

<p style="text-align:center">◖　◖　◖</p>

On my final night in Spain, I took myself to the rooftop of an expensive hotel for a glass of wine overlooking the city. I felt defeated. I was leaving on the strangest possible terms: resentment, regret, and longing.

After a second glass of wine at the rooftop hotel, I left to prepare for my early flight the next morning. The streets were beautiful this time of night, glowy and full of people who appeared to be in love. In fact, the lovers dominated the whole town, and everyone else catered to them. Even I felt like a sort of prop for honeymooners, just someone to add a bit of bohemian atmosphere to their cocktail hours—the girl alone in the flowing dress, writing in her journal.

I took the long way back to my Airbnb, cautiously picking up each foot and placing it on the uneven road before me so as not to trip. At occupational therapy, I learned strategies to "trip well" because they knew I'd be doing a ton of it in the following months, and steep streets certainly didn't help. I missed being able to just traipse down a block that looked intriguing without having to assess its level of walking difficulty.

Tomorrow I'd be home, with my mom again. Over the weeks in my hospital bed, I'd become attached to the comfort of that reality. At the time I'd wanted to leave

the hospital, but now that I was set to fly back to the States, I clung to the memory of that temporary home: The food was great and the nurse painted my nails to match hers because she could understand why I'd still want to look pretty. Why did I ever want to leave that?

At the same time, I was disappointed. I hadn't gotten the experience I wanted in Spain, and I was jealous of my alternate-life self, the ghost wandering around enjoying flamenco and sangria who would never learn what hospital flan tasted like.

Hanging lights swung above me as the sky darkened to the color of summer berries in front of me. I scooted myself up on the low wall that hugged the sidewalk and watched the clouds thin out in the background of lovers going to or coming back from dinner.

I felt almost smug at the absence of those unfaithful birds.

○ ○ ○

A nice thing about the concept of ritual is that you don't have to feel it in order to do it. A priest friend once explained to me that the beauty of Catholicism, as opposed to more emotionally driven evangelicalism, is that you say the same prayers whether you are into it or not. There is a comforting history there—millennia of people saying the same words in all different states of mind.

She said that Easter comes around once a year, whether you feel prepared to shout your alleluias or not. Sometimes it comes right after babies are born, the sun is out, and bright tulips begin to break through the earth cracked by cold. Sometimes it comes right after a series of massive earthquakes, job losses, unexpected deaths.

The Easter litany wisely and kindly instructs us, "BE joyful." Not "FEEL joyful,"

but "BE joyful." This is the beauty of liturgy and ceremony. Ritual acknowledges that in times of powerful emotion—hurt or elation—we need a rhythm to make sense of our season.

But in the midst of great pain, what is the rhythm? Where are we to even begin? How do you start a life after one has ended?

There are so many moments in life where it can hurt to live, hurt to move, when time seems so inescapably heavy that you can barely think about living through the next minute much less an entire lifetime of minutes yet to be broken into. But having a place to begin, having a ritual that tells you what to do, having to recite the same affirmation every day whether you're in too much emotional pain to speak or not . . . this is how you begin to get through.

"Whether or not you feel thankful," my priest friend says, "the Eucharistic Prayer instructs us to say 'Let us give thanks to the Lord our God,' which folks have recited every Sunday through wars, plagues, deaths, breakups, sore backs, lost pets, terrorist acts, hurricanes, hurtful words."

◦ ◦ ◦

It was getting dark now and I took that as my signal to leave. I hopped off the ledge, wiped the sandstone from my dress, and carefully put on my backpack with my weak little hands that were trying so hard to remember what it was like to properly function.

I took one last intentional glance at the sky, and saw a stray bird swirling around a street lamp. It was a swallow, so it had one of those dramatic two-pronged tails that made a beautiful swooping motion every time it changed direction, almost like the stroke of a paintbrush that had just been dipped in a jar of black paint. I

smiled with delight at how pleasing this image was, and was further delighted to see another bird join the first. They danced around each other like folk dancers in a circle, their rhythm and moves coordinated and dramatic against the sky.

My eyes followed the long tail of the second one, and then, against the last remaining cloud, I saw the most enormous mass of swallows I could ever imagine— larger even than they'd been depicted in paintings or photos. They were all dancing in the same direction as the first two, creating a living abstract artwork in the sky. They dove down, then shot up, then shimmied sideways, then spiraled inward. There were easily a hundred of them, probably more.

I couldn't stop smiling as I watched their elegant dance routine. No one around me seemed to be enchanted with them, or to even notice them from what I could tell. I very quietly and self-consciously whispered "Gracias" as the last several gave me a final encore before following the flock away.

They showed up for me, I thought.

The ritual isn't only to honor good things, but to honor everything. It was all sacred—this too. They led me here and led me out. And their benediction was how I began to get through.

I Have a BuNCH oF LiTTLe DAiLY
RiTuALS I PRACTiCE WHen I
WALK ARouND My CiTY...

I LiKe CoMiNG HoMe To
FiND SoME STRANGER SiTTiNG
oN My STooP BeCAuSe I
KNOW THEY'RE GoiNG To
APoLoGiZe AND I KNOW iT
DoeSNT BoTHeR Me iN THE
SLiGHTeST. So iTS The EASieST
"No WoRRieS, YouRe FiNE"
I'LL Say ALL DAY. EveN So,
THey ALWAYS Seem SuRPRiSeD
AND DELiGHTeD BY THAT
SMall BuRST oF GRACe. I See
THiS AS AN EASY WARM-uP
To FoRGive The BiGGeR THiNGS,
AND ALSo AS A WAY To Believe
iN My owN WoRTHiNeSS oF
EASY GRACe.

The writer Amy Krouse Rosenthal taught her audience to think of the phrase "Always Trust Magic" whenever they see an ATM. These days I imagine it stands for "Abundance To Mari" because I need that reminder.

You can make your own reminders for things you see every day: a bank can remind you to invest in yourself, a walk sign can remind you to keep going, the sight of someone's green juice can encourage you to eat a vegetable, a stop sign can remind you to stop checking your ex's Instagram.

DAWN

MORNING IS a SYMBOL
OF RENEWAL. AFTER STRUGGLING
THROUGH a DARK NIGHT,
DAWN EVENTUALLY BREAKS.
IT MAY NOT Be THe TiDY
CONCLUSION To THe TOSSING aND
TURNING We JUST SUFFeReD
THRoUGH. BUT iT'S a GiFT To
BEGiN AGAiN. MORNING BRiNGS
a SENSE oF TRiUMPH AND
GRATiTuDe: WE MADE iT!

DAWN GiveS uS The oPPoRTUNiTY
To BeGin BRiGHTeNiNG ouR FuTuRe.

New STARS

y first year after college, I moved to Santiago, Chile, arriving in August. It was the coldest winter I'd ever experienced in my life—and that was after four Chicago winters. Houses aren't heated, and while the outside is cold, it's colder indoors. There's no relief to be found anywhere.

At the risk of burning my bedroom down, I got a space heater that I kept close to my bed all night. I wore two sets of pajama bottoms, a tank top, T-shirt, sweater, and big scarf that I wrapped around me like a mummy costume, plus a floppy knit hat I bought from a small nearby town that said *I love Chile* around the brim. It smelled like sawdust and was the only part of the outfit I enjoyed.

A few days into my time in Chile, my iPod crashed. I couldn't afford a new one and it was my only way of accessing music—until I discovered the piano music I heard coming from the window of a home on my street at night.

I stood there, evening after evening, listening to that piano player for hours on end, shivering as they improvised or played something simple and familiar that I couldn't place. In the window the music came from, there was a small ceramic vase holding a Chilean flag and an American flag like two droopy flowers. I imagined the inhabitants were a married couple, that the piano player was the American husband, and the familiar songs were familiar only to him and me—that in this foreign place, we shared a bond (even though he'd never know about it). I left him a note after several weeks: *Thank you for the free concerts.* The next day, I saw that someone had taken it, but it frustrated me that I couldn't be sure whether it was really him or the gardener or his Chilean wife, who was actually the American and maybe even the piano player.

I didn't want to stare into the window while the mystery person played, so I took my eyes elsewhere: to the sky. Nighttime in Chile looked completely different. The stars seemed farther away, not the way they looked on Pacific Northwest hilltops where they lay out right before you so it feels like you could scrape your fingers across the dark and collect them under your fingernails.

Out of habit, I searched for my touchstones—the Big and Little Dippers. When I was little, my dad would point them out as we walked from the car to the house at night. Amidst the sound of the closing garage door, he'd hold me up toward the sky and point. "Do you see the Big Dipper? And there's the Little Dipper . . . Daddy and Baby."

I couldn't find them. Oh right, I thought, I guess they're different here. It made sense—everything was different here: August was freezing, Christmas would be

sweltering, Easter would mark the beginning of the leaves changing to red and brown—of course children's fathers would point out Scorpius, not the Big Dipper.

These new stars felt like an alternative sky, the B-side.

Not the real thing.

<center>◑　　◑　　◑</center>

Living in a foreign country feels surreal at first, like the real you is still back at home carrying out mundane activities—reading on your same old chair, telling your roommate to keep the oven on because you're preheating it, while the traveling alternate-reality you is hyper self-conscious about every move you make, from negotiating with your new landlord in a foreign currency to simple interactions in a Chilean convenience store: *Do I put the money down now? Should I expect he'll have change for this bill? Is this the water I wanted? Am I saying "thank you" too formally? Am I the absolute worst?*

When I first moved to Chile, my emotions and thoughts kept swirling around in Chicago, clinging to my rhythms of the past five years: dinner at six, autumn in September through November, interactions in English, dependency on a daily soy latte, the ceremonial words from the elevated train: "Belmont is next. Doors open on the right at Belmont," reverberating through my thoughts as a sort of morning prayer of the city at dawn, urban vespers at dusk. That first month in Chile, I felt disconnected from my body, my heart and mind insistent on staying in the season I left.

However, sometime between August and December, I began to follow the Chilean rhythms: dinner at nine, natural pleasure in the ripe watermelon of December, pre-conjugated Spanish verbs pushing their way out of my mouth without having

to think first, an afternoon craving for *miel de ulmo* ice cream or a shot of Colombian espresso, the 8,936 times I'd heard the words from the subway: "Estación Baquedano, lugar de combinación con Línea Cinco." It no longer felt like an alternate life, but the real one.

I'd somehow brought my life to Chile. It was completely by accident—I was so sure I had left it at home. How did it manage to get here without my knowledge? Was it the misty morning when I ordered a latte with chalky soy milk from a vegan cafe called La Chakra and realized that maybe I would be able to contentedly live here after all? Was it when Pilar rushed out to greet me and gave me a discount on my haircut for my patronage? When I finally learned what a "ristretto" was and why it is important to my life? When I realized that a week without talking to a new Chilean friend felt like an eternity of suppressed stories and observations bursting to be released? When I took a walk home and saw the Andes in the spectacular twilight glory, purple and naked against a marbled scarlet sky and instinctively looked for the Southern Cross constellation above them?

◐ ◐ ◐

Christmas in Chile began exactly at midnight—the moment of Christ's birth, as it was explained to me. I wasn't sure if the claim that Jesus was born at midnight on December 25 was a cold hard fact but to my fifty-seven-year-old roommate Cecilia it didn't matter; she smiled and gushed that she loved Christmas so much. On the porch, we sipped pisco with guava juice and I gave Cecilia a basket of spices and herbs wrapped with a bow. "Que liiiiiinda, Mari!" she said with the level of enthusiasm she kept steady all evening, even for some truly awful presents, so I

told myself her appreciation was genuine as she hugged me and gave me copper earrings.

The next morning, I woke up wonderfully sleepy and cheered by the lingering smell of fresh bread from the kitchen, and I shuffled across the tiles in my slippers to bake a caramel apple crisp for our English teacher party. Later, I took my crisp wrapped in tinfoil and my canvas bag of red wine on the Metro. My wine bag bumped into babies and I felt like a big doofus. But a big doofus full of holiday cheer.

When we met, my fellow teachers and I were all in shorts and skirts except for Jonathan, who claimed he could wear pants because he was used to this heat, being from Georgia. "We can't all wear pants when it's two hundred degrees!" yelled Evan, and I laughed a lot.

We drank wine and ate mashed potatoes; we listened to the musicians among us and I felt a little sting in my heart when someone sang, "We'll be home soon; it won't be long." Another sang a Hanukkah song and we clapped and danced. Cookies and presents were shared, and laughter and Bing Crosby were the ambient undercurrent. I got the hot Australian with the long hair as my Secret Santa and he liked my gift of art supplies, winking at me as he began sketching us one by one.

As the day finished, we played catch at the park during the sun's favorite time of day to show off. Heather picked daisies, Vic sang "Ob-La-Di, Ob-La-Da," Seth gave me paper for drawing, Jonathan counted dogs. All was bright. I wrote a letter on the grass and I looked up at the full and healthy trees. Even they were celebrating.

Christmas in Chile didn't carry with it that same need for hope that a twenty-degree windchill Christmas in Chicago demands. But that Christmas was a cele-

bration—a sweet, singing, drunken, happy, rejoicing celebration of family outside of family and of music . . . and pie and paint sets and definitely ice cream, and Jim Carrey movies and sun and a lot of laughing.

I went to bed that night full of apple pie and with a little light inside of me that maybe wasn't the soft hopeful glow of winter but instead was the bright garish celebratory light of the recent solstice, the sort of light that reminded me of all the wonderful things yet to come that year.

Two months later, in the middle of the scorching Chilean February, I visited Chicago. Before I left my mom had emailed me the weather—twenty-five degrees—so I packed my sawdust-scented knit hat. How strange that you can fly to another season. How strange that you can fly to a different set of problems.

"Christmas was good," I told my Chicago friends. "Kind of weird that it's in summer."

"Oh, you mean because it's close to the equator? It was hot?"

"No, it's actually literally in summer—southern hemisphere! Weird, huh?"

"Oh, right. Right. Huh. That is weird."

I told them how the poor Santa had to sit outside in the plaza all day in that suit. I repeated a remark I thought was very intelligent, about how our Eurocentric society burdens the southern hemisphere with its holiday traditions even if they don't match the season. Why isn't Chile celebrating its summer holiday with flower wreaths and watermelon sorbet on the beach? Why force them into velvet ribbons tied around holly and spice cake that only really tastes good near a fire, or at least the idea of one? Why does Santa have to be involved at all, but at the very least why must he wear black plastic boots on a ninety-nine-degree day? I was proud of myself for making this point, but it was lost on my friends who wanted to catch me up on some college gossip instead.

It was strange, having my two lives lined up side by side, like uniformed soldiers guarding a palace. Summer and winter. Chicago and Santiago. North Star and Southern Cross. Real Me and Not-Real Me. I didn't like it.

If Chile Mari and Chicago Mari were distinct people, then which one was the authentic one? I had just heard the Walt Whitman line "I contain multitudes" for the first time and was struck by it, but right then, I hated containing multitudes. I didn't want a blizzard and oppressing heat in one month. I didn't want to feel like one group of friends wouldn't understand the other, and I especially didn't like how hard it was to talk about my new episodes with the old cast.

<center>◐ ◐ ◐</center>

Years and years later, in the summer of 2016, I'm supposed to be preparing for a trip to Australia. Instead, I spend the day before I leave lying on my bed in the air-conditioning, despairing over a breakup and the political climate. It feels like too much. Like my heart and mind are both filled to the brim, flooding with overlapping thoughts and feelings that contradict and make no sense.

Not only do I think about the issues at hand, but my mind flips through a Rolodex of the saddest news stories I've ever heard starting from when I was in kindergarten, plus the fact that my mom won't live forever, *plus* my cat—the only truly pure soul I've ever known—will die from cancer soon.

I fret about the flight: sixteen-plus-five hours. What if I have a panic attack over the ocean? What if there are no good movies? What if I'm seated next to one of those people who slowly eats pistachios one by one, and spends the next hour picking their teeth?

Meanwhile, outside it's too hot. I've been joking that "the weather hurts my

feelings." It makes me mad, and maybe even sad. It overwhelms me and I feel frustrated, and I remind myself it's relentless and won't be stopping soon.

But two days later, when I arrive in Melbourne, I'm shocked to shiver and feel a dramatic rush of nostalgia: black tights, smoke-scented evenings, the orange street lamp glow of an early winter's evening, flushed cheeks and a sniffly nose. Twenty-seven hours after leaving New York summer, I've arrived in winter. It feels like visiting a memory that I haven't yet experienced.

I had no preconceived notion of what Melbourne would be like, but when I see it, I immediately know it, like when you meet a new friend at a party and they're somehow miraculously articulating thoughts you've had all your life but never put into sentences. I love the city so immediately it startles me.

Completely disoriented but determined to stay awake until Australian night, I take a walk to the nearby beach, the dainty and charming St. Kilda. It looks like a scene from a movie about a northeast fishing village, complete with an old man in an elbow-patch plaid jacket reading a newspaper.

A family of women in headscarves are the only ones on the actual beach, running and laughing, playing tag. The littlest one keeps screaming in delight, like she doesn't have enough words to express her own comfort and glee so she just has to yell out a single syllable. An older one runs over and scoops her up, twirling her around so her pink leggings and Velcro shoes dangle over the horizon.

Australians are perfectly aware of the political situation in the US but it is a sixteen-plus-five hour flight and two seasons away. My heartbreak also exists back in New York's sticky summer, but here, my heart feels fresh and new, young and tender.

I can't believe how much can be happening in the world at once: a season of death and a season of abundance separated by a thin line in the middle of the

earth. Not to mention heartache and new love, persecution and freedom to run and scream on the beach, dull errands and dramatic flights across several oceans. Ten years ago while making sense of my life that spanned Chile and Chicago, this duality would have unsettled me. Now I find it freeing: How much else can my life hold besides what I'm experiencing right this second?

◦　◦　◦

In a previous era of my life, the one in which the line running around the earth separated my Chile identity from my Chicago identity, I thought that authentic living must mean This or That. You can only pick one, and that's the correct answer. Are you sad or happy? Do you read the news or celebrity gossip? Is the world a good place or a bad place? Is the piano player Chilean or American? Am I looking for the Big Dipper or the Southern Cross? I spent so much time trying to make up my mind about all of this, unaware of the lush freedom of answering, "I don't know" or "Probably both."

Maybe it is age, or maybe it's life experience, but now I relish uncertainty. Making room for uncertainty, complexity, ambiguity has opened my world and my heart up to embrace beauty, grief, hurt, and delight in the same place, at the same time.

Sometimes when I'm in so much pain I can't think straight, I close my eyes and imagine what's also happening at this same time, in the same world. It seems completely preposterous that I'd be walking through the park aggressively wiping my eyes, as if to force them to stop producing tears, while bumping into families on their first walk with a new baby. Suffering exists here, and music exists here, and they are both real. Summer Christmas in Chile and Winter Christmas in

Chicago, my life in New York and my life in Melbourne, dictatorships and cherry trees, bad presidents and saxophone solos, one hundredth birthday parties and bronchitis . . . they are all real and occur on the same day.

On the flight to my dad's deathbed on Valentine's Day, the plane was decorated with paper hearts. At first I thought, "All this, when my world is falling apart?" Then I thought, "All this, while my world is falling apart." People celebrating romance the same day I was losing a parent. How odd. I pretended the hearts were for me, a dark surprise party of love from unknown sources, accompanying me as I flew to a new version of myself.

When the world feels too heavy for me, like it must be a scam that I ever came to live here in the first place because I'm too sensitive for it, this is what I tell myself: You think the world isn't for you because it's too harsh, too violent, too full of disappointing dates and friends who can't catch a break. Too much "Why," not enough "This." You think you're so sensitive that one day it will crush you—that you will crumble under the intensity of sirens and the poisonous news and the bearded man you love too much.

And you will crumble, for a while. You'll get even more sensitive, so much so that you will actually feel other people's pain, including the lonely stranger waiting for the bus. You will hurt, but you'll also manage to feel excited to watch your favorite show. You will cry on vacation and laugh the day of your dad's funeral and you'll be amazed at how full and whole a broken heart can be. The world may be simpler for people who carry less emotion but it's not only for them, it's for you too. You will break up in New York's summer and learn a new man's name in Melbourne's winter, you will feel excruciating pain in your back as your hands feel blissful from your mother's massage. The planet holds confusion and innocent curious creatures. You will learn that the world is painful and covered in daffodils.

You will find a paper-heart celebration on the most somber flight of your life. You will nearly fall apart and you will also have Christmas picnics in the park and your friend will be playing "Ob-La-Di, Ob-La-Da" on guitar.

When I first learned that there were brand new stars in a different season, they didn't seem real. If anything, they were alternate stars. But these days, whenever I start tumbling into despair because I've decided that my life and the world are headed one way and I can see no other reality, I look at my big world map on my wall and think about those other constellations. I can't see them from here, but they're out there brightening the sky for the other half of the world. They're seeing Scorpius while I'm seeing the Big Dipper. They're crunching autumn leaves on their walk home while my shoes are squishing cherry blossoms. Somebody is mourning and somebody is dancing around the living room. All real, all beautiful, all happening on the same night.

THE NIGHT SKY IS VAST ENOUGH
TO HOLD SO MANY STORIES IN THE
FORM OF CONSTELLATIONS: SOME ABOUT
VOYAGES HOME, OTHERS ABOUT ESCAPE,
MANY ABOUT WAR, AND SOME ABOUT LOVE.

YOUR INNER LANDSCAPE IS VAST
ENOUGH TO HOLD SO MANY STORIES
AND FEELINGS AT THE SAME TIME.

DAUGHTERS OF HOPE

I know people who love turbulence.

These are really, really different people from me.

Counterintuitively, the more often I fly, the more I seem to fear it. I've read all sorts of tips from psychologists and watched videos of pilots, and their suggestions seem so easy when I'm on my yellow couch, feet firmly on the ground, listening to the languid hum of my air conditioner. It's a different story when I'm 30,000 feet up, engines roaring, tray table chattering, as the vessel responsible for my life is swooping up and down above a cloud. I try to imagine the plane as a leaf floating down the river, occasionally swaying side by side or bobbing up and down yet always staying above the smooth, hospitable water. But it never helps.

On a fourteen-hour flight to Rio, we hit rough turbulence that was the worst I'd ever been in. The anxiety of others heightened my fears. Around me, little kids were screaming, and their parents aggressively rocked them while crossing themselves and muttering prayers. The mother and daughter next to me held each other as the mother kept saying "I love you" over and over.

Most people were doing some version of praying, even the man who was just muttering "Please please please" over and over, although it was unclear whether it was directed to the pilot, God, or aeronautical engineering. It seemed clear that the majority were thinking about loved ones in some capacity. I was combining the two: praying to anyone who would listen that my mom would be able to find joy again and that she'd be fully supported during my death.

Along with praying, pretty much everyone was also bonding with others. The guy who had annoyed me with his snoring a few minutes ago was now my ally on this journey to the unknown. We exchanged looks and he nervously laughed, which made me smile, and I felt my nervous system relax just a little. When a particularly violent swoop made me attack the armrest with a clawed hand, the teenage girl next to me did the same, and we looked at each other and exchanged a glance of terror; we were feeling each other's pain.

If you ever want to feel immediately bonded with someone, all you have to do is assume you're going to die together. I'm pretty sure this is the psychological impetus of the many helicopter rides and rock-climbing dates featured on *The Bachelor*.

Of course, a funny thing happened a few minutes after intense armrest-gripping and promises to God. The plane leveled out. The tray table stopped being a per-cussion instrument and went back to being a sad little rest for a sad little cup of cranberry juice. We all annoyed each other waiting for the bathroom once again.

As quickly as it began, the plane stopped being a sacred vessel full of religious converts and turned back into just a plane: a dry, smelly, claustrophobic cabin full of people watching bad action movies and eating crackers.

The cultural narrative is that, following a near-death experience, you'll have a transcendent sense of constant gratitude. You'll live on a higher level than most people walking around being annoyed about bathroom lines and small cups of juice. The little things won't bother you. You'll make holy decisions about money and career—both for the greater good. But I doubt that anybody from our flight to Rio is now living on that level, me included. We probably just fear air travel a little bit more.

That day, when the plane landed, we began clapping, but it wasn't clear if the applause celebrated our survival or the fact that we had just landed in what appeared to be paradise. As we waited for the doors to open, people scrambled for bags while others awkwardly leaned on seats, some looking as grumbly as they would on the subway platform.

A man raised his voice: "Why are you guys stressing? We're in Brazil!"

○ ○ ○

On that trip, *Why are you guys stressing? We're in Brazil* became my mantra as travel crap inevitably happened. You know, the usual: overpaying for a cab, waiting in several wrong lines, getting lost beyond hope of cell service coming to my aid.

I'm in Brazil!

Before I left for the trip, friends and family expressed concern about my plans: "You're going to Brazil. Be careful." It started getting on my nerves. I was definitely going, so it wasn't helpful to have such ominous feedback. My personal stance

on unsolicited advice is that it's pretty harmless far in advance of the anticipated action. When someone has already bought the ticket and is days within leaving, what's the point? Just make them feel good about it. (My mom didn't quite share this stance.)

Brazil was so colorful and cheerful, I couldn't believe what a bad rap it got abroad. It was like an infinity mirror of enchantment and charm, a kaleidoscope of vibrant pink corners turning to reveal three more turquoise houses, turning to show a forest populated with friendly monkeys. After a day and a morning of half-assed vigilance, I started to ignore the advice and the signs to put my phone and camera away.

It happened in broad daylight, in a tourist area, just steps from a police station. Families with children and uniformed cops were walking by, forming a sort of social bubble around me as I was skipping home from the beach with my phone in hand. Embarrassingly enough, I was listening to "Copacabana" because, after a couple oceanside caipirinhas, that song supported the exact mood I was riding on.

I guess you could say that I should have stuck to the main street when I turned into the next neighborhood. But it was the middle of the day, I was surrounded by people. I cut the corner and went down a slightly smaller street. I could still see the police station in plain sight.

A kid lunged out in front of me from behind a rock I wasn't aware of, and he looked so young to me I didn't think anything of it except that he was in my way. He stretched out his skinny arms so I couldn't pass, and his stance reminded me of boys in my high school who played basketball, trying to guard each other from making a shot as their sneakers squeaked on newly polished wood floors.

He gestured to my phone and yelled something in Portuguese. Right. Duh. This is why you don't bring your phone out.

His voice scared me. I softly repeated "No, no, no" thinking about how much I'd be reliant on my phone in the coming days, especially during my trip to a very small town several hours south of Rio. In my shock, I really thought I could win him over with my decisive headshakes. He grabbed my hand, the one holding the phone, and he reached back with his other hand to pull a long machete out of his back pocket or pants. I'd never seen a machete before, and it was a striking tool—glistening in the afternoon sun and intricate with saw teeth and an upturned blade.

Human instinct is totally bizarre. Everyone expects survival instinct to kick in and tell you what to do in times of distress, but from what I know of personal experience, survival instinct is bullshit. A few years prior, I was stuck behind a backyard gate while a floor of my apartment building was on fire, and the smoke was so thick it felt like trying to inhale an object. I knew that I should cover my nose with the neck of my pajama top, but I was frozen at the thought of doing anything more, including reaching in my coat pocket for my phone and at least trying to dial 911. Vague messages from PSA posters and after-school specials came hazily to mind: do I get down low?

In that alley in Rio, my survival instinct was to keep my phone. Even with the knife inches from my face, my shocked mind thought I was supposed to guard my phone over my life. That might sound like a reaction specific to the 2000s, but it's probably more primal than that. I might have done the exact same if he wanted, say, the cup of açai that I'd thrown away a few moments ago. People are likely to guard the thing they're carrying—a sort of endearing leftover from a much more dramatic time in human history when the things we carried were either our only source of sustenance or younger humans.

A sign at the airport popped into my memory right then: *If you get mugged with a weapon, give them your money. Your life is worth more.*

As though I were reading instructions for a much more banal project, I handed him my phone. I even wondered if I should begin emptying my purse of money, but my survival instinct was to get the hell out of there, and the kid didn't seem too interested in making chitchat either. In fact, he yelled at me a word I understood: "Vai! Vai!" And so again I followed instructions and ran away. I kept running until I landed at the police station, where they offered me a paper cup of water and I began to shiver even though it was eighty-five degrees.

"All he took was your phone?" an older officer said. "A guy cut off a Japanese tourist's arms with a knife last week. So you're lucky."

A younger officer, possibly in training since he had a more casual uniform, shook his head and said, "I'm so sorry this happened." His kindness is what made me start tearing up, and I said in pathetic Portuguese, "I still love Brazil." He told this to the old grouch at the desk, which softened him up too.

The young officer, Mauricio, made a lot of hand gestures and spoke in a combination of Portuguese and English to say that he felt bad that all my photos were lost, and insisted on taking me around touristy sites in Rio for the day to make sure I had plenty of footage. The fact that he had an ancient flip phone made this proposition all the more lovable, and I was relieved to get to spend the rest of the day with someone.

Mauricio art-directed about fifty photos until the depleted storage made his phone crash. He even demanded to get my better side, and angled his camera to get a diagonal portrait a la edgy Tumblr photos in 2002. He made corny jokes, which made me laugh, and laughing made me feel safe. He re-familiarized the city for me, helping me reclaim some of it with silly tourist antics and giggling.

When he had to get back to work, I felt a little sick. I almost pleaded with him not to leave me, but realized, in light of the Japanese tourist, maybe I was overre-

acting a little. Or maybe it was completely normal to be shaken up by a kid who held a machete near my face. As with most unusual circumstances in life, I wasn't sure how I was supposed to be feeling.

I told people at home in vague terms that my phone had been stolen, which made me feel more isolated. Now it was a secret between me, Mauricio, and the kid who had taken my phone. It was easy to forgive him. My heart ached thinking about what had driven him to be able to conceivably hurt someone he'd never met.

But easy forgiveness didn't mean easy reconciliation. I was no longer invincible in Rio, although there was an interesting new freedom in knowing that my most valuable possession had been taken, and I'd gotten the inevitable mugging out of the way. Everyone said it would happen, and here, it happened. Now I could move on without the burden of grim anticipation.

Later that afternoon, I attempted a nap but grew restless and took a walk instead. With a change of light, my mood shifted. Not necessarily for the better, but just different. I was now a science experiment unto myself, observing all my thoughts and feelings. Hmm, new freedom. Hmm, new fears. And how might my mood shift with new light tomorrow?

◦　◦　◦

I learned from Brené Brown that the root of the word courage is cor—the Latin word for heart. We think of bravery as being inextricably tied to action: being valiant, riding to war on an armored horse up a mountain with orchestral music booming in the background. We consider it courageous to speak up, cowardly to be quiet. Brave to try something new, timid to say, "Hey, maybe that's not for me."

Valiant to stand up, sheepish to sit out. But if we look to the Latin root of courage, and the early definition "to speak one's mind by telling all of one's heart," it becomes a more nuanced word.

We reward action with the valued word "brave," but inaction can be its own kind of bravery too. Isn't it courageous of a kid who doesn't want to play dodgeball to tell the teacher, "I'd rather sit on the bench for this one?" At least, that's what I tell myself as a thirty-two-year-old adult who is still recovering from the trauma of Dodgeball Day in P.E.

That night, I thought about courage and bravery as I ate a fish dinner at a nice restaurant. By all means, that moment should have been blissful: I had an entertaining waiter, I was seated on a banana-leaf-covered peak next to an unbelievable shimmering city, I was eating my favorite meal so far in Rio, wondering why on earth I never thought to pair fish with fresh coconut and mango. But the sun was setting now, and I felt uneasy. Throughout the day, it was as though I'd been emotionally skinny-dipping in Rio until this point—aware of my vulnerability but completely carefree. Now, at night, it felt like my clothes had been stolen, or maybe just washed down the river. Moments ago, it was exciting to be a little risky. Now I was exposed.

My questionable survival instinct nudged at me to go home, an act that would have been perfectly brave. Or, at least, perfectly understandable: "Just go to bed, love. Watch a movie. Have wine in the backyard." But my heart pulled back like a disappointed kid: "But I wanted to have fun. Getting mugged shouldn't ruin my fun."

As was usually the case in these fights, my brain conceded with a big sigh. "Okay, if that's what you want. Go, whatever. Take a paper map!"

And my heart took me out on the town. In fact, I went to the same neighborhood I'd been mugged in earlier that day, because it was the party neighborhood. Now it was packed with dressed-up people—almost to an unsettling degree. My solitude easily turns into loneliness when surrounded by lots of groups and couples in one place, so I headed deeper into the neighborhood to find a chill bar or more casual club.

A block away, the area became quiet, but as I continued to walk, I began to hear loud music again. I was familiar with the type of music—forró—the country folk music of Brazil. I thought a forró club would be entertaining and fun, like those line dancing bars in Nashville, so I followed my ears closer. When I turned a corner toward the music, I saw a block that had erupted with dancers of all ages, heights, sizes, hairstyles who were tossing back drinks in plastic cups, all following a similar set of simple steps at unsynchronized beats. Children were cracking up as they danced with earnest teenagers; old women shimmied their hips up to twenty-something men, and an old man offered his small hand to guide me into the party. The fact that everyone in Rio seemed to be invited didn't make this personal invitation less special.

I read that the opposite of violence is not peace, but play. When you're curious, laughing, playful, it's pretty hard to summon the energy to fight. My heart must have known this better than my brain. My mind wanted me to go home, do yoga, meditate on love and blessings toward the kid with the knife. My heart wanted me to join a dance party in the streets. I was grateful for its courage.

I didn't know any forró steps, but it wasn't that hard to pick up—at least, that's how the old man made me feel when he brought me closer to the middle of the crowd. Some families had brought their own lanterns and, late at night, the street

was as bright as day. The more maternal women shook their hips over to a teen-ager to deliver him some cheese bread, or two-stepped over to me to tell me that my hair tie was falling out. I felt protected, acknowledged, embraced.

Anne Lamott writes, "Show up with hope." By arriving with the goal of giving hope to others, you create more of it. You create goodness. It's the antidote to despair. Dare to come to the neighborhood cleanup, the rally, or the dance party with an expectation that it will be helpful, and maybe it will. To someone. To you, even.

To the more cynical among us, dancing in the midst of fear or even mourn-ing might seem totally childish or even deranged. They don't realize that what's going on in front of them is very powerful. Smiling, shimmying, and swaying is a triumphant response to scariness. Dancing sends a strong message, even to the participants in a street-wide disco themselves. What's the last thing you can take away from someone? I suppose you could keep them from dancing, but could you keep someone from laughing or experiencing happiness? If someone didn't give you joy in the first place, it's not theirs to take.

Only recently have scientists begun to understand just how miraculously malleable the brain is. I'm no scientist, but I do know that I used to associate "Always Be My Baby" with one person only, and now I can hear it in a drugstore and not think about him at all. Or maybe even associate it with someone else. Memory is naturally flexible. And giving memory more to work with is like taking it to a yoga class.

Psychologists generally agree that we tend to cling to our negative memories more than positive ones, an evolutionary advantage from when we needed to

constantly scan for aggressive dangers. Associating a certain patch of the jungle with a tiger we once saw isn't a bad idea if you're someone who lives outside in the Chalcolithic period. But we're still wired that way for a different world, and now our tigers are a critical email from our boss or getting dumped at a West Village bar or getting mugged in Rio. Our survival-motivated brain says, "Panic when you look at your inbox" or "I hate the West Village" or "Rio is dangerous."

But our inbox is actually neutral territory, good things also happen in the West Village, and Rio is a safe place. Our worst experience with a certain place is not indicative of the overall goodness of the place itself, just like no guy should have ownership over "Always Be My Baby." We don't have to worry about the tiger anymore. Our brains can cover old wounds with new memories.

Showing up with hope means that you're going to give the benefit of the doubt to the circumstance at hand. Maybe we *can* really get Tompkins Square Park clean today. Maybe our protest *will* make a difference. Maybe going out dancing tonight *will* be fun, and maybe fun is what's going to soothe my fears.

◑　◑　◑

I got tired in the middle of the crowd, so I twirled my way to the sidelines and sat on the steps of a closed restaurant with a woman selling cups of caipirinhas out of her cooler. We pointed out the bad dancers and the best outfits, and I ended up telling her that I'd been robbed earlier that day. "*Roubado?*" she asked with horror. "Ohhhh, you *coitada!*" She patted my back with one hand as she summoned her friends over with her other, and a group of plump ladies, each with some sort of sequined accessory, strutted over. "This poor thing got mugged today," she told them, and their faces twisted into inordinate pity. "Just my phone!" I clarified, but

I clearly couldn't argue with their distress. They muttered between them, pooling together snacks and candy for me, handing me one of their coats on a warm night. They asked one of their husbands, João, to walk me home and sent me with a drink and a few hugs each.

St. Augustine said, "Hope has two beautiful daughters; their names are Anger and Courage. Anger at the way things are, and Courage to see that they do not remain as they are." Dancing is the only place where I let myself really express anger (flamenco is especially great for that), and dancing requires at least a little courage. Summoning some heart bravery and letting out your feelings on the dance floor are an excellent prescription for hope, and I had a lot more of it that night after João dropped me off at home from a night of laughing and twirling at the street disco.

That night, I demanded my brain secure this memory: *Let this be how I remember Rio.*

To Live Life To The Fullest
MEANS To :Feel: Life To The Fullest:

FULL PAIN, FULL BOREDOM, FULL UNFAIRNESS, FULL MAGNIFICENCE, FULL MOURNING, FULL LAZY DAYS, FULL JOY, FULL DISAPPOINTMENT, FULL CREATIVITY.

HURTING BETTER

My friends made fun of me for traveling all the way to the Redwood Forest to do ayahuasca, because making fun of your friends for their kooky antics is a love language. I'd never done a psychedelic in my life—I don't even smoke weed—and they started calling me Mari S. Thompson.

I playfully whined "Stoppppp" when they'd tell me scary urban legends about the thick and bitter Amazonian plant tea that was supposed to bring healing visions and revelations to anyone called to "the medicine," as "she" (ayahuasca uses a female pronoun) is known in her birthplace of South America. I was already so nervous.

There's no way in hell I would have drunk a psychedelic tea a year ago, but

there are a lot of things I wouldn't have done a year ago. In 2019, I was on a mission: to heal. And I would use any medicine available to me.

People often don't reach out for help until they hit rock bottom. That's why I tell people to have an emotional "emergency kit," like the kind you keep in your glove compartment in case you're stranded in a blizzard or something. Yeah, you don't need peanut butter and a flashlight *right now*, but they'll come in very handy when your car is half-buried in snow. Likewise, you might not feel like you need a therapist on a given Tuesday, or a strong friend community, or a bookshelf full of Pema Chödrön, but these things are pretty useful when your life is blowing up.

I know all this, and yet I hit rock bottom before I decided to begin healing myself. For me, rock bottom looked like throwing a ceramic parrot against the wall when my boyfriend hurt my feelings. Just to clarify, I didn't throw it *at* him. I'd never do such an unhinged thing. But I did end up shattering it on a wall that was in his proximity, and afterward his face resembled *The Scream* painting, he was so horrified.

I'd met my boyfriend in Australia a few months before, and we had a blissful couple of wintry weeks together while my friends at home were baking in the New York summer. Our cozy romance in the middle of July involved hikes among eucalyptus trees and borrowing his scarf on the walk home. I adored him, and I didn't know him. I loved his accent and his height and the way that he followed me around the east coast of Australia on my book tour. For me, that was enough evidence that I should invite him to spend a month with me in New York.

It was a big, bold invitation, and my friends were in awe of my bravery and the romance of it all. In their eyes, I was taking this gorgeous risk—a chance that perhaps it could be love. In my mind, it wasn't a risk at all because I'd already decided we were in love. For me, it was a trip in which we'd solidify our love and he'd in-

vite me to Australia for Christmas and our children would share his accent. That's where my mind goes after a couple of dates.

During his trip to New York, I introduced him to every one of my friends, and my mom, and all my most treasured restaurants and little corners where the ivy fell on brick particularly beautifully. Poor guy, I was setting him up for disaster. If he didn't respond perfectly to my favorite spots and didn't say the right thing to my friends, I'd be inordinately disappointed. He actually did a great job, all things considered, and always charmed everyone with his accent and sweetness. Even so, my expectations of him formed a cage around his own agency and freedom and ability to be exactly the person he was (whom I wasn't nearly as interested in getting to know as I was the person I desperately wanted him to be).

He still found ways to get out from under the pressure and surprise me, God bless him. One Sunday morning I found myself passing him my section of the newspaper and realized that we'd been quietly reading together for the past hour, drinking coffee from my favorite mismatched mugs and listening to a record he put on, and it was just so *nice*. I hadn't planned that morning and it was by far my favorite of the twenty-eight we spent together. Toward the end of his trip, I felt grateful to have his friendship and knew that, no matter what happened, I'd be happy to have that.

Except, that wasn't the truth at all. The evening of the Ceramic Parrot Shattering Incident, we lay on my bed as I played with his hair and we hopped around the topic of his impending departure by laughing about the hyper bartender we'd just had and the neighbor we could see cooking through his window. During a ripe silence, I asked, "So . . . have you thought about . . . next steps? Like what happens with us when you go back?"

For the record, I was not asking whether we should stay together or not. Re-

member, I was already planning our kids' international education. He'd just met my mom and she loved him. I'd even met a couple of his friends who were living here. I'd paid for so much of his trip, I imagined myself like a cartoon, taking out my wallet and dumping money over his head for a month straight. The question was not "Do you like me enough to continue a relationship?" The question was "When am I meeting your family and what do you think of a City Hall wedding?"

He stumbled over a couple of words and spoke slowly before saying something about "taking it slow" and "seeing where this goes."

Who is going around teaching people these phrases? Of course I'd heard them before, far too many times, and they always hurt in the same place. This time, they came from someone I'd grown to really trust, and I began to panic. That's what it felt like in my body: panicking. I was a wounded animal. I began thrashing around because I was in such hot pain that I wanted to escape it, like how my cat ran around my apartment for an hour after she was stung by a bee.

"Seeing where this goes" hurt somewhere in my insides. I knew there was a wound in there, as some variation of it had happened with every man I'd loved in some way or another my whole life, as much a part of my identity as *Writer* and *Golden Girls Fan.*

It's perfectly reasonable, in hindsight, that a person who lived halfway across the world and wasn't in any rush to commit to anyone or anything wasn't totally sure about his next steps with someone he met only a few months ago. But I heard his ambivalence as rejection. I was in so much seething pain that I had to get up and leave, but not before throwing the ceramic parrot coat hook against the wall. I would have thrown up if I could, or screamed if it wouldn't have upset the neighbors. I wanted to make my surroundings look as chaotic and ugly as I felt. A broken ceramic would have to do.

I woke up by his side in the middle of the night and wrote in my journal:

We've talked every day, took trips together, you've gained exclusive access to my memories, you've met my loved ones, you've received so many lovingly selected gifts—including that vintage blazer which was way more expensive than you think—and my thoughtfully rationed affection. We're not seeing where this goes, okay? It's going, my friend.

You're either showing up to have fun with me, receive and give support, respect each other's agency, spread healing balm over each other's wounds, belong to each other, self-reflect during conflict, and communicate our needs and wants. Or I already know where this goes, and would rather not stay to see it leave from shore.

We stayed together for a little while after that, even when he went back to Australia. He never understood why I got so upset but he had grace for it, which seemed like a good sign. He's a good person. I hope I properly communicated that. But I never wanted to feel that way again, the feeling that makes me want to break things.

The breaking-things feeling arose because of his inability to commit, yes. But it seemed deeper than that, because not everyone would feel like a wounded animal when their hunky boyfriend told them that they wanted to "see where this goes." They might be annoyed, they might even have a little argument, or it might not bother them at all. But because that phrase hit me on such a soul level, it occurred to me that maybe I had a wound to heal, and it would never heal if I kept trying to patch it up with the words and actions of men who exist only in my imagination.

My soul carries around an open wound that I've never taken the time to heal before: the abandonment of a parent who, after all the pain he'd inflicted in life, had the nerve to die. By every account from every witness, I was the light of his life, and then he abruptly rejected me for a reason that has never been knowable to me, and now most certainly never will be. On even my best days, this is excruciating to live with.

My dad was not a monster. Quite the opposite. He was surely the funniest, smartest, most fascinating, enchanting person I've ever met, with the most exquisite collection of vintage cuff links. I can still remember him telling witty jokes at a dinner party and his laughter warming up the room. Of course, I heard this from behind the closed door of my bedroom upstairs, where I'd been banished to go sleep as the grown-ups stayed up and talked over wine, and it made me feel so comfortable and safe: my two beautiful parents, a Ray Charles record playing, and this candlelit life they built for me.

He tended to get along very well with Brits—though not nearly as well as he got on with the French—because his humor was dry as a bone yet somehow completely bubbling-over effervescent. Not only that, but he was remarkably good-looking and stylish, handsome in a European way, I think. Even as he got older, I could still see him as this dashing student at the Sorbonne where he studied every language and every instrument he could get his hands on, before dropping out to play rock music for the rest of his life. He did an interview in the late '90s about his career and was asked what his greatest accomplishment was: "My daughter. Any musical accomplishment pales in comparison."

I love him so much it hurts. But it's a burden of loving someone who scratched

my growing soul and then left me to deal with it myself. What am I supposed to do with that?

Well, I've done what anyone would do: I've dated a long series of men who remotely reminded me of him, and either left them preemptively or crumbled apart when they left me. This is what therapists call "repeating trauma patterns."

After my fight with the Australian, I decided for the first time that I needed to do something about this. It became totally clear to me that I'd been looking to men to heal me since I was twenty-two, but I'd never really taken steps to heal myself. As hokey as this sounds from the outside, it was a revelation to me.

I guess, for a long time, I thought I shouldn't have to. The horrifically named "daddy issues" weren't my issues in the first place, so why was I considered the broken one? Why did I have to spend money and time to deal with this, when I never asked for it? Couldn't I just find love and call it a day? This is what therapists call "unhealthy attachment."

When I realized that I could choose to heal on my own, it felt like a daunting but kind of exciting task. I've always really loved school and taking classes, and this felt like doing an educational program of some kind. I had a long list of assignments, a notebook dedicated to the journey, and even an accountability partner who acted as my teacher through the proceeding months: Ruthie.

◑　◑　◑

I sought Ruthie out after I heard her on a podcast. Her voice itself—not even the words she was saying—resonated somewhere deep within me, probably around the same layer of my soul that was wounded by abandonment. But the soul holds everything very close, the wounds as well as the plump healthy parts that some-

how recognize a voice they've never heard before. My soul knew Ruthie's voice right away. She was somewhere inside of me before I even met her. "Oh, there you are," I thought when I met her. "I've been hoping you existed."

Ruthie had recently begun a crusade to heal from chronic physical pain. She'd already made mind-blowing progress with the use of what many people patronizingly call "alternative" medicine. I was fascinated by her story and when she insisted, "Healing is for you too," I believed her.

She gave me a list of healers and medicines that had helped her in some way, plus some extracurriculars for my specific area of pain, and I took the prescription. This is a sample of the methods I explored between October and June:

- ★ Tarpana meditation

- ★ Reiki and other forms of touch-energy healing

- ★ A psychic who specialized in health concerns

- ★ A psychic who claimed she could talk to the dead

- ★ Past-life regression therapy

- ★ A womb-healing ceremony

- ★ Oxygen therapy

- ★ Abandonment-wound coaching

- ★ Morning pages

- ★ Sound bathing

- ★ A ritual I invented in which I say, "Hi, Dad, I forgive you" every morning

Plus, of course, my talk therapist on the Upper West Side who gives quips in a Jersey accent like, "Sounds like he's got more issues than the *New York Times*."

I sort of knew ayahuasca had to be in there somewhere, possibly even as a symbolic final step (of course, there's no true final step). So when Ruthie invited me—she'd been to four ceremonies already—I didn't question it the way I would have with probably . . . anyone else. After all, she was my guide on this crazy-ass journey. If she knew my next step, then so did I.

◑ ◑ ◑

Ruthie has described neuropathy—a permanent side effect from surgery on her spinal cord—as the sensation that one side of her body is constantly on fire. But despite that, she is a human fireworks display. Nobody in my orbit lives with more color, passion, enthusiasm, and regular dance parties as Ruthie Lindsey. Upon deciding that she could either be in pain in her bed, or in pain while traveling, loving others, having backyard dinners, and exploring the forest in bare feet, she chose the latter. She is a living story of triumph.

Around the time that I was becoming aware of my abandonment wound, Ruthie had begun a journey to heal her own pain. She'd spent the beginning of her career showing how you can be a joy-seeking, life-loving person who happens to feel like you're on fire all the time, and recently she'd become determined to be that person but without the pain. It didn't occur to me that you could do that. It didn't occur to Ruthie either, or she surely would have done it a long time ago.

Ruthie lived with a couple of assumptions: She would be in pain the rest of her life, and her pain would get worse every year. This is what she was told, and she

folded it into her story and identity, the way a lot of us do with our most intense wounds.

I did the same with my emotional wounds. The Easter after my dad died, I read a meditation about Easter Sunday. The essay was about a woman whose daughter was sick, and she quoted a particularly poignant Biblical moment: "Put your hand into my wounds," said the risen Jesus to Thomas, "and you will know who I am."

I took a cue from Jesus and identified with my wounds. Put your hand in, and you'll know it's me. They're what I wrote about publicly and talked about on stage, like I fancied myself some sort of poster child for emotional resilience. In a way, I saw myself as an alternate version of Ruthie, striving to live with joy in the face of pain, only mine was chronic emotional pain rather than physical.

When Ruthie began unlearning the beliefs about her pain that she'd clung to, she repeated a mantra over and over: "Healing is possible, and healing is for you." She had adopted a new mission, and along with it, cut her hair short and painted her door pink as a symbolic embrace.

She said that for years she'd been looking to every doctor, man, friend, alternative healer, and freelance job to heal her. "Heal me, boyfriend; Heal Me, community" was her impression of her former self. "Make me better." But in all those years of reaching externally for a miracle cure, she'd never begun the journey to do the healing by herself.

The similarities were so obvious they bonked me on the head. I'd been living with a deep gash on my soul left by my father when we became estranged years before he died, though the feeling of abandonment surely began much earlier in the most tender years of my becoming.

I knew rejection seemed more painful for me than the average person, and I knew that my nervousness over being abandoned made me push people away and

break up with them before they could leave me. I knew all this, and yet I always blamed it on the guy. Obviously, sometimes it was his fault for being a total bonehead, but I was usually too busy obsessing over him to realize his boneheaded ways right off the bat. It was a vicious cycle that never gave the wound time or space or care to heal.

"Healing is possible, and healing is for you" I repeated to myself over and over after the Australian and I broke up. It sounded so simple when I thought about it. Of course I could heal from this wound, and it would make everything easier. If I wasn't going around town terrorizing men with my panic over rejection, I could enjoy dating so much more and was far less likely to throw tchotchkes against walls.

So why hadn't that occurred to me before? Why did we cling to our pain, Ruthie and I wondered together? Well, for one thing, we hold empathy in high regard as one of our most treasured values. And from what I understood about empathy, it has a lot to do with being able to sit with a friend's pain in a place of expansive understanding. I equated that with quite literally feeling their pain, and wasn't that a lot easier if your own wounds still throbbed?

For another thing, we were both artists in some way or another. And yeah, yeah, we know that the "tortured artist" trope is a cultural myth that society needs to debunk. Creativity can certainly come from a place of pleasure; you really don't need to be an unstable addict with a perpetually broken heart to be able to write words that touch people. And yet, I'm just a lot more poetic when I'm going through a breakup. And when I get really sad listening to one of my dad's songs, I'm able to make some pretty angry art that I'm proud of. I was slightly concerned that if I really worked on healing, my art might suddenly turn into Hello Kitty.

Ruthie quite literally talks about her pain for a living, and I teach a class called

"Turn Your Pain Into Art." So it's not much of a mystery why it didn't occur to us to heal. Healing could mean we were out of a job.

I had always assumed healing wasn't possible for me. It didn't seem like it could be. Movies about dysfunctional families (one of my favorite genres) had taught me that to move forward from the wounds of an estranged parent, you need to have a dramatic talk with them while they're on their deathbed—but are still miraculously articulate and well made up. The source of my pain around men—my father—was dead, so I couldn't reconcile with him anymore. The pain was just a part of my personality and that was it. I didn't know there were other ways to heal.

Ruthie's healing journey involved enlisting every single physician, shaman, therapist, doctor, curer, and medicine person in the greater Nashville area to see what they could do for her. Instead of going in with the intention, "Fix me," she'd go in and tell them point-blank, "You are going to be part of my healing."

The distinction made all the difference. People love asking, "What's the *one thing you did* that really made a difference for you?" But that's the "Fix me" mentality—an attractive fast track without any of the pesky internal work required for lasting, real transformation.

This was the "healing journey" mentality, and it involved anyone and everyone. Ruthie would describe walking down the street and thinking about strangers, "You are part of my healing! This building is part of my healing!" Beauty, enchantment, and lovely architecture lines had done as much for the healing of humanity as therapists, after all. Why not use every single scrap available?

When I asked Ruthie about the potential grief involved in healing—the wounds that she'd no longer identify with—she said, "Hurt people hurt people. Healed people heal people. Transformed people transform people." If she still

closely identified with her pain, she was likely to unknowingly inflict that pain. If she was fully healed, she was likely to help heal others. It was as simple and as complex as that.

●　◑　◐

I began my great healing adventure with a relationship coach who specialized in attachment and abandonment wounds. I hadn't been officially diagnosed, but I'm pretty sure "throwing a ceramic parrot because a guy said he wasn't ready to commit" probably fell into one of those categories. He was a delightful bald gay man who seemed to make videos from his basement, which was endearingly decorated with a Van Gogh print and a multicolored Medusa floor lamp from the likes of Ikea. He spoke so earnestly, I was instantly charmed by him.

He helped me understand behaviors that, until then, I figured everyone shared to varying degrees. I really thought that every woman who claimed she never thought about her wedding day went home and secretly designed complex seating arrangements and cut up photos from *Brides* magazine to create her own Franken-Dress from different skirts, straps, and bodices. I believed that any friend of mine who claimed she was dating just for fun and wasn't looking for anything serious dated for fun the same way I did—with the secret expectation of something serious. I was surprised to hear otherwise from Basement Bob, as my friends began referring to him. My guru in a polo shirt.

Basement Bob was Step 1 of my healing journey. If the journey was a Candy Land path with colored squares snaking through various dangers (texts from exes, romantic comedies that ended in a wedding), he was the Start square. He gave

me words to describe my phobias and desires—a backpack of self-knowledge to begin walking forward. He also clarified the destination for me: not a relationship, necessarily, but a different and healthier approach to relationships.

As my time with Basement Bob was coming to a close—that is, I'd completed nearly every worksheet and field trip he suggested (i.e., dates with myself, as though I weren't an expert in those already)—I hired an astrologer to tell me what my future held. Rakesh had an email address as long as an old web address from the late '90s, with a lot of symbols and back slashes and numbers. His website was one page, presumably made with GeoCities, and his name flashed in 3D italics at the top. There was one fuzzy photo of him at the bottom and a bio in hot pink font. Perfect. I'm not about to get my future told by someone who has mastered minimal space and Helvetica.

Rakesh had a soothing voice, of course, and a very matter-of-fact way of delivering emotionally stirring news: My purpose on earth was to be a messenger for divine information. Most of my career success would happen in my sixties. And I'd meet my soul mate—couldn't miss him—within the next year. I could tell Rakesh was getting frustrated with how many times I asked him to confirm this information, but he did so with a disarming, easy steadiness. No part of me was skeptical about what he told me, and every part seemed integral to my healing journey.

Hearing that I'd meet my soul mate in a timely fashion was the permission I didn't know I needed to stop dating. Since turning thirty, I'd succumbed to the unfortunate and totally untrue fake-science of the biological clock—even after I froze my eggs!—telling me that my worth as a person was rapidly dwindling and soon I'd actually be invisible to men so I better capture one while I could. I knew that pressure was a total lie and yet I felt it, and I saw it confirmed by movies and

iconic love stories and by my male friends who high-fived each other for getting a date with a twenty-four-year-old.

I know it sounds like I'm lying, but I actually really didn't care if Rakesh was correct or not. His correctness was not nearly as important as the truth he unknowingly revealed: I had permission—from the stars, in fact—to take time off from dating while I healed. I had the blessing to forget that men existed, and I could spend the next several months, or however long it would take, to close the wound on my soul. My soul mate would be waiting, and in all likelihood closing his own wounds at the same time.

Healing has a strange side effect: grief. It's actually not all that strange if you've ever been through a gruesome breakup and wanted nothing more than to feel normal again, only to realize that feeling normal again would mean disconnecting from the person who caused all this despair in the first place—evidence that you're still madly in love with them. The more healed you are, the further you are from the pain, and there's something comforting about that pain.

In my case, as a card-carrying member of the Bad Dad Club (and its subgroup, the Dead Bad Dad Club), I could relate on the soul level to a handful of hip, chain-smoking women about what it meant to have a dad who abandoned me. I loved being a member of this otherwise intimidating community. Women who have been abandoned by their dads tend to dress really cool. Sorry, they just do. They relate to deep, dark art on a level that women who still have "Daddy" on speed-dial in their phone never will. They distract from their wounds with casual, heartless sex, and they tend to be poets, or poet-adjacents.

Of course, I'd occasionally meet a woman whose outward presentation didn't scream "Daddy Issues" but I could bond with her easily when we shared little else in common. This wound, like any other, gave me a bit more street cred. I had a par-

ent who didn't love me, or at least acted like he didn't. What was more fundamentally painful than that? Whenever I felt self-conscious about the more bubbly side of my personality—the mask that never stops smiling, the tendency toward the color fuchsia—I'd reveal this hidden dark basement in the bright Victorian home of my psyche: my father abandoned me. I'm not worth loving.

During Month 5 of my healing journey, I was on the square that directed me to forgive the men who had hurt me. I'm guessing that included my dad—it all started with my dad—but I decided to save him for later. First I'd take care of the low-hanging fruit: my last few exes. I found a womb-cleansing kit online and, a hundred dollars later, apparently my body would be purified from the disappointments of men. Trust me, this wasn't even the weirdest thing I'd tried in the last few months. The purification involved a series of ten herb-filled baths and listening to specific songs and guided video meditations to help me release emotional blocks and get in touch with my Sacred Feminine. Sure, why not?

Mostly I just enjoyed taking a sweet-smelling bath, although the cleanup process was kind of a pain, and involved scooping up dried flowers and stray herbs in a colander from my bathtub. The black chalky incense got all over the place, and don't get me started on the oils. None of the deep trauma work really applied to me, and I'd get bored listening to the same prayers and songs every night. I've never been good at sitting still and concentrating, and it became clear that purification involved a lot of that activity combo.

Toward the end, though, there was a bath devoted to thanking and forgiving our exes. Well, my exes. I was instructed to pour cups of cold water over my heart as I extended my gratitude to every man to whom I'd given it, and to tell him that I forgave any ways he had hurt me.

I had to pause the video because I had so many men in the queue, and I poured

so many cups of cold water in their honor that the bath got chilly and I had to drain it for a while so I could replenish it with hot water from the faucet. It was quite the to-do. But really, beautifully worth it.

My DIY ceremony looked like this:

pour cup of cold water "Thank you so much for being in my life, James. I really appreciate your intellect and how you challenged me . . . dear lord you argued so much . . . why couldn't you just let it go? Did you always have to be the right one? I'm smart too! I mean, sorry, I really appreciate your intellect. You were good at arguing. Too good. Good luck to your wife putting up with all that. I MEAN, thank you, James. Thank you for our year together. I'm grateful for you, and I forgive you."

pour cup of cold water "Thank you for coming into my life, Daniel. I loved so many things about you. I never told you, but I did love you. Sometimes I think that if I ever do end up meeting the love of my life, I'll recognize him because he'll remind me of you. I miss you so much it hurts. And I'm so sad that things didn't work out. You'd love New York, and you'd love the bar near my apartment, and I wish . . . thank you for showing me so much love. I'm grateful for you, and I forgive you."

pour cup of cold water "Really? I have to do Marcus? Well, thanks, Marcus. For what, I'm not really sure. But I forgive you. Okay?"

This probably doesn't sound like it did anything, and maybe it didn't. But even the act of proclaiming forgiveness in a bathtub seemed like a healthy and significant step on the healing journey.

◐ ◐ ◐

At Month 9, I began running out of ideas for the next steps on my journey. I'd done all the big stuff: I'd been seeing a therapist that whole time, I recited daily affirmations proclaiming my beauty and self-worth, and I began taking walks at sunrise in which I'd get in touch with any part of me that was hurting and I'd summon my self-compassion to soothe my own aches. I'd made appointments with a past-life regression hypnotist (in case there were any clues about my relationship with my dad during my life in Ancient Rome), with a psychic (in case she could give me any messages from the Great Beyond), and with the pastor of my church to become a member (unrelated, but a nice balance). I knew that the healing journey board game most likely didn't have a final square; after all, it's a nonlinear and lifelong process, but I felt pretty solid at this point.

I'd walk down the street and take a jubilant cue from Ruthie: This tree is part of my healing, this street musician is part of my healing, my art is my healing, watching TV is my healing, my dance class is my healing. If it contributes in any way to my joy, self-worth, curiosity, and compassion, I'll use it! I was writing in a joy journal, which is something I made up to take the pressure off a gratitude journal—just things that made me smile, that's it. No need to be grateful for them necessarily. I could feel myself becoming a better friend, and I incorporated a new prayer into my morning routine: "May everyone I encounter feel valued in my presence today." I felt myself caring less about what men thought. I was on a roll.

This is where ayahuasca comes in, around Month 10. Ruthie had invited me to a retreat in the Redwoods led by two shamans, who practiced curanderismo—the beautiful practice of administering indigenous Latin American remedies for physical, spiritual, and emotional healing. The shamans used the sweat lodge, sacred music, stones and feathers, Aztec astrology, and plant medicine in their work. Who was I to deny such an invitation? I'd tried just about everything I could in New York; it felt like time to experience what the Redwoods could offer me, and I knew that potentially involved ayahuasca.

I only knew a couple of things about ayahuasca: it was one of the most potent psychedelics you could do, and it made you throw up a lot. Neither of these sounded remotely appealing to me. My stance heretofore on psychedelics was that the non-hallucinated world seemed like . . . enough. Plus, I already believed in God and aliens. I was accepting of death. I already saw colors when I heard music. I didn't feel compelled to throw up to get anything deeper out of life. I'm all good.

But when you're on a mission, you take opportunities pretty seriously. I was on a mission to heal and I hadn't tried any medicine, much less THE medicine, as it was known. Here it was, available to me, guided by people who really knew what they were doing, in a yurt surrounded by ancient trees. It seemed like a no-brainer.

Imagine what kind of people you might meet at an ayahuasca ceremony, and you're probably right. The first guy I met looked like a parody of a surfer dude—the kind of central casting blond bro who'd show up as an extra in a beach episode of *Saved by the Bell*. His floppy, sandy hair stuck out from his backward baseball cap, and his biceps billowed out from his muscle tee. He moved like a big puppy who didn't know what to do with the paws he'd yet to grow into, and he spoke like a cliché of a stoned college student, though I'd later learn he was in his late thirties.

His name was Cat ("Like the animal?" "No, like Stevens") and he came barging

into the yurt I shared with Ruthie and asked if he could borrow a pillow, before reaching out his hand and shaking ours so forcefully I felt like I was going to fall over. Wiping his brow with the bottom of his T-shirt, exposing an impressive set of abs, he playfully smirked, "Get ready for some *dark* stuff tonight—I hear they're using a new brew."

"Huh?" I said, longing to be back home.

"I heard the shamans talking earlier. Apparently last night they used the easy stuff. I was here. Dude, I've done LSD, 'shrooms, peyote, you name it—nothing even comes close to ayahuasca."

Ruthie looked at me but spoke to Cat, "I don't think you should be telling her this . . ."

I wondered if I *had* to do it. Of course I didn't have to. I knew I had the freedom to sit there on a yoga mat with eighteen other people, watching them hallucinate and puke and whatever else would go on starting at 7 p.m. tonight. But I'd made a commitment, one I wasn't even fully aware of until that moment. I knew I had to. And I'd only take a very, very small amount.

Taking the medicine felt like going up for communion, only most of the partakers were wearing caftans and would say something into the cup right before they drank it. We were told to go up with an intention—something we specifically wanted to ask the medicine. I, of course, was there for healing from the wounds of men, but as I went up there, I decided that might be a little too negative. I switched the language right before I kneeled to receive the tea: "I would like more beautiful relationships with men, and a more beautiful relationship with my own self-worth." I took one small sip of the grossest liquid I'd ever consumed, and went back to my mat to wait.

Describing a trip is a lot like describing a dream, and just about as interesting to

hear about. It's all visions and odd connections that don't make much sense unless you're seeing it yourself, and to anyone else, it's not real. But to the trip-taker or the dream-er, it feels more real than reality.

Nothing happened for the first two hours, so I sat there in the dark listening to the shaman play a drum and shake some dried plants in the foreground of vomiting and crying. This was pretty unpleasant and I desperately wished I was watching reality TV instead. Crossed-legged, holding my heart, telling myself I was safe and good and loved, I was half-relieved and half-disappointed that nothing seemed to be happening. It got so boring that I had to go outside a couple of times just to get a change of scenery. I'd heard that people had mystical experiences with nature while on the medicine, and I hoped to talk to a tree or see art in the stars, but no such luck. I just felt a little nauseated and couldn't look at the stars too long without my stomach churning.

But all of a sudden, after what felt like hours into the drumming and leaf-shaking part of the ceremony, I felt what I can only describe as a roar in my brain, and then the visions started: twisting colors and bright lights, flashing and swirling like the world's most annoying video game. Every time the shaman began a new icaro—the song that would guide the medicine to help us experience visions and memories and feelings—the landscape would change. Most of it seemed insignificant, and even in a hallucinatory state I felt disappointed that I wasn't having revelations about God or aliens or my ancestors. I was just seeing lots of plastic palaces and wheels made of hard candy. I felt jealous of Ruthie, for whom the medicine gave creative breakthroughs and information about her soul mate and her career. These Technicolor swirls were just giving me a headache.

This could have lasted two minutes or three hours. I wasn't sure exactly when the icaros stopped and melodic music began. Our shaman switched from the

tuneless, chanting "magic songs" that seemed to create this overstimulating mind landscape for me, and picked up his guitar. I didn't think I'd ever heard such beautiful music in my life. His voice was gentle and soothing as he sang in Spanish about sunsets, Mother Earth, and giving thanks for trees and stars. I opened my eyes and I was no longer seeing visions, but *feeling* messages wash over my body—messages like "The medicine is healing you"—and an accompanying euphoria.

I was so sure I was going to talk to my dead dad during the ceremony. Positive. If I was going in to heal the wounds of men, or, er, have more beautiful relationships with men . . . surely a hallucinated reckoning with my dad's ghost would be a part of it. I'd heard of people who communicated with dead relatives or friends on psychedelics, and my dad seemed like the most likely candidate—though, sure, I would have taken Whitney Houston or Salvador Dalí.

His ghost never showed. Rather, these positive, peaceful messages kept lapping over me like cool ocean water: "You are meant to be a woman of joy, and that joy will come from your work, and your friends, and afternoons in your future garden wearing a floppy hat and dancing among the ranunculus." I saw myself twirling in a pink dress like Maria in *West Side Story*, flouncing around with my hair perfectly blown out and my lipstick masterfully applied. I looked so happy, and therefore radiant, the ideal version of myself dancing carefree in my own garden. At this point I thought, "Wait, where does the healing from men come in?" Only to immediately receive the message, "Your joy has nothing to do with men."

I curled up with my pillow and giggled for a while as I watched delightful visions pass through my mind—sunsets, rivers, a kite reaching up from earth to tickle God's beard. The music became lullaby-esque at this point in the late night, and I assumed the shaman was trying to gently ground us back to reality with James Taylor and Bob Dylan songs. I began feeling mostly back to normal, except that

every lyric sounded profound, as though it was the first time I'd ever heard it. I was as much of a cliché now as Cat swaying in his backward hat a few mats away. I was lying in a yurt, wearing a multicolor caftan, clutching my rose quartz necklace I'd worn because the crystal's energy was supposed to be positive, *really feeling* that the answer, my friend, was blowing in the wind.

◦　　◦　　◦

Some veteran psychonauts talk about the afterglow they routinely experience the next day, an energized elation that makes them feel accepting of their life's adversity and more grateful for what life has already offered them. I felt mostly just grateful that I didn't die.

Our group sleepily and contentedly met back in the temple (a well-decorated yurt) to have breakfast and talk about any revelations we'd had the evening before. I was jealous of a few of them—especially the young gorgeous woman with the thick dark hair who'd done several ceremonies in Peru and had a new understanding of the expansiveness of her womb through this particular experience. Even her visions were feminine and flattering. I admired the man who reconciled with his own death, and envied the woman who felt herself become a badger for a few hours. I couldn't come up with a succinct way to summarize my own experience, except maybe "Women are fabulous." I decided to keep my mouth shut and eat some vegetable soup that had been poured for me in a ceramic mug by a man with gentle eyes.

They call the post-ayahuasca experience "integration." This is an easy way to recognize a devoted shaman: their attention to the integration process. The good ones say it's as important as the journey itself—considering how to integrate the

information you received at midnight in a yurt surrounded by like-minded strangers into the considerably less enlightened streets of Manhattan.

We received emails in the following days with tips on how to integrate insights from the ceremony: journal, spend time with close friends, take long walks, basically a bunch of things that would be a lot easier if one didn't have a job. I drank a lot of tea that week, looked at the moon more often, and told myself I was beautiful and worthy and healed. I told others too, with the zeal of the converted. "Your beauty is just for you! It doesn't matter if the guy texts you or not! It has nothing to do with your worth and inherent beauty!" This is a lot easier to believe if you saw it in a vision the other night. If you didn't, it sounds a little Barney.

I spent time with my journal and I set up a date. Not with myself—with a man! A concept that had been totally abstract for the past ten months, now a reality thanks to a guy who'd attended a workshop I hosted a while back. After a three-day retreat in which he was surrounded by women and emotional vulnerability, he wrote me a beautiful handwritten letter saying, among other things, that he'd like to take me on a date sometime. Micah already had a lot of points for being one of three men at a journaling workshop, and his letter was straightforward and swoonworthy—not fond and florid encomia to my wonderfulness, but just appreciation and curiosity about knowing more. I liked him.

The night we went out, I felt like a parody of a woman who'd forgotten what it was like to date, like a rom-com middle-aged divorcée who thinks Tinder is a German chocolate bar and will be shaving her legs for the first time in two years tonight—get ready for a madcap plumbing scene! My muscle memory no longer served me as I fiddled with my curling iron, and I washed off my wing-tip eyeliner three times before giving up and giving my eyes a solid swipe of mascara. I couldn't

remember what my go-to date outfit was anymore, and had trouble remembering a time when I did this multiple times a week. Playing into my own parody, I silently whined to myself about having to get out of leggings. It's not that I don't go out anymore—I still love nightlife and late dinners and even my local low-key club—but I'm a lot more comfortable than this when I leave my apartment. I forgot what dressing for the male gaze entailed.

Micah had clearly done some googling for our date. Although I'm as enchanted by effortlessness as the next person, I also really appreciate research. It makes me feel really *considered*, which I don't always feel. I could tell that Micah looked for a Mari-specific restaurant, and it warmed me up to him right away. The restaurant was enchanting and very feminine, with lots of hanging flowers and Spanish moss inside. Twinkle lights abounded. I knew he didn't care that much about food but it was a farm-to-table situation and that made me feel considered too. He'd looked at the wine list and the appetizers before we came, so he was prepared to make decisions on both.

He was as sensitive and sweet as a guy who attends a journaling retreat is probably imagined to be, and he was cuter than I remembered. He was tall, wore a cute and well-fitting shirt with a whimsical pattern, and jeans that fit really well. You probably know as well as I do that men with well-fitting jeans are not a dime a dozen. To top it all off, he smelled like spices. He told me stories about living in Japan—stories that made me sigh and guided me to imagine the little bars he described—and I felt funnier when I talked to him. He made it easy for me to think of one-liners and he always laughed way too hard at them, which I loved.

It was a cinematic first date, and included drippy ice cream cones in the park while fireflies danced around. Our knees touched on the bench and I wanted to

kiss him so badly I could have died. You don't get that type of date too often in your thirties—maybe you never really do. Maybe it's the type of date that exists primarily in summer romance movies or the episode of your favorite ensemble comedy when the two characters with the insane chemistry finally kiss. We even watched the stars together. These all should have been signs, in hindsight. But signs of what? A fantastic first date? That would have made the most sense.

Instead, as we paused in front of my apartment, Micah gave me a First Date Long Hug, and I put my nose right in his neck because it smelled so good. I wanted desperately to kiss his neck but decided to play it coy. He held my shoulders like he was going to pull me away for ideal kissing geometry (he was tall, did I mention?) except he didn't kiss me. Well, he asked if he could kiss me on the *cheek*, which I thought was quite Puritan of him, until it dawned on me that a cheek kiss signified something more sinister than secret Amish tendencies. He mumbled, "I'm sorry, I'm bad at this," and suddenly I wanted to throw up the ice cream I'd been naively lapping up just moments earlier.

"I don't . . . know how I feel about you," Micah said with assertiveness normally reserved for calling in a pizza order. "I mean I do know. I don't feel . . . I think we should just be friends."

Can we review a couple of things for a moment? One, empathy is sort of my thing. Yeah, I can't do math, can't run very far, and I'm spiritually and emotionally unable to understand political theory. But I can usually look at a person's face and have some idea of how they're feeling—at least in the same ballpark. I've also been on one million dates. So I like to think I know if I'm having a good date or bad date and how the other person is feeling about it too. And we were on a *great* date.

Two, Part A, this guy had already gotten to know me over three days at the workshop he voluntarily attended. Not only had he seen me talk about some really

raw and honest stuff (hell, I even told the ceramic parrot story!), but he'd seen me with three-day unwashed hair. Now that I get all dolled up, going so far as to wear a strapless bra for the occasion . . . this is when he decides he doesn't have more-than-friend feelings?

Two, Part B, I care way more about my friends than I care about guys I date. So I don't know why we're using "just friends" as a way to take it down a notch. That's actually a luxury and a right I give to someone with whom we share mutual love and commitment and wine nights. I'm not giving it to any Tom Dick or Harry who decides to pay for my dinner and decides he wants to cheek-kiss me.

Three, why did this hurt so badly and so immediately when ancient practices had just healed me?

If ten months on a healing journey and a psychedelic administered by *shamans* in the *Redwood Forest* couldn't take this pain away, then I felt totally doomed. I can't remember what I said to Micah, who, bless his heart, probably thought he was doing the exact right thing his buddies had told him to do: be honest, don't lead her on, etc. And it was the right thing to do. But it still didn't feel good.

In fact, it made me want to throw up more than the ayahuasca did. I think I said something like "Thank you" and ran inside. I felt embarrassed. I felt shocked. And I felt so weak. All the same stories came rushing to my head, as though this was their big moment, at last. It had been ten months and they were eager to come on the scene again:

It's so hard to love me.
This comes so much easier for everyone else.
I am fundamentally worth leaving.
I am not worth loving.

I am ugly, not funny, broken, uninteresting.

I have too much baggage.

I'm not going to find love until I'm sixty and I'll have to get married in a pantsuit.

I hated how awful these thoughts made me feel, but I felt even more awful that they popped up in the first place. Wasn't I all done here? Didn't I just spend upward of a thousand dollars and every night and morning of my life doing this healing work? For what? To be ruthlessly cheek-kissed and crying in a fetal position again?

It wasn't about Micah, of course it wasn't about Micah. That's something that my darling coupled friends could never quite seem to grasp, unless they'd been very recently single. Micah is a great guy, but I know he's not the only guy, and plus his music taste is completely bizarre.

You know the pain you feel when you have a big bruise on your thigh and you absentmindedly bump it on a coffee table one day as you're rushing to answer the doorbell? A bump on a coffee table shouldn't hurt this bad, you think. But of course, it's not the bump that hurts—it's the bruise. And my bruise was throbbing, excruciating. And I was extra mad because I thought I was *done* having a bruise.

〇　〇　〇

In the morning, I called Ruthie. In her signature chipper south Louisiana drawl, she said "Hi!" Except "hi" sounded like "*haahhh!*"

"How was your date?"

Ruthie's heart is as big as the Redwood Forest, and yet I still felt embarrassed. I was embarrassed to be rejected and embarrassed for how much it hurt me. I knew

I was going to start crying, and I knew she'd understand, but it felt so pathetic I just wanted to float away with the kite that tickles God's beard.

"It was really hard," I admitted, and I choked a little on the tears so I couldn't speak for a few moments. Ruthie's voice is warm even when she's not speaking; even her "mmm"s are filled with sweetness, like she's pouring honey over the heart.

I told her the story and found myself crying—really shaky crying—by the end. "I thought I was healing," I squeaked out.

Ruthie's honey voice covered my crying. "You *are*, sister. You *are* healing."

The next couple of days I wondered how on earth it could hurt so bad if I was healing. Why did one date seem to throw me back right where I began? I reflected on the last few months as fake progress—just illusions that made me believe things were really changing for me.

I thought about Ruthie and her physical pain. I knew she was still in pain, even though she rarely talked about it. Of course she was. There was a wire stuck in her spinal cord! She was most definitely hurting, and there were many things she loved doing that exacerbated her ache. And yet, she'd still easily and confidently say she was healing. The pain was just a reminder that her body was trying to protect her, and delivering her a kind message to be a bit more gentle. In turn, she'd talk to her pain, which she nicknamed her "peonies" to make them seem more benevolent: "Hey peonies, I know you're trying so hard to protect me but you really don't have to—I've got this! We are so safe and loved. We are okay. You can relax."

It all seemed so logical for physical wounds. Of course they'd continue to hurt even as we healed. I once had a mole removed on my shoulder and the stitches healed years ago, yet it aches a little whenever I touch it or bump it. And even so, I've never questioned my body's healing.

But after Micah's dismissal of my worth, I felt like I was back on Candy Land

Square One in this emotional healing journey. This is what therapists call "non-linear healing."

But then, wait. I thought to myself, *I'm worthy without his approval. So really, it's his issue and his alone if he's missing out on that. His interest or disinterest in me has nothing to do with my beauty, joie de vivre, intelligence, humor, fun-loving spirit, or ability to guess what time it is without looking at a watch. If he projected anything else onto me, it was completely his problem. I was still fine. I was still worthy of love. And, beyond being worthy, I had a lot of love in my life.*

Much like the ayahuasca visions, these realizations sound a little hokey unless you live them. But I'll put it this way: I never would have been able to think this way a year ago. I would have taken it so personally, and used it as evidence against my attractiveness. Now I was hurt—of course I was hurt, who wants to be cheek-kissed when they're expecting a make-out session?—but the hurt didn't have any effect on my self-worth. It was as personal as my shoulder still hurting after mole-removal surgery. Yeah, a bit painful. Nothing to do with me as a person. Can I thank the ayahuasca for this, or the reiki? I guess we'll never know.

◑　◑　◑

I took gymnastics as a kid for many years. My favorite event was the balance beam. I was okay at it, but I think it was the adrenaline rush that really got me hooked. It's exciting to do fancy moves on a tiny space! I liked how precise we had to be; it was so unlike anything else I enjoyed. I'm not a precise person by any definition so the challenge of keeping my feet neatly together and my landings meticulous was kind of exotic to me.

At level 3—that's around fourth or fifth grade—we started learning much more complicated moves to perform on the beam, so it was inevitable that we would fall. My nine-year-old mind found this very funny, and quite different from anything we were learning in school. Why would we learn something we knew we wouldn't be able to do? The gymnastics coaches explained that falling was probably going to happen, but it would teach us our limits and how much we were capable of. From now on, falling was a part of our learning, and we should take a moment to think about the lesson that every fall taught us.

Before we started learning how to do a cartwheel or back walkover on the beam, we had a falling lesson, much to the giggling of the girls on my team. A *falling lesson*, we asked? Yes, exactly, the coaches said, we were going to learn how to "fall better" today. That is, because falling was inevitable, we might as well make it safe. We learned to cross our arms in front of our chest as we tumbled, because human instinct is to put down your hands. We learned that if you're carrying something like a ribbon, you will want to save that ribbon because your body thinks it could be a baby. We had to take practice trips off the shortest beam so we'd remember to toss the ribbon into the air as our feet wobbled. I quit gymnastics pretty soon afterward, but I still cross my arms over my chest when I slip on a stair.

I thought about learning to "fall better" when I still hurt during my healing journey, post-ayahuasca and everything. Not hurting wasn't the goal of healing, so it seemed. Not feeling pain anymore is not entirely why I began this process. I started taking cues from Basement Bob and moving toward ayahuasca because I, essentially, wanted to fall better. The fact that I hurt ten months into my journey had very little to do with my progress—Olympic champions still fall from the

beam. But now my pain didn't pulsate from that abandonment-induced gash across my soul, and didn't make me want to throw a single thing. It hurt in my heart, hurt less, hurt better.

A few days later, I opened up my Healing Journal to Month 11. I'd heard good things about walking the Camino de Santiago, Internal Family Systems therapy, and daily rose-hip tea, and figured they could be worth a shot. After all, I'm on a mission to heal. Why stop now?

I WANT TO CARRY PAIN LiKe
a TREE DOES: LeT The RiNGS
oF My EXPERiENCES PuSH Me
To GROW WiDeR aND STRONGeR.
I NeveR WANT To FoRGeT
EACH RiNG ThaT HoLDS
EVERYTHiNG i've WiTNeSSeD, LoveD,
aND LoST...

BuT I WANT
To KeeP
EXPANDiNG.

A TRee GROWS iN MANHATTAN

There used to be two trees side by side in Tompkins Square Park, but eventually one was chopped down. On my daily walks, I often wonder where it's gone. It exists—somewhere—but didn't get to live the life that was promised in its seed. The stump, of course, is fascinating; looking at tree rings up-close is poignant and visually pleasing. One hundred and thirty rings. Too young for a tree to die, when the one next to it is about 150 and as strong as ever.

I read that trees can actually feel each other's pain, at least on some level. When a tree is in danger, it can send a signal down through a massive system of roots and fungi telling upward of forty other trees to stand guard. So if the tree is

suddenly threatened by a bark-eating beetle, for example, its neighbors may begin emitting a chemical that makes their own bark taste bad.

Their communication with each other is far more advanced and magical than we have previously imagined. Somehow, when a tree is hurting and possibly very close to death, it's able to send its carbon—its resources and nutrients—to healthier trees. More often than not, a tree's final legacy is shooting its riches through its roots to a younger tree thirty feet away. And, even more miraculously, it will send food not to its children or even its same species, but to the trees that seem most likely to survive. A tree that is having trouble faring the threats of global warming, for example, somehow, astonishingly, mind-blowingly, knows to dump its precious carbon to a neighbor who can thrive in a warmer climate.

I wonder if a tree cut down by a chain saw has enough time to send its nutrients elsewhere. I wonder if its roots thrive long enough to still communicate with its neighbors and instinctively leave the legacy of generosity for their well-being.

◐　　◐　　◐

"This isn't a life," I thought and said over and over while paralyzed. Being completely dependent, not being able to explore on my own terms, needing someone to attend to every one of my basic comforts, took every bit of motivation out of my days and weeks to the point where I felt like a shell.

But at least I had occupational therapy.

Occupational therapy in Spain was my favorite part of being in the hospital. Unlike physical therapy, which helps you recover strength and flexibility, occupational therapy is practical. I learned how to use a phone with one finger, and type with very weak hands. It was empowering to learn how to be more independent,

but really I just loved the community. We would laugh a lot—especially at my bad Spanish—and the therapists I worked with were funny and kind. They could empathize with my frustrations and also easily and lovingly made fun of me, which is what I needed most days.

Even though the days felt like years, after a few weeks, I began showing signs of recovery. Every day, I gave myself a new list of tasks to accomplish:

* **Climb one stair**

* **Type a word**

* **Lift up a book**

* **Wiggle one toe on each foot**

Halfway through my time in the hospital, I joined a new class, a younger class, with a few people around my age. For the first time since contracting Guillain-Barré Syndrome, I felt self-conscious. While I was in hospital pajamas, the other people in my class were wearing street clothes, and human impulse to fit in is strong even in a hospital. So I asked my mom to pick me up some cuter loungewear in town at H&M. I began putting on a necklace before heading to class in my wheelchair, and asking my mom to leave my lip gloss tube open so I could put it on by myself if she wasn't there to help me.

This was mostly because of two guys in my class: Adrian and Manuel. Adrian was an adorable, scruffy hipster, who wore band T-shirts over his skinny torso and bracelets around his wrists. He was a commuter student, so to speak; he had cerebral palsy and had come in to learn new ways to be independent—such as getting around in his wheelchair or taking money out of his wallet. He had a hard

time talking and I had a hard time understanding Spanish so we were useless communication buddies, but my therapist would exchange our secrets between us: *He thinks you're pretty, he's wondering what you're doing in Spain, she likes Bright Eyes too.* We smiled at each other all through class.

Manuel had recently been in a motorcycle accident and lost the ability to move from the waist down. He was just as cute, though "dashing" might be a more apt word. Unlike Adrian, he seemed completely uninterested in me. Such a heartbreak, as he looked exactly like the kind of guy I'd dreamt of meeting in Spain: flawless olive skin, dark hair and beard, great build, and a deep voice. He clearly prioritized fitness and was constantly seeking new ways to exercise up and down the halls, popping wheelies in his chair and softly singing along to the music in his headphones. I could so easily see the life he had before.

While I was in the hospital, I found it challenging to be identified mainly with my disease. I would tell the nurses and therapists that I was a writer, an artist, I loved dancing and taking long walks and going to parties. I had a lot of friends, I was fun, and I really enjoyed fashion and wearing colorful outfits. But none of this really matters when you're in a hospital gown unable to move. You're the patient on six medications, four times a day.

Of course, I knew who I was while in hospital pajamas and a wheelchair. But when I went to restaurants with my mom, to the waitresses, what if I was the poor girl in the hospital pajamas and wheelchair? Could they see me any differently? Why would they put effort into imagining me as anything but?

Even knowing this dissonance intimately, I surprised myself when I'd think "Adrian would be so cute if . . ." If what? He didn't have a condition that contributed significantly to the formation of his soul and personality?

I caught myself in ableist thinking when I teared up looking at Manuel, thinking there was a feisty fun guy now forever trapped in a chair. I, of all people, knew that a wheelchair was freedom, not confinement, but those thought patterns don't break overnight.

●　　●　　●

I loved being in my little occupational therapy community, especially because my usual communities weren't available to me. All my friends at home were online dating, taking ceramics classes, going on an early spring getaway vacation to Miami. They sent supportive texts, but that's not what community feels like. It's being in the trenches with people, and in this specific case, laughing at dark jokes and teasing each other in ways no one else was allowed to.

It was safe there. The room resembled a nursery, with lots of primary colors and toys. We'd spend hours playing games like throwing wooden blocks into a bucket. Such simple, unsurmountable tasks felt good to do in the presence of others. We were witnesses to each other, which felt like the point of companionship.

The day I began breaking from our sacred little community was the day I stood up for the first time. I wasn't planning on doing it, but Carmen, the twenty-two-year-old OT student who instructed most of my activities, told me I could that particular afternoon. And, in fact, that I would have to. I said, "Nope, no, I can't," several times before she showed me step-by-step how I could use my chair to hoist myself up, leaning heavily on the communal table for support.

It took about half an hour for me to muster the effort, but very slowly, and awkwardly, my wobbly legs straightened and my puny arms appeared to be supporting

my weight. I think I was up for three seconds but it felt like minutes. The therapists and my classmates looked up from what they were doing and gasped and cheered with words I didn't understand.

Our culture lives for moments like this. Millions of people consume "Disabled person stands for the first time" viral videos, sometimes titled with a clickbait amendment like "INSPIRING" or "EMOTIONAL." Ableism is so embedded in our society that we feverishly celebrate when we see people who were once sitting in wheelchairs stand. For the record, my first wobbly stand after a month was neither inspiring nor emotional, and I wouldn't have wanted anyone congratulating me for it, or worse, feeling inspired.

As I stood, I half-smiled to my classmates, presuming they envied my ability. Survivor's guilt is equal parts grief and gratitude, and it feels equal parts overwhelming and insignificant. My thankfulness for recovery seems directly related to the fate I could have had, the one so many others have had. My depression over the loss that I did endure is always in direct relation to the much greater loss that others have experienced. There was no way I could celebrate the day I stood up. My triumph was covered in guilt.

◑　　◑　　◑

A year before getting ill, before learning how to stand again, I was walking with my friend Rodrigo through Tompkins Square Park.

"Why would someone cut down that tree?" I asked. He lived smack dab in the middle of the East Village, with a coffee shop on one side and a bar on the other, with clothing stores and old diners and Japanese toast cafes lining the rest of the block until it ended in the park. My heaven. I fell madly in love with New

York through Rodrigo's home and through his way of living—his love of this colorful neighborhood and the quiet moments he created within it.

"Oh, I don't know," he answered. "Maybe it was in danger of falling over? I'm sure there was a reason."

I looked back at the stump, engraved with different carvings and growing a few tiny branches that boldly refused to acknowledge the tree's fate. I wondered if the growth of the thriving tree next to it was at all stunted when its neighbor was chopped down. I wondered if the stump still gave off that tree energy I read about.

We walked through the park to a cafe that used homemade brioche to make sandwiches packed with unusual and messy combos like pork, carrot, and cabbage. It was a place where Rodrigo probably went once a week, but the journey there was dreamy to me. I kept thinking that if my current city of DC had that sandwich shop, we'd never hear the end of it. There would be a line wrapping around the whole neighborhood. Meanwhile, he could just casually go get one of these sandwiches, through a lush old park, past groups of people who looked like a film studio's costume department had outfitted them, any old day of the week he wanted. I was in awe of this life.

Overwhelmed by the enchantment of the East Village in April, I sighed, "I can't get over that you live here, in this neighborhood, in this apartment . . . and this is just your real, everyday life." I said.

He smiled. "It is pretty great."

● ● ●

One year later in the midst of recovery, New York suddenly seemed like a scary place to me. I had planned to move there when I got back from Spain, but it felt

as inaccessible to me as the moon. Post-hospital in Spain, most of my recovery had instead taken place at my mom's house outside of Baltimore. And the bulk of it looked like me sitting on a couch, scrolling on my phone, occasionally opening up an app designed for sufferers of PTSD with generic tips like "Call a friend" and "Take a walk outside."

I'd jolt upon seeing such a brazen suggestion. I did take walks outside, the kind I used to love, where you don't have any aim except to listen to a new album and feel the changing breeze on your shoulders, and I hated every second of them. Every step was an enormous effort with painful resistance. The smaller muscles in my feet were still learning how to move, so I walked down the sidewalk with dramatic thuds, like I had scuba flippers on. Nothing about it was casual or pleasant. My calf pulsed with the beginning of a charley horse. I literally had to pick up my thigh to place my foot where it used to go naturally. I wondered, "What if walking just isn't enjoyable for me ever again?"

I thought of my former paralyzed self, who would be elated just to take a step, and felt bad for complaining. *But I'm allowed to hate this*, I told myself.

My self answered back, *Gratitude!*

I huffed and thought, *Shut up.*

I used to imagine myself on my deathbed going through any regrets I might have in life. Even more than not writing a book, or not marrying a Javier Bardem lookalike, I could foresee myself regretting not living in New York City—my favorite city, my spiritual home. But right then, I didn't care. I felt like I'd already been on my deathbed, and all I wanted was a more comfortable mattress.

To make matters more frustrating, I was mad at myself for despairing so much. After all, I survived. I was even improving, though it didn't feel like it. My recovery was considered the quickest and most successful it possibly could be, verging on

the point of miraculous. This is what people around me—doctors, friends—wanted to focus on. But I felt completely empty inside. It wasn't good enough that I could walk; I wanted to walk like I used to.

When you get sick, people use others' misery to gauge how good and grateful you're supposed to feel. *At least you can walk. At least you didn't lose your ability to write. At least you're alive! At least, at least . . .*

It seemed like I was supposed to feel lucky, but this shouldn't have happened in the first place, so how lucky could I really feel?

I felt like I should be seizing the day, but it felt like the day had been seized for me, and I was only meant to sit among its leftovers. I made food, tried to read, took showers, went to bed with an empty spirit. There was nothing about these days worth seizing.

<center>◗ ◗ ◗</center>

One afternoon, in the midst of my sadness, I talked to Rodrigo for the first time since I got sick in July. He had just started a new job at Google and lovingly spoke of his commute from the East to the West Village—the coffee shop that he'd adopted and the comical struggles of walking through rambunctious St. Mark's on the way home when he worked late. I tried to think of interesting things to say about my mom's suburbs and the books I'd been reading.

"And when are you moving to New York?" Rodrigo asked, and I winced. I expected tears to obediently form, reminding me that possibly giving up on this dream was painful. But they didn't; I felt nothing.

"Oh yeah," I answered, my coolness surprising me. "I don't know if I'm going to do that anymore."

"Huh?!" He responded with shock.

"Well . . ." I didn't feel pained, but I did feel guilty. I knew he'd judge me and I couldn't take that on top of judging myself. I swallowed and tried to explain with full conviction. "I just feel like a really different person than I did . . . before. Things have changed so much."

"Yeah, I get that, but what's your plan instead? Stay at your mom's house forever?"

"You don't know what it's like," I answered.

Of course it pained me that New York now seemed scary and hard. After each visit, I had always prided myself that it was my happy place, my easy place, a sleeping bag for me to curl up in when the rest of the world was harsh. New York was a snow globe: a bubble of magic that I could joyfully dwell in and be shut off from my problems at home. Now the bubble had popped. It was just a big city.

<p style="text-align:center">◐　◐　◐</p>

There wasn't one day where I felt back to normal. There wasn't one moment where the trajectory seemed to change indefinitely. The line on the healing graph would begin to turn upward, then plunge back down, then make a couple of loops, then level out. And how was I measuring healing, anyway? Through how well I could walk, or do things with my hands, or how present I was able to be with friends, or how rarely I felt sorry for myself? Each of those would have a wildly different graph.

There was, however, one day when I actively began *wanting* again.

I was reading a blog and saw travel photos that would be aspirational for anybody, except for me. Up to this point in my healing, photos of somebody's fabulous

vacation made me wince, and home tours overwhelmed me. New clothing trends just looked uncomfortable. But there was something intriguing about those photos in that moment. I wasn't envious, nor was I anywhere close to imagining myself on vacation in the strappy dress of the moment, but I felt a familiar stomach leap at the sight of these photos: the beginning of longing.

The opposite of depression is not happiness, but *wanting*. I thought the bounce in my step would have to do with my literal steps—how well I could walk—or with the bounce indicative of a cheerful mood.

But it wasn't anything about physical ability or cheerfulness.

It was about the restoration of want.

◑ ◑ ◑

I felt awkward saying it: "I think I want . . . to move to New York now."

I felt guilty because it felt like more than I deserved. Why was I allowed to do something big and grand and scary when other people couldn't walk? That sounds like an altruistic thought but it was a logical conundrum that burdened me at most moments. In reality, Manuel was probably living a fuller life than I was at that time, but I couldn't free myself from what I'd projected onto him. I didn't think I was allowed to take risks after being punished for a low-risk adventure, and I didn't feel like I should be able to look for apartments in a five-story walk-up building when my community back in Granada was learning how to enter doorways in their wheelchairs.

I'd been seeing myself as the thriving tree when really I was the stump next to it, stuck at the exact moment I got sick. I didn't see myself deserving of new leaves, and therefore I couldn't imagine being able to give shelter or shade to anyone else.

My lack of desire and my preoccupation with guilt had kept me very, very small. It had nothing to do with physical ability; there were times when I was paralyzed where I felt much more large-tree-like than I was in recovery. My ableist-enhanced arrogance led me to believe that I was thriving just because I had survived. Therefore, it confused me how stuck I felt in apathy and frustration.

 ◐ ◐ ◐

Grief often accompanies good things. I've had friends get pregnant after years of desperate trying, and find themselves going through a surprising period of private mourning for all the trips to Spain they wouldn't be taking, all the career changes that suddenly felt too irresponsible to risk, all the Saturday mornings with the *New York Times* and a hangover bagel they'd be giving up. I've seen other friends get married and wistfully lament even the most miserable parts of their single days.

Moving to a new stage of life implies that there's a natural trajectory in life, that adulthood is a series of milestones, when we all know it's much more scattered and nonlinear than that. Perhaps a more accurate phrase would be to see life as less of a graph and more of a map. *I'm in a different area of life*, we could say, as though we were in Zimbabwe for the next couple of years rather than San Diego, with no implications of progress and no logical way to compare benefits and challenges.

Because people love to put emotions into neat boxes like the makeup organizers we had in seventh grade to separate our chocolate ChapStick from our cherry lip gloss, we get a little uncomfortable with grief in the midst of the good. Therefore, it was very challenging to talk to people about the strange and overwhelming guilt and hesitancy I had after being sick.

A very loud part of my spirit just wanted to run back to the hospital—hard mattress, itchy gown, nonfunctional feet and all—and continue my routine of being abruptly woken up in the mornings by a team of underpaid sponge-bathers, taking a nap, going to occupational therapy, watching an episode of *The Golden Girls*, having dinner followed by hospital flan, and getting to sleep by nine. The security of rules and routine when I wasn't feeling well was safe, comforting, and easy. I knew exactly where I fit. I was even a bit spoiled—receiving flowers like clockwork and being able to freely ask my mom for anything I wanted at the grocery store. Who wouldn't miss certain aspects of this life?

It didn't take long for me to assume the identity of *Sick Person*. Just a couple of days, in fact. So deciding to shed that identity with a symbolic move to New York was not an easy or purely joyful decision. For me, it very much meant leaving Manuel, Adrian, the daily exercises that I started pretending were more difficult than they actually were in order to keep myself in that now-familiar place of personal striving and limitations. It would mean leaving the ambiguity of the recovery process in DC, which gave me space to act "back to normal" one day and back to square one the next. Moving to New York would shake, if not obliterate, my comfortable new identity. I didn't know what to do with that.

I also didn't know how to be a recovered person. Being a recovered person meant stepping into a brand new way of seeing myself—every bit as transformative, disorienting, and uncharted as the territory of a sick person—but this time I actually had a while to think about it. I never asked to get sick, but recovery was a journey within my control, and a journey I had the opportunity to prepare for. I was flung into the "life area" of disease, but stepping out of it felt more like a decision than a natural progression.

At a certain point, I knew I had to get back to the life I'd built for myself be-

fore part of it crumbled. To other people, my life looked like a castle—let's say it's one of those moody grey stone structures in the middle of Ireland, for extra gravitas—and this blip was a patch in the roof or a door that had fallen off. For me, though, it felt like half the castle had washed away in the storm and I needed to come up with completely new materials to rebuild. It would never look or feel the same, but I suppose it would make for an interesting tourist attraction, at the very least.

○ ○ ○

Picking a day to move to New York felt every bit as simultaneously arbitrary and important as picking a day to be (from the public's standards) recovered. As soon as I moved, people would stop asking me how I was feeling. People would assume I was working. They'd assume I was up for parties, and dates, and dance class. Thank God none of my friends knew me to be a hiker before, so there was no danger of being asked to do something to that effect.

It was like the first date after a long period of heartache, the first party thrown following a season of grief. Like any heartbroken person will tell you, going on dates doesn't mean they're over their ex. I didn't want moving to New York to somehow dismiss what I'd just been through, or what I continued to go through— namely, the survivor's guilt that throbbed in my brain every time I took the stairs. I hated falling backward into a neat, tied-with-a-bow narrative that I got really sick all of a sudden and then recovered and became this person living a big wild life, no longer afraid of risks and what people thought. I was still terribly afraid of risks and what people thought, and I wanted people to know that.

I arrived in August. August, like its winter sister February, seems to be a uni-

versally disliked month in the city. For August haters, it's the worst of summer: the time when summer's potential is cut short and what we're left with is regret and longing, at the beach on borrowed time.

But I'm not an August hater.

For many creative people, regret and longing is what we *live* for. We love limitations, especially the wistful ones. August is a three-week foreign love affair that you can't bring back home. August is a beautiful person who just got off the subway, or a tomato whose prime you may miss by a couple of hours. August is a sunset, a Sunday, the last hour of the best party.

It is one of my favorite months. Every year, like clockwork, I begin to see summer's charms when its days are numbered. I get preemptively nostalgic for the nights that feel as plump and sultry as an overripe plum, and I begin to miss the sundresses I haven't even worn yet. It's like living the last days of a relationship you know is about to end, and there's magic in that ache.

I was coming in on the tail end of a New York summer, the whole city quietly and collectively yearning with fleeting time and heat. The weather report showed a decrease in temperature, one day at a time, one digit at a time, and there were half-hour glimpses of autumn every few afternoons. In this erratic weather I didn't know whether I should be listening to pop ballads or moody folk music, so I did a mix of both as I took the train up from my mom's house with two big suitcases that I wouldn't have been able to roll behind me a month ago.

I spent my first three months in one of those first apartments you read about in a magazine feature of a movie star's penny-pinching early days in New York: bathtub in the kitchen, no light, crime-scene lobby with cockroaches hanging out around the one flickering light bulb . . . and three times as much as my rent in DC. I didn't care. It might have been in a tenement on a busy Lower East Side street,

but I still felt like Carrie Bradshaw when I sat at the writing desk, half of my body bathed in lamp glow and the other half shrouded in late night summer darkness.

I did the things I thought I was supposed to do when I got to New York. I attended niche art shows in Chinatown basements where the AC was broken but everyone was trying to have intellectually stimulating conversations anyway. I went out for dinner constantly, learning about trends that wouldn't hit the rest of the country for a year or two. I began working out like a Manhattanite, going to trampoline class and gyms with equipment I'd never seen before.

Instead of feeling like an imposter when I fully participated in a New York August, I began feeling like an imposter when I'd tell a teacher before class, "I have some nerve damage and I can't point my toes all the way." The story began to fit oddly, like when a dress starts to cut into your stomach after months of being comfortable. It wasn't that it was untrue; my nerves *were* damaged and I *did* have trouble standing on my toes, but Sick Mari felt even less familiar than the ambiguous identity I was currently borrowing.

I tried to connect with Sick Mari when I made *tostada con tomate*—my favorite hospital meal—for breakfast, and I'd talk about her to new friends or on dates. Sometimes it felt like I was trying to keep her with me for the same reasons I tell people I was a vegetarian for eight years and a barista for six; I want them to know I empathize with them in ways that aren't immediately obvious.

And sometimes I kept her with me because I was still nervous about stepping into my fully healed identity. I was afraid of ever being pregnant—anything that would threaten control over my body again—and still skittish when my foot would fall asleep and I thought I was losing mobility. I tried to stay close to Sick Mari so I could justify these new phobias, but she seemed less interested in staying close to me.

The magic of plump August transformed into a different magic: the newness and restoration of fall. The city felt like it had turned another year older, turned a new page. Even very familiar facades looked different to me, like their colors had either muted or brightened. I'd only ever seen my new friends in tank tops, and they looked different in sweaters.

In the midst of all this autumnal glow, I was panicking a little about where to live after my extravagant sublease was over. I'd heard of someone's friend who needed a roommate, and a place nearby was going to become available for the next month, but I was anxious to get settled in a permanent place. I wanted a cat. I wanted an address. I missed my art, I missed my forks, I missed the person who preceded Sick Mari.

And then, the way it tends to do, it worked out. Rodrigo had been dating a PhD student he'd met in the spring, and in the vigor of infatuation, they'd decided to move in together. He offered his beloved apartment to me. Having lived there for four years, it felt too precious and too his to make available to the general public. No telling how much a stranger would appreciate its hardwood floors and fireplace and big windows that opened to the backyard of a coffee shop.

I wasn't positive I could afford it, but I wasn't positive I could afford New York in general. I wasn't positive of a lot of things at that time, and the financial risk seemed as sensical and nonsensical as anything else. One lasting effect from surprise paralysis is that my gauge for logical cost-benefit analysis was pretty warped. I wasn't sure if I should just spend all my money on grand and beautiful experiences because I could die at any moment, or if I should pinch every penny as a reverent act of newfound cautiousness. I wasn't sure what gratitude was supposed to look like in this new chapter of health, but doing something I really, really wanted—

moving to the neighborhood where I'd first fallen in love with New York—seemed appropriate.

It was still early in the morning when my stepdad and I finished unpacking the moving truck that he'd driven up from my mom's house. It was one of those energetic November weekend mornings, cold and sunny, promising and limiting. My stepdad departed without much fanfare, and I was left wondering what to do exactly. I probably spent a bit too much time looking at the boxes, deciding which to open first, and ultimately resolved that I'd dig into that project later. Right now, I was tired but wanted to move.

I took a walk to Tompkins Square Park, the first of many walks I'd take over the years from my 9th Street apartment to the middle of the park. I used to see this whole walk through Rodrigo's eyes, so my landmarks were the line outside the vegan burger restaurant, the bodega where we'd get cash for the burgers, and the dive bar on the corner with the PBR special that reminded us of being twenty-two. Now the landmarks looked different. I noticed the stationery store, the açai bowl stand, the vintage store that had antique cream nightgowns hanging by pink ribbons in the front window.

And as I got to the park, it opened up as a new place for me—not the one I'd stroll around with Rodrigo as the person preceding Sick Mari—but as a new place altogether. I took a slow, long walk around the outer edge, reading every dedication on every bench. I noticed a fountain dedicated to Temperance, which amused me, and a dog park dedicated specifically to smaller breeds, which delighted me.

I saw a family with a stroller and it occurred to me that this beautiful park in all its spaciousness was perfectly wheelchair-friendly and could be fully experienced at any height. I quickly realized I liked it best from a seated position, where I could

watch people walking by or, if I switched sides of the park, kids playing basketball and men playing chess.

I was surprised to find the stump had been removed since I'd been here last. At first, I didn't even notice it was gone, the evidence was so thoroughly dug out. But in the shadow of the much larger elm exploding with powerful branches on all sides, there was a patch of wood chips that you'd completely miss unless you knew its history. They weren't able to get every one of the tree's roots, and there were still slivers between the octagonal flagstones of the park's paving where a thick root popped up like a little ear, listening to prayers and shouts and footsteps and laughter of its downtown home. Maybe those roots were delivering the last of their nutrient reserves to the enormous elm next to it. Maybe the elm could provide triple the sheltering branches to park patrons this year because of its friend's final act of generosity.

I was both the tree and the stump, my former identity sending her last reserves to a thriving version of myself. The battle between my two identities softened into a peaceful passing-the-baton between them. I felt Sick Mari letting go, while sending all her lessons and values and love to New Mari: New York Mari. I could feel the grief fading away—the guilt that kept me stuck like a tree stump unable to offer anything but a carving canvas. And I felt invigorated by the dose of nutrients.

I spent most of that day outside, enjoying the very last breath of summer and making my new neighborhood mine by picking up two loyalty cards at different coffee shops and deciding on a usual sandwich order at the place by the park.

It was only when I returned home later that night that I realized I had my work cut out for me. I still had the monstrous chore of unpacking, and as the early evening darkened I also realized I hadn't taken out any forms of lighting yet. A closet

and oven and bathroom light weren't totally sufficient, but the task of trying to find a lamp among the thirty boxes felt monumental at the moment so I set my phone and bag down and sat on the floor, thinking I could create a makeshift table for the pizza I felt suddenly desperate to order. Besides, if I wanted to get to the lights, I'd probably have to move the books first, and where would I put them? My entire apartment felt like an if-then puzzle that I was too exhausted to tackle after a day that began with moving.

I hadn't set up internet, so when my pizza arrived, I wasn't sure exactly what to do while eating. It was getting darker outside, so I ended up sitting next to the bathroom and eating pizza while flipping through an issue of *New York* magazine. At the back there was a list of upcoming events, and I realized that a lot of them were within walking distance of me. In addition, there were movies coming out, and bands coming here, and several new restaurants I wanted to try.

I felt a tickle in my stomach thinking about all the remaining Saturdays in this year alone, how many more park walks I would take, how much more of New York I had yet to even imagine, how much more of life and adventure and beauty were completely mine to experience. I looked around at this dark apartment, waiting to be filled with the tchotchkes and furniture I'd brought from a former life, and I imagined it filling with light some spring day months from now. I wondered what I'd create here, which friends would visit me here, if I'd fall in love here, what I'd cry about here, all the dinners I'd cook here. I wanted all of it so badly.

At the other side of the room, my phone lit up the boxes around it. A text came through, from Rodrigo: "I can't get over that you live here, in this neighborhood, in this apartment . . . and this is just your real, everyday life."

The FIRST TiMe You WALK FRoM THE SuBWAY STATioN To YouR New APARTMENT, iT MAY FeeL LiKe A NEVER-ENDiNG WALK.

"I HAVE To DO THiS EVERY DAY?"

BuT oveR TiMe, iT BEGiNS To SHoRTEN.

YOU FIND YOUR MARKERS:

The PET STORE. ALMOST THERE.

The LOCKSMITH. A FEW MORE STEPS.

THE FIRST TIME YOU MEET A
FRIEND AT THE STATION AND
YOU WALK TOGETHER, SHE
MIGHT SAY: "THIS
IS A REALLY LONG
WALK."

AND NOW YOU CAN CONFIDENTLY
SAY, "THAT'S JUST BECAUSE
YOU DON'T KNOW WHERE YOU ARE
OR WHERE YOU'RE GOING. NEXT
TIME, IT WILL FEEL SHORTER
AND EASIER."

AND IT DOES.

PLUS ONE

I was just waking up from a nap in my hospital bed when I heard the nurses talking about me in Spanish, so of course I pretended to keep sleeping.

"Does she have friends?" (Um, yeah?)

"I mean here. Who is she traveling with?" (Myself!)

"I don't think she's with anybody!" (Yeah, no shit)

"Not even family?" (Stop reminding me)

"Yeah, she's completely alone." (Okay, I get it!)

"Oh, yes, you know American girls, they're so independent. They just have to do everything by themselves." (That's kind of flattering actually)

"You're right, they don't care about family." (News to me)

"It's odd, huh? Going to a foreign country by yourself. Poor thing." (Uh, excuse me)

I guess I really am so American that it never occurred to me that my independence would be talked about pejoratively when I was overseas. Since I began traveling alone, I was often called "brave" for doing it. That adjective felt as uncomfortable to me as a thick sweater in July, and I'd try to brush it off: "Nah, if I were really brave I'd stay here," I'd say, or "Ha, no, bravery is traveling *with* people." But not once had someone accused me of not caring about my family because I liked having a hotel room all to myself and didn't like planning my day with someone else.

Truly, at the end of the day, for me, traveling solo is about not having to share. I'm an only child; I never learned how. (And I insist there are many other ways to be generous.) But maybe, in the depths of my psyche, my compulsion toward autonomy is because I'm terrified of being dependent on people: People can leave, people can die, people can take you out for a candlelit dinner and then tell you at the end that they see you more as a friend. People, like my dad, can carry you on their shoulders and spin you around at weddings and then suddenly stop being in your life at all. Why would I want to rely too much on another person?

When I was a child, I heard a horror story of my mom's friend whose husband unexpectedly died, and she had to pay all the household bills for the first time by herself. She had never opened these envelopes before in her life—it was always relegated to her husband—so she looked at the pile of them crying, feeling overwhelmed realizing that her world had become much bigger and scarier than it had ever been. That story makes me so, so sad, but it also made my too-young-to-think-this-way self leap to a grim resolution: I will never depend on anyone else.

Fortunately, as the nurses so bluntly concluded, my culture supported this decision. Americans value self-sufficiency and we worship the self-made success story (not acknowledging, of course, that "self-made" is most often the result of every advantage pulling for you). Solo travel may not be the norm, but it's an admired choice.

<p style="text-align:center">◖ ◖ ◖</p>

Lately, I've been reading a lot of self-help books and articles because, let's face it, I'm the target audience: I can spend money on bubble bath and whatever other equipment they might suggest, and I'm interested in improving my life in ways that aren't too revolutionary and therefore time-consuming. Sure, I can light a candle. I can get up a little earlier. Let my new and improved life begin.

Self-help is also very attractive to me personally because it provides me with a temporary high of feeling superior. Of course I want to be able to brag about my newfound efficiency, my forgiveness campaign, the ritual in which I talk to my money for some reason. It makes me feel instantly enlightened! Disciplined! Isn't this the entire psychological impetus for drinking a green smoothie for breakfast or am I missing something?

But I realize we/I could benefit from swinging the pendulum a few inches in the direction of communal living—the kind of culture where one person's healing and self-improvement serves the good of the community.

I'm not about to start trying to convince you that you that you need a Wendell Berry lifestyle of staying in one place for more than a decade, living off the land, attending regular gatherings with your neighbors, possibly wearing only linen gowns . . . but I'm curious what community looks like today, in a city.

I think it might begin with acknowledging that we do actually need each other—independent tendencies or not—and that we belong to each other.

◦ ◦ ◦

Recently I decided to become a member of my church, for which I'll have to endure a painful little ceremony at some point in which I say something about myself and maybe get some water sprinkled on my head. I've been going there about six months, and am genuinely moved by how committed they are to serving the poor above all else. I love how they pray for artists, for environmentalists, for migrants, for janitors. I love how they have paintings of LGBTQ+ martyrs on the altar. I love how they allow dogs.

I tell friends that after each service I feel like I've just scarfed down a big salad full of various types of greens and fresh herbs; it feels so *healthy* for me to be there. I feel extra attentive and compassionate the rest of the day after a service, and isn't that the point of . . . everything? When the pastor emailed me about becoming a member, I thought, sure, why not.

(This is exactly how I've made every big decision in my life. The "Mari Andrew Method of Decision-Making" goes: a thought casually passes through my brain, and I do it.)

Anyway, to become a member I had to attend an orientation, which is a rather strong word for an hour during which two other East Village bohemian (their word) men and I sat in an awkwardly small semicircle while the pastor, Will, told us a history of the church (surprisingly interesting!) and we each presented brief autobiographies of ourselves (some briefer than others).

Will's husband, Steven, was there too, presumably for moral support, and he

was instructed to give his bio as well. His was the most interesting, as an opera singer currently training *America's Got Talent* hopefuls. Steven was funny, but his story became so poignant when he talked about Will.

He told the tale of growing up in a conservative church where being gay could get you kicked out, and how he assumed he'd always have a painful relationship with the religious world. Then he met Will, a pastor, on an app where he didn't expect to meet a pastor, and he described their relationship as "healing." So many of the wounds of self-doubt and rejection were soothed by the love of another person.

And then Will, normally a pleasantly introverted man (think: friendly guy at the dog park with whom you engage in jovial small talk), got a bit emotional as he reciprocated that meeting Steven had been very healing as well. Will had grown to assume that no man in New York was interested in dating a pastor, given the Church's violent history with homosexuality, so he was torn between his beloved vocation and the desire for a partner. Meeting Steven, who was not only interested in but actively participated in Will's church life, was also described as "healing."

Because of all the self-help books I've amassed, I didn't know that you could heal with the love of another person. I thought you were supposed to do it all alone. I thought the worst thing that could happen to you, in fact, was depending on someone else for your emotional stability, and then not being capable of pumping gas by yourself.

I saw dependence in a new way: capable of healing. Will's marriage with Steven was healing, and vice versa. Maybe wounds aren't meant to be completely healed alone. It makes sense that relationships are necessary to help build trust in others and trust in your own self-worth, as much as adopting a cat is necessary to learn

about pet ownership or buying your first herb garden kit can help you become a good plant owner.

◑　◑　◑

You can't heal with just anyone. There are people who haven't yet been to the same life forest as you and don't carry the familiar scent with them. Likewise, I haven't climbed mountains that others have, and don't have the leg muscles to show for it. We subconsciously recognize each other's journeys through our scents, battle scars, and stories, and it's comforting to meet people in the middle of the path who have been through similar landscape. It's even nicer still to decide that we will accompany each other on the path going forward, even if we drive each other nuts.

It's amazing that when you meet these people, they slip so perfectly into a space that seems expertly chiseled for them in your heart, so you're left wondering what on earth you were ever doing without them. What business did you even have, walking down the path, not knowing about Cindy? How did I process my thoughts before I met Henry—did I just talk to myself? Did I ever really have a full belly laugh before meeting Jumana? Seems outrageous.

My friend Susan and I refer to each other as "my forever plus one." Whenever we're invited to a wedding, we know who we're bringing. Neither of us has dated anyone long enough in the past few years to have the kind of plus one that's implied on the envelope, but we know we're probably better company anyway—at least until we meet Javier Bardem and Jake Gyllenhaal. I often wonder, when we're sitting together at a reception table deciding whether we should leave our slices of cake to go dance to "Hey Ya!," what would I do without Susan?

For someone who prides herself on being independent, this sounds like reliance on others to me.

I did all the healing I could possibly do by myself. For my physical issues, I went to physical therapy and stayed home to do my exercises for months. For my emotional issues, I went to every healer you can begin to name. Both of these healing journeys were the type I could really only do alone: they were self-motivated and self-directed, and they had to be. I had to continually make the tough decision to keep going even when I was discouraged and didn't think I could do it.

But at a certain point, healing means going out into the world and being in it. This is the hardest part. You can read all you want about how to grow a garden, but until you take yourself down to the plant store and ask for help, invest in some seedlings, and try your luck at keeping them alive, you're never going to become a gardener. I'm sorry. You can't be one in your head.

And you can soothe the wounds of your complicated dad and the ex-boyfriends who failed you, you can come to grips with your childhood and your sore spots, but at some point you might want to give yourself another chance at falling in love if you want to learn to trust romantic love again. A man might really poke at that sore spot you've worked so hard to heal. But it might hurt a lot less this time, and he might even know how to soothe that spot with the balm of his humor, his compassion, and the way he quotes Keats in the same breath as Lizzo.

As it turns out, healing doesn't look like some Don Quixote crusade into the sunset on your horse all by yourself. It is more likely to look like walking down the streets of New York, past people who don't care that you exist but are still a part of your renewed optimism. It may look like joining a dance party in the streets of Rio, or dancing at a wedding, or asking a guy to dance in your kitchen after the last one left your living room abruptly. It is likely to look like a community that

knows your name and makes you laugh, and gives you new things to appreciate about yourself and new ways to see your hair or your voice or the way you write. It is likely to look like friends who tell you that you are beautiful, whole, good, and loved until one day you catch yourself in the mirror and realize that you believe them. The journey itself is not as transformative as the welcome home party waiting for me at the end, and all the friends waiting to toast me whether I'm all the way better or not.

My favorite Wikipedia page is called "List of Names for the Milky Way." Across the East Asian languages, they refer to the Milky Way as "Silver River." In Estonian, it's called "Way of the Birds." Scandinavians call our home galaxy "Winter Street." My favorite is the Sanskrit: "Calm."

When I think about the inner sky of my being, I imagine a blotchy patchwork of colors and weather patterns referencing the whole cosmic landscape of moods, experiences, seasons, and changes I've summoned into my life.

And then I imagine the love from people around me beginning to show up as stars. There's one. Plus one. And another. And another. And another, until my whole soul is canopied with beaming little stars that brighten up the night and keep shining even on the afternoons when they're harder to see. When I feel knocked around by inner storms or defeated by an early lonely nightfall, I look up and see them spread out above me: a whole galaxy I call Calm.

ACKNOWLEDGMENTS

Cindy Uh: You are my sister, angel, rock, and family. And yes, yes, also agent!! You treated this book the way you treat everyone in your life: with unmatched care, attention, and passion. The way you advocate for the people, projects, and causes you love takes my breath away.

Meg Leder: Thank you so much for handling this book like a precious teacup you bought on a special trip. You are a divine editor and phenomenal human. It would have been a joy to spend time with you in any capacity but spending time with you here was the honor of a lifetime.

Amy Sun: You are responsible for carving so many of my big blocks of thought into smaller, more useful shapes. I'm so grateful for your fingerprint on my words!

Folks at Penguin: It was an absolute dream to work with all of you. Thank you for your enthusiasm and expertise from Day 1. Thank you Paul Buckley, Sabrina Bowers, and Lucia Bernard for beautifying this book!

Jumana Qamruddin: You have mastered the art of embracing all experiences—from the depths of grief to the heights of dancing joy. Anything good you see in me is just an example of me taking your lead and studying your life in order to live mine better.

Susan Alexandra Korn: You are a bouquet of sweet peas with a Victorian love note tied with a pink silk ribbon that one might find tucked in the hollow of a tree inhabited by a kind old owl and a family of bonnet-wearing mice. Thank you for all your emotionally rich encouragement and all the colors you've brought to my life.

Kim Rhodes: Your friendship was the happiest surprise of my first book. I'm certain that the stars put us together and I'm thankful you believe in that stuff! I'm also so grateful for your belief in me, and your belief in your own self-worth.

Darya Khaneghah: As wise as you are I swear you're 350 years old, but in actuality I love learning from someone younger than I. Watching you grow is such a privilege, and I so appreciate you watching me grow too! You're a wonderful advice-giver and meaning-maker and your friendship is a non-dairy but ultra-decadent treat.

Karim Said: You are a constant encouragement and a twenty-karat diamond with A+ clarity rating. You've taught me that optimism is the most challenging, rewarding, and realistic stance to take.

Jess Charles: You've seen it all, and you've been steadfast through it all. Thank you for the post-heartache brunches and pre-adulthood fun. Growing up with you is a gift.

Madeleine Dore: Your mellifluous voice accompanied me through this year's challenges and this book's themes. Thank you for so effortlessly understanding it all!

Jessica Irish: All the love and squalor you've sent me through the years have brought forth so many of these self-reflections. My creative process comes down to this: your constant companionship and conversation.

Ruthie Lindsey: You taught me that everything is medicine: from the song "Shoop," to trees decorated with Spanish moss, to a soft pillow, to friendship with incredible humans who can chat for hours on the porch with Topo Chico. You are so special.

Henry Wong: I'm madly in love with your soul. Thank you for the hydrangeas and double violets in a shower of rain.

Joanna Wong: You gave me a new definition for the word "gorgeous": compassionate. You embody it.

RZ: I call you "light upon the water" because no matter how much space you give or

take at a given moment, you shine so bright that the ocean's murky mysteries become interesting and exciting rather than scary.

People of New York: You are my muses. My prayer is that every person who loves NYC will be loved back by it. Please remember to vote for the good of your neighbors and don't forget that we all belong to each other.

Trinity Lower East Side Lutheran: Your unwavering commitment to poor, hungry, and marginalized New Yorkers makes me so proud to call you my community.

Mama: Whether we're eating tomato toast on a hospital bed or spilling the tea in your kitchen, my favorite place on earth is wherever you are. Everything I do is for you. I love you as big as the sky!